The Mirror of the Artist

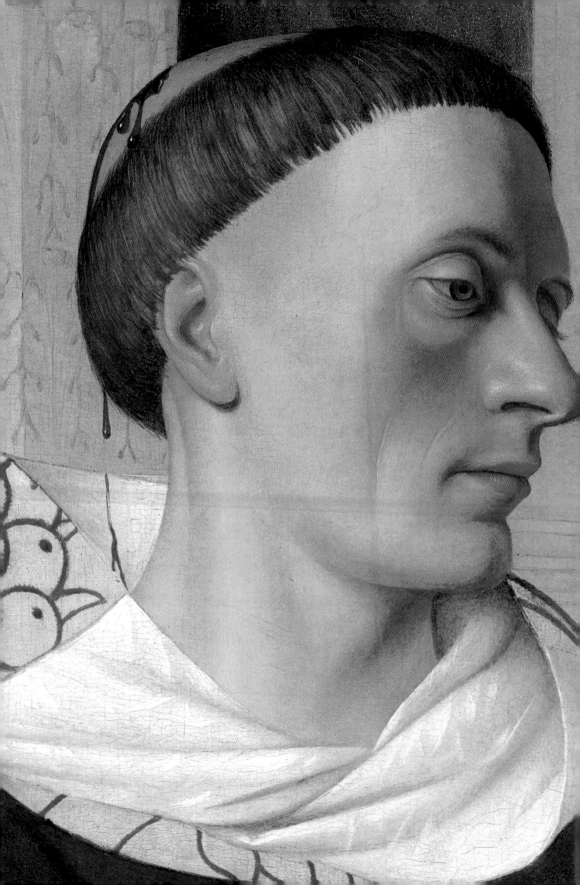

The Mirror of the Artist

*Northern Renaissance Art
in Its Historical Context*

Craig Harbison

PERSPECTIVES

HARRY N. ABRAMS, INC., PUBLISHERS

Acknowledgments

The author wishes to thank the following individuals for helpful comments on the material of the book: Maryan Ainsworth, Christy Anderson, Robert Baldwin, Margaret Carroll, James Cheney, Brian Curran, Sherrill Harbison, Elizabeth Honig, Lynn Jacobs, Georgia Krantz, Bret Rothstein, Larry Smith, Mark Tucker, the late Wendy Wegener, Diane Wolfthal and Vigdis Ystad. Debra Jenkins assisted with typing, and Edla Holm and the staff of the Interlibrary Loan Office at the University of Massachusetts, Amherst, helped procure important source material.

Frontispiece JEAN FOUQUET *Etienne Chevalier,* page 96 (detail)

Series Consultant Tim Barringer (Birkbeck College, London)
Series Director, Harry N. Abrams, Inc. Eve Sinaiko
Senior Editor Melanie White
Designer Karen Stafford, DQP, London
Cover Designer Miko McGinty
Picture Editor Susan Bolsom-Morris

Library of Congress Cataloging-in-Publication Data
Harbison, Craig.
 The mirror of the artist: northern Renaissance art in its
historical context/Craig Harbison.
 p. cm. — (Perspectives)
 Includes bibliographical references
 ISBN 0-8109-2728-4
 1. Art. Renaissance — Europe, Northern. 2. Art, European — Europe.
Northern. I. Title.
N6370.H26 1995
709'.02'4 — dc20 94-48786

Published in 1995 by Harry N. Abrams, Incorporated, New York
A Times Mirror Company

This book was produced by Calmann and King Ltd., London

Printed and bound in Singapore

Contents

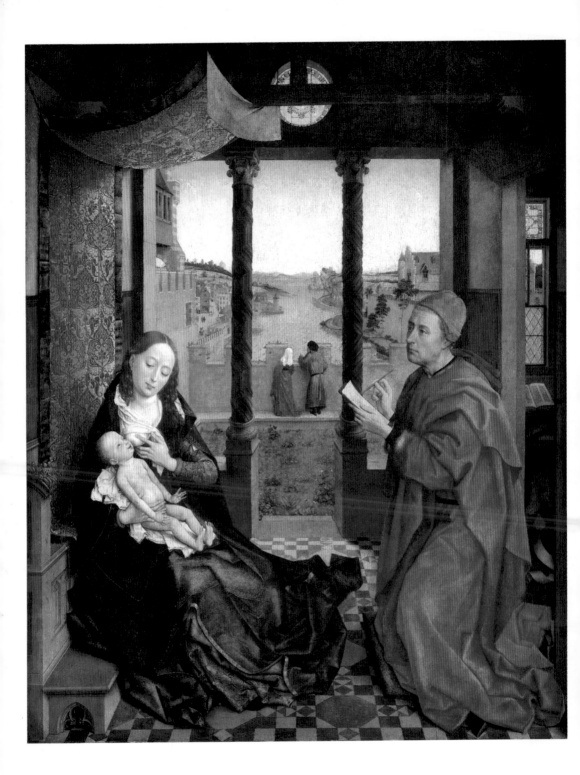

The Self-Conscious Pragmatic Artist

This book describes the art produced in a wide and varied geographical area – from the flat fields, surrounded by canals, stretching unimpeded toward the horizon in the northern Netherlands to the mountain peaks of Switzerland. In between these extremes are the fertile, rolling hills of Belgium and France, crisscrossed by rivers running to the sea, and the picturesque lakes and dense forests of southern Germany. All this, and much more, can be glimpsed in the paintings of the Northern Renaissance. It is a rich and teeming landscape, and similarly the fifteenth and sixteenth centuries were extremely varied and changing periods in this area of Europe. It is a challenge to condense such a complex time and place into a short survey. One of the watchwords in this overview must be *discovery*, a sense of exploration of the world both large and small. The art of the Northern Renaissance is, to a great extent, based on that simple point – discovery of the world and of the self.

A broad chronological and historical framework is essential for an understanding of any period of art history, and certainly it is a prerequisite for an examination of the chief characteristics of fifteenth- and sixteenth-century north European art, to which the label "Renaissance" can be applied. Some modern historians have expressed hesitation about labelling north European art at this time a renaissance, for one of the chief reasons for the term's application in Italy is that it signals the rebirth (renascence) of an

interest in classical Greek and Roman culture, and that does not readily apply to much that was taking place north of the Alps. Still, the term "Late Gothic" is not a very useful substitute for "Renaissance" in the North. There was enough new birth or sense of discovery throughout northern Europe at that time to justify using the term Renaissance.

Church and State

Some definition of that term "the North" also seems necessary, including its basic physical geography. Going northwards from the Alps, Switzerland was the only republic. On its western frontier it was bounded by the kingdom of France, stretching from the Mediterranean north to the English Channel. On its north and east, Switzerland was the neighbour of the Holy Roman Empire, comprising German-speaking people in dukedoms, counties and lesser powers united by loyalty to an elected emperor. Between France and the German lands lay the duchy of Burgundy, known geographically as "the Low Countries," the Netherlands, nominally a French fief until, in 1482, part of it went by marriage to Austria. Burgundy had sufficient size and wealth to gain virtually independent status. Beyond the sea, the kingdoms of England and Scotland jealously guarded their independence.

This definition of "the North" deliberately ignores Scandinavia, Russia, Poland, Bohemia, and the Balkans. The affairs of state that drew their western neighbours sometimes into conflict, sometimes cohesion, left the "outer" states of Europe marginalised, intent on their own problems unless one of the "inner" European states turned a land-hungry eye on them. They were also "outsiders" in the history of European art at the time of the Renaissance, having their own traditions and remaining virtually aloof from the rest of European art until late in the sixteenth century. Only their ties with the Church bound them to the western states, and even then Russia and the Balkans were excluded, being Orthodox Christian, not Roman Catholic.

The term "Catholic," meaning universal, is misleading. Not since 1054 had the Christian Church been united. In that year east and western Christendom had split, the east claiming to be "Orthodox," true to its origins, the west being "Roman," in its obedience to the pope, who was also bishop of Rome. Nevertheless, "Roman" and "Catholic" were not terms that any western Christian would have applied to the Church in the Middle

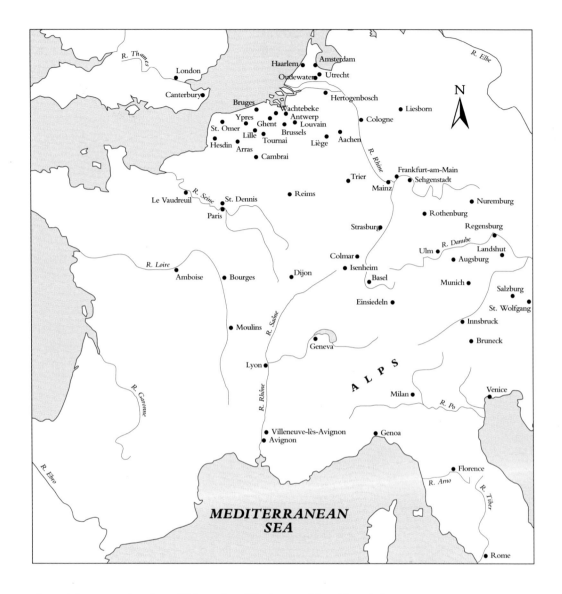

Map of Northern Europe showing location of chief commercial and artistic centres in the fifteenth and sixteenth centuries.

Ages. The central point of his or her life, it was "the Church," without qualification. Only when the sixteenth-century Reformation split western Christendom did the term "Roman" or "Roman Catholic" take on new meaning, in the mouths of the dissidents whom the Church called "Protestants."

Throughout the Middle Ages, the Church was the single most powerful institution in Europe, and, at least on the surface, the vast production of religious art mirrored the Church's central social, political, and economic, as well as religious, position. More than half of the art included in this book is religious; to be strictly representative of the period c. 1400–1600, a greater per-

centage of Christian imagery should probably have been included. By the year 1400 Christian art had had a long and venerable history, and its role in support of the faith – and the institution – was accepted by most of the devout. At various times, however, during the Middle Ages questions arose about the use and abuse of religious imagery. The worship of images themselves, rather than the ideas for which they stood, was a recurrent problem. The painting by Roger van der Weyden (c. 1399/1400-64) showing *St. Luke Portraying the Virgin* (FIG. 1) explains why many opted in favour of the instructional power of art. The evangelist St. Luke is here represented as the first Christian artist, recording in a drawing, as he did in his Gospel, the Virgin and Child. His traditional artistry caused him to be chosen as the patron of artists' guilds throughout Europe. In fact, Roger van der Weyden probably painted his panel for a guild of St. Luke, to hang above an altar maintained by artists in a local church. Painters thus honoured their profession, proclaiming its holy status and lineage. Roger van der Weyden probably also honoured himself since, from other contemporary portrayals of the artist, it appears that he included his own face as the saint's, claiming the role of a new St. Luke. Painters, as well as the religious institutions for which they often worked, wanted to promote this image of continuity and tradition, which was a major factor in favour of maintaining popular allegiance to the Church and a prominent role for art within it.

As an institution, the Church had always had its critics, though it generally managed to silence them by campaigns against dissent, as it did against theological heresy. However, in the fourteenth and fifteenth centuries, the higher clergy came into such disrepute that popular allegiance to the Church was at a low ebb. During most of the fourteenth century (1309-77), the pope resided in Avignon, under the control of the king of France, and from 1378 until 1417, rival popes, sometimes as many as three at once, claimed the throne of St. Peter. This period of political turmoil was known as the Great Schism. Subsequently, during the second quarter of the fifteenth century, the College of Cardinals tried repeatedly to limit the absolute power of the papacy. In order to form advantageous political alliances throughout the fifteenth and into the sixteenth century, the pope had to cede important rights to various European rulers, especially to the kings of France and Spain, who gained the right to name their own candidates for high ecclesiastical positions in their lands, thus bringing the Church under monarchical control. The more spiritually minded members of both clergy and laity con-

demned the Church's temporal powers but, until the sixteenth century, to no avail.

The increase of royal power over the Church in France and Spain was one facet of the general expansion of monarchic, centralised power throughout the states of western Europe; in the Holy Roman Empire it was firmly resisted, and the emperors, by now all drawn from the Austrian House of Habsburg, had to be content with strengthening their grip on their own large patrimony. One feature of the centralisation of national power was the monarchs' acquisition of formerly independent territory, adjoining their kingdoms. For example, although the Burgundian dukes in particular were able to increase their holdings and stature throughout much of the fifteenth century, after 1482 their lands were divided between French and Spanish rulers. Everywhere, the nobility looked to maintain their personal powers in the face of their monarch's incursions and the growing menace of royal bureaucrats.

Artist and Patron

At the beginning of the fifteenth century, the courts of Europe's rulers were still the main artistic centres, employing artists for the creation of ephemeral decoration and pageantry as well as permanent memorials. But after the first quarter of the fifteenth century, noncourt production became increasingly important. Court style continued to be dominated by the extravagant display of costly materials; even images of artists themselves became part of these rich ensembles. The self-portrait (FIG. 2) of the French court artist Jean Fouquet (c. 1420–c. 1480), barely three inches (6.8cm) in diameter, was part of the original, elaborate blue velvet and pearl-studded frame made for the *Melun Diptych* (see FIGS. 61 and 62, page 96). However, the domination of society by a tiny noble minority, probably only about one percent of the population, was definitely on the wane. Monarchs were encouraging the nobility's demise, weakening their potentially unruly nobles by the creation of a middle-class bureaucracy that centralised power, taking it out of the hands of erstwhile overlords. These new court

2. JEAN FOUQUET
Self-portrait, c. 1450. Enamel on copper, diameter 2¾" (6.8 cm). Louvre, Paris.

Fouquet's *Self-portrait* is painted in gold on a black enamel surface, a unique example from this period of a portrait in this technique. It bears some resemblance to earlier Netherlandish enamels, which were, however, painted in grey, not gold. Some similar enamelled portraits from the ancient Roman Empire were also being discovered during Fouquet's lifetime. The work is considered to have been a self-portrait, from the direct glassy stare of the sitter, typical of many self-portraits.

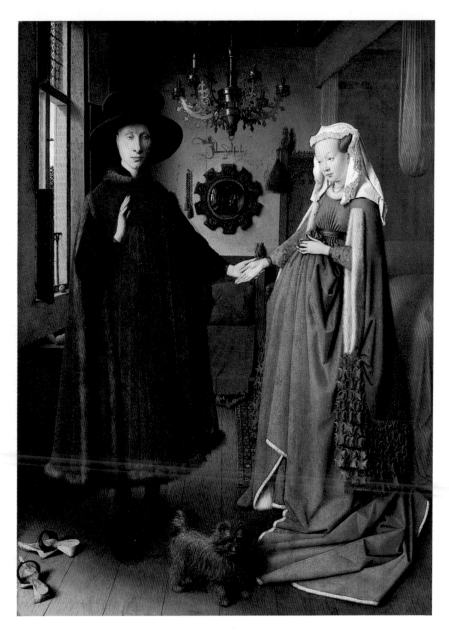

3. JAN VAN EYCK
Arnolfini Double Portrait, 1434. Panel, 32¼ x 23½" (81.8 x 59.7 cm). National Gallery, London.

Innumerable details in the image seem to shed light on this couple's relationship and the function of their portrait. The crystal prayerbeads could have been a wedding gift from husband to wife, meant to reinforce the need for the woman as temptress (Eve's successor) constantly to engage in prayer. The household dusting brush, which hangs from the bedstead, probably referred to the importance of the woman's domestic duties. Carved on the bedstead is a statue of a woman with a dragon, who could be St. Margaret (patroness of childbirth) or St. Martha (patroness of housewives). Such details in fifteenth century northern works are often indicators of the social, political or religious interests of the patrons.

functionaries joined the merchants and traders who had dealings with both court and city to become important patrons of art. In particular, they quickly realised the value of illusionistic panel painting: they could engage painters to fashion their images, just as they themselves manipulated their financially successful lives. The artists who worked for them matched their patrons' self-awareness. When Jan van Eyck (c. 1390-1441) painted the Italian merchant Giovanni Arnolfini at home with his wife, Giovanna Cenami, he, the artist, signed the painting on the wall above the mirror, "Jan van Eyck was here, 1434" (FIGS. 3 and 4). Further, he painted himself into his patrons' world as a reflection in the mirror.

Roger van der Weyden and Jan van Eyck were founding members of a powerful and influential tradition of early Netherlandish (largely Burgundian) painting, their genius given full rein by the commercial expertise of their locale. The Netherlands' growing production of commercial goods, paintings included, was based in cities and, in particular, in the various carefully distinguished and regulated guilds, in which craftsmen who produced the same kinds of goods from the same kinds of materials joined together to protect their livelihoods. The guilds' officers supervised everything from training to pricing and quality. In this way, the production of art became increasingly city-based and carefully controlled for commercial purposes.

Mercantile cities, linked by good roads and waterways, were the powerbase of Netherlandish prosperity. Local pride and identity were reflected in the increasing number of fifteenth-century paintings that featured actual city views. For example, the Burgundian (now Belgian) city of Bruges, an important art centre, features in the background of several late fifteenth-

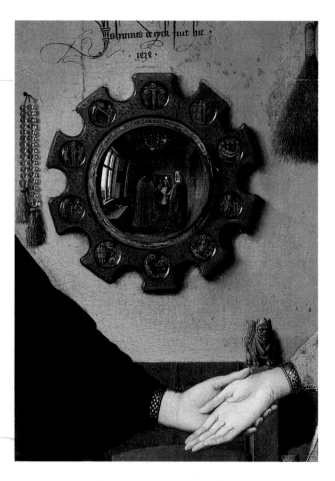

4. JAN VAN EYCK
Arnolfini Double Portrait, 1434, detail of the mirror, signature, and hands. National Gallery, London.

The carved monster on the bench at the rear of the chamber – which seems to float over the couple's hands – perhaps denotes their belief that sin must be exorcised from their lives before they could have children. Unfortunately, they remained childless, although the woman, by pulling up her dress, clearly wants to appear pregnant (fertile).

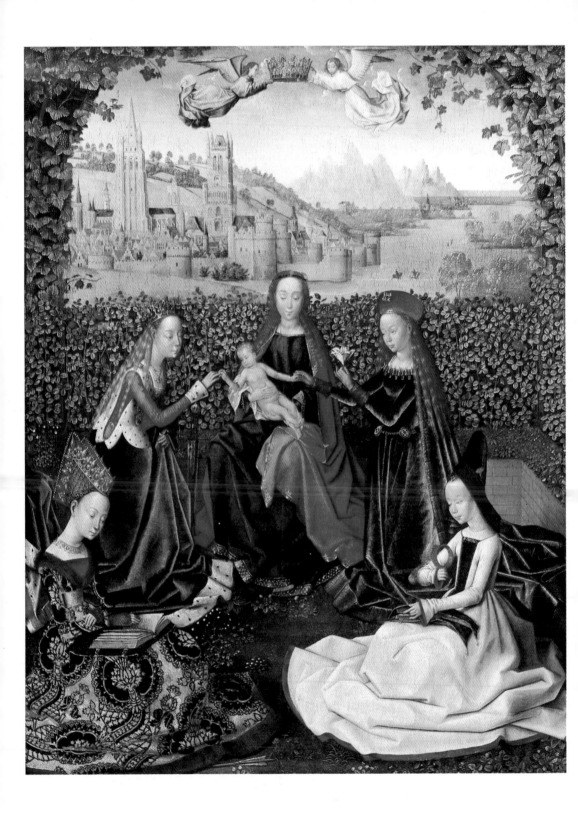

The Self-Conscious Pragmatic Artist

century panels executed there (FIG. 5). To that city's patrons at the time, these city views – ideally including one recognisable sacred edifice, the Church of Notre Dame, and one secular, the town belfry – acted in part as trademarks, certifying the origin and quality of the work of art.

The contemporary carved self-portrait by the south German sculptor Adam Kraft (c. 1460-1508/9) of Nuremberg reinforces the idea of the commercial regulation of art from a slightly different angle (FIG. 6). Although Nuremberg itself was free of complex rules governing the various crafts, the patron for Kraft's work, the wealthy citizen Hans Imhoff IV, made detailed stipulations about the completion date, quality of materials, and involvement of the master craftsman in this elaborate project, a Holy Sacrament House, or large free-standing shrine for storing communion wafers, in the church of St. Lawrence in Nuremberg. Such stipulations, laid down in a contract, were common. However, Kraft obviously felt sufficiently free to include a personal statement, portraying himself, hammer and chisel in his hands, quite prominently. The commission was treated like any other commercial proposition in the growing urban centres of Europe, only in this case the creator's representational skills allowed him to insert his own stern countenance into the finished product.

At the beginning of the period covered in this book, c. 1400, works of art were usually produced on individual commission. Especially when the production of art was funded by wealthy noble and ecclesiastical patrons, specific requests led to specific works of art. However, as

6. ADAM KRAFT
Self-portrait, from the base of a Holy Sacrament House, c. 1493-96. Stone sculpture, approximately life-size. Lorenzkirche, Nuremberg.

Kraft is one of three life-size figures (the other two are thought to be his assistants) who help support the over sixty-foot-high (18.2 m) Sacrament House, a stone shrine meant to hold the reserved host. It was a common practice for German carvers to include their self-portraits in works like this.

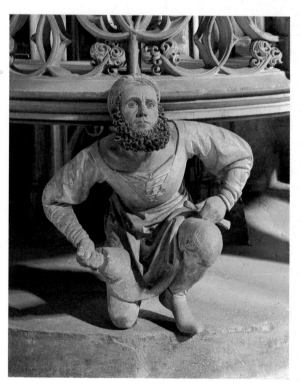

Left 5. MASTER OF THE ST. LUCY LEGEND
Virgin Among Virgins in a Rose Garden, c. 1480. Panel, 31⅛ x 23⅝" (79.1 x 60 cm). The Detroit Institute of Arts.

The saints in the foreground are, left to right, St. Ursula (identified by the arrows at her feet), St. Catherine (being mystically married to Christ), St. Barbara (holding a lily), and St. Cecilia (her name is written on her neckline). Many paintings done in the late fifteenth century in the Netherlands feature these female saints and scenes from their lives.

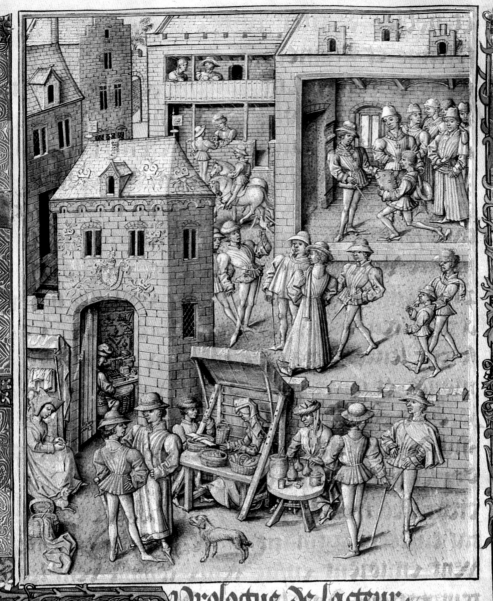

Prologue de lacteur
L̃et fais des anciens doit
on voulentiers lyre ouyr
et diligentement retenir
car ilz peuent valoir et
donner bon exemple aux hardis en armes

cities and guilds grew in size and number, so did the need for greater production and for the stockpiling of goods to be sold at urban fairs and markets, full of craftspeople hawking their wares for sale, such as those depicted in the busy Flemish streets, shown in mid-fifteenth-century manuscripts (FIG. 7) and panel paintings (see FIG. 1 and FIG. 32, page 51). In the sixteenth century, works of art were increasingly made speculatively for sale on the open market. Artists were thus freed from the precise, often petty demands of potential patrons. Now an image was less often tailored to the specific details of a wealthy individual's existence than designed to catch the eye of the "man-in-the-street," searching for a smattering of culture. It did not take long for artists to satirise their new situation, as a drawing by Pieter Bruegel (1527/28[?]-69) shows (FIG. 8). The patron in Bruegel's drawing may have money, but does he have taste? Can he even see through those thick lenses perched on his simple, cut-out face? Times may change, Bruegel reminds us, but the artist's job does not.

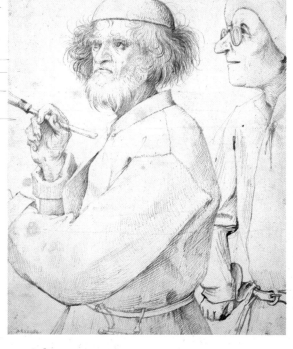

8. PIETER BRUEGEL THE ELDER *Artist and Patron*, c. 1565. Pen and ink drawing, 9⁷/₈ x 8¹/₂" (25 x 21.6 cm). Graphische Sammlung Albertina, Vienna.

One observer has suggested that Bruegel may have intended this to be a portrait of Albrecht Dürer, who had been depicted in a humanist dialogue as the epitome of a crusty and assertive artist hounded by foolish buyers.

Opposite 7. JEAN LE TAVERNIER *Town Gate and Street Scene*, c. 1458-60. Manuscript illumination from David Aubert, *Les Chroniques et Conquêtes de Charlemagne*, ms. 9066, fol. 11, parchment, page size 16⁵/₈ x 11⁵/₈" (42.2 x 29.5 cm). Bibliothèque Royale Albert 1er, Brussels.

Individualism and Self-Awareness

The Protestant Reformation, ushered in by Martin Luther's 95 theses or complaints against the Church, which he issued in 1517, brought to a head many of the problems that had plagued the institution for centuries. In France and Spain, where the papacy had already ceded power to secular rulers, the Reformation lacked support from monarchs and nobles. In Germany and the Netherlands, where the Roman hierarchy and its faithful agents the Habsburg monarchs still tried to exercise control from afar, the Reformation was as welcome to many secular rulers as it was to the independent town-dwellers. At some points Protestant and Catholic clashed: the new town hall in the flourishing Burgundian trading centre of Antwerp, built in the early 1560s, shows an appropriately international mix of stylistic elements – northern gables and pitched roofs alongside Italianate moldings

and pilasters (FIG. 9) – but in 1576 it witnessed a less peaceful mingling of northern and southern forces called the "Spanish Fury," as Spanish troops tried to maintain Catholic Spain's political and religious control over the increasingly Protestant Netherlands.

Despite the fact that in the sixteenth century German cities remained relatively free and stable from a political point of view, because of the relative independence of Germany's many and largely complaisant rulers, the conversion of many of them to the new Protestant faith took its toll. Portraits of contemporary leaders who voted to change systematically their city's religious practice show men both wary and determined. In fact, in the Protestant states portraiture flourished, in painting and prints, and the demand for cheap, mass-produced prints increased, addressing a variety of popular topics. One of these is shown in the fascination of the artist Hans Baldung (1484/5-1545) with supernatural experiences, witchcraft in particular. His woodcut of a *Bewitched Groom* (FIG. 11) shows the stable hand dramatically prostrate, having been attacked by both horse and witch. This work also seems to be an artistic self-image, because Baldung included his coat-of-arms, depicting a rearing unicorn, on the wall by the witch's brand.

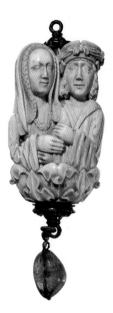

Below 9. FRANS HOGENBERG *View of the Antwerp Town Hall during the Spanish Fury, November 4, 1576.* Engraving, 8¼ x 11" (21 x 27.8 cm). Stedelijk Prentenkabinet, Antwerp.

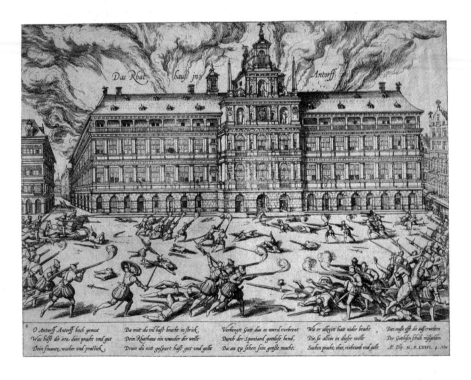

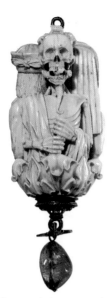

Above and above opposite

10. ANONYMOUS GERMAN ARTIST
Early 16th century pendant to a rosary, showing Death and the lovers, ivory with an uncut emerald, height 5¼" (13.3 cm). The Metropolitan Museum of Art, New York.

The increasing sense of self-consciousness or self-determination found in northern Europe in the fifteenth and sixteenth centuries was often tempered by an obsessive acknowledgment of the ever-presence of death and mortality. In this pendant to a set of prayerbeads, a young couple, nestled in a flower blossom, is dressed in the height of contemporary fashion. At their backs is carved a skeleton with hands that mimic theirs, while lizards and toads emerge from its skull.

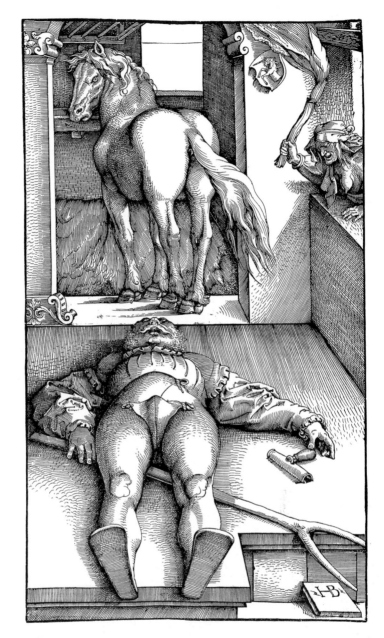

11. HANS BALDUNG GRIEN
Bewitched Groom, c. 1544. Woodcut, 13⁵/₁₆ x 7³/₁₆" (33.8 x 19.8 cm). British Museum, London.

Baldung's print is an intriguing combination of technical prowess and control, the exactly defined, sharply foreshortened perspective and demonic frenzy, the fierce wild horse and the torch-waving old hag. The groom himself seems to embody this duality with a neat, serrated comb at his left hand and, in his right and under him, a pitchfork. The latter could be used to clean the stable but is also a frequent attribute of witchcraft (see FIG. 81).

At the end of the fifteenth century, as in the Middle Ages, when rulers moved from one castle to another, artists went with them, but as art became more city-based in production and more broad-based in clientele, artists' travel opportunities were likewise expanded. Northern artists also became increasingly aware of the variety of benefits that travel would bring, including the opportunity to examine the ancient sites and classical works of art that so strongly influenced the Italian Renaissance. This urge resulted in an interesting series of painters' travels to Italy in the fifteenth and sixteenth centuries, as is illustrated by the many sketches and finished pieces of artwork they took home from their travels, such as the *Self-portrait before the Colosseum* (FIG. 12) by Marten van Heemskerck (1498-1574). Heemskerck's is a doubly self-conscious work since his foreground likeness shows him at a more advanced age than he was when actually in Rome. The painting in fact represents the artist standing in front of another painting in which an artist (Heemskerck himself?) is represented sketching in front of the Colosseum. Heemskerck was reported to have done a series of self-portraits, documenting different stages in his life, of which this would be one. We will return to a consideration of the effects of Italian travels on northern artists in the Conclusion to this book.

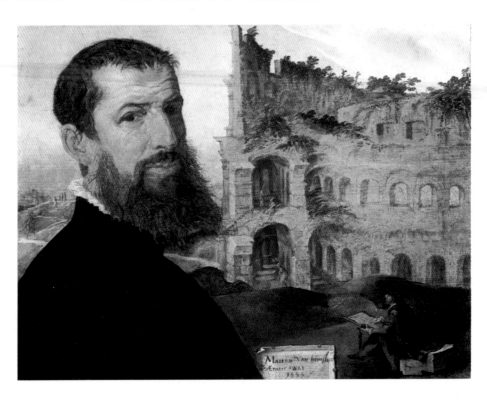

Developments in the status of women during the Renaissance remain a controversial topic. Certainly, during the fifteenth and sixteenth centuries women did not gain much power and prestige; a case can be made that they lost it, except in the religious sphere. This debate can be illuminated by portraiture and self-portraiture. Sixteenth- century Flanders presents the first known north European self-portrait by a woman (FIG. 13). Admittedly, Caterina van Hemessen (1528-after 1587) was a special and limited case: the training of artists from an early age in all-male environments made it difficult for most women to enter this profession, but Caterina van Hemessen had the advantage that her father was a painter. Apparently she had only a short career, for all her surviving work is dated before her marriage to a musician in 1554. Notably, she developed a straightforward realism of style, demonstrating her independence of her father's influence – his work was mannered and highly contrived. Her self-portrait is thus a tantalizing but conflicted image of a woman's ambition and its thwarting by both family and society.

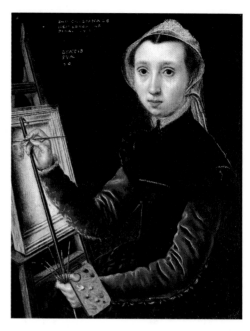

13. CATERINA VAN HEMESSEN *Self-portrait*, 1548. Panel, 12¼ x 9⅞" (31 x 25 cm). Kunstmuseum, Öffentiliche Kunstsammlung Basel.

The painting is inscribed in the upper left: "CATERINA DE/HEMESSEN ME/PINXI 1548/ ETATIS/SVAE/20" (Caterina van Hemessen painted me 1548/ her age 20).

Hallmarks of the Northern Renaissance

In the four chapters of this book we will examine topics – realism, physical location, religious meaning, and the development of "secular" specialities – that seem to embody various northern European ideals, ideals rooted in the work's relation to the world around it and in particular to the viewer of it. These topics are broad enough so that they are applicable to Renaissance developments throughout Europe. And indeed it is assumed that the reader will have a natural tendency to make analogies between what is observed in the North and what is thought to characterise the period of the Renaissance in general. One problem here is that the "general" is all too often synonymous with the "Italian." Thus northern and Italian art, their aims and ideals, are almost invariably elided, making them seem to pursue similar if very general Renaissance goals – such as an interest in individual consciousness (portraiture) and a desire to make images of the visible world, often portraying a religious scene, more believable and accessible (naturalism). The humanisation of art

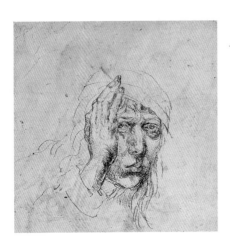

14. ALBRECHT DÜRER
Self-portrait, c. 1491.
Pen and ink drawing,
irregular approx. 7 x 8"
(20 x 20.4 cm).
Universitätsbibliothek,
Erlangen.

and culture is seen as an overriding, European-wide ambition. This book is meant to render such grand pronouncements unsatisfactory, far too simplistic and not attuned to the geographical discrimination and development of different – northern and southern – traditions taking place in Europe during the Renaissance.

In his early twenties, the great German painter and printmaker, Albrecht Dürer (1471-1528), drew a remarkably penetrating self-portrait of his face and right hand (FIG. 14). This was just one of a series of six observant, changing self-images (three drawings and three paintings) that Dürer produced before his thirtieth birthday. Somewhat later, in 1514, Dürer completed his engraving of *Melencholia I* (FIG. 15). From Dürer's diaries and letters we know that he felt himself subject to the melancholy temperament, at times divinely inspired (as indicated by Dame Melancholy's wings); at others, unable to rouse himself to productive action (as indicated by the limp manner in which she holds the compass). This complex, detailed engraving has thus often been viewed as a kind of elaborate, philosophically based self-image. No other northern artist exhibited such an intense and repeated fascination with his or her own face and with a complex theoretical understanding of the nature of his or her art and inspiration.

Dürer is exceptional in more ways than one. Many northern artists portray themselves as identical with their craft (see FIG. 6). Their approach to a painting tradition is practical and actual, not theoretical. It is perhaps little wonder that whereas images of St. Luke are frequently found in the North (see FIG. 1), they are very rare in Italy. There, at the same time that Roger van der Weyden painted his St. Luke panel, the architect Leon Battista Alberti (1404-72) composed the first Renaissance treatise on painting. Alone among northern artists, Dürer wrote treatises for artists as well, but not until 1525.

Emphasis on the physical craft of making a work of art in the North brings with it almost invariably a certain preciousness (see FIGS. 2, 3, and 4). And this in turn elicits from the image, sometimes in a positive, sometimes a negative manner, a sense of social class distinction or position. Northern artists and patrons seem acutely and even minutely aware of their current, or potential, social position. Some Italian artists do exhibit a degree of social consciousness, but it does not seem to be of such overriding importance in Italy as in the North. Northern European

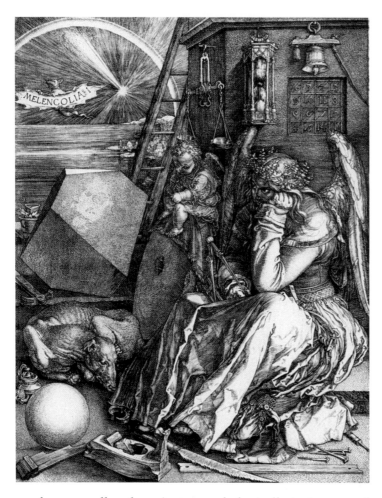

15. ALBRECHT DÜRER
Melencholia I, 1514.
Engraving, 9⅞ x 7⅜" (24 x
18.7 cm). British Museum,
London.

The Roman numeral I after
the word "Melencholia"
(inscribed on the bat's
wings) probably refers to a
subtle philosophical
distinction between various
kinds or levels of
melancholy genius
espoused by the German
philosopher Henry
Cornelius Agrippa of
Nettesheim; this was
ultimately based on Italian
Renaissance humanist
speculation. In rare cases
like this, the contemporary
Italian fascination with the
place of the individual in
the cosmos coincides with
the northern.

works are small-scale, private, psychologically intimate, and
individually calculated. There is not as much of the grand pub-
lic, civic posturing that seems to dominate Italian production.

Northern artists do seem bent on making provocative com-
mentaries on their times (see FIG. 13); they see themselves as con-
duits for important political, religious or social change (see FIGS.
3, 8, and 12). Their works are instrumental in helping their con-
temporaries formulate issues and ideas. In this way, there is a
sense of contingency and ambiguity in the North which con-
trasts with the fixity, the monumental stable forms so typical of
the Italian Renaissance. These generalisations are meant as stim-
uli, prods to the reader not to accept traditional generalisations
uncritically – but not to substitute new stereotypes too easily,
either. The following chapters hopefully allow for the kind of
dialogue between reader and text that the great works of the
Northern Renaissance hold out to the viewer.

Realism

16. BOUCICAUT MASTER
Visitation, c. 1410.
Manuscript illumination
from the *Book of Hours of
Maréchal Boucicaut* , ms. 2,
fol. 65v., 10 x 7½" (27 x
19 cm). Musée Jacquemart-
André, Paris.

The Virgin Mary is here
shown as Queen of
Heaven, with two attendant
angels holding up her train
and carrying her
prayerbook. This no doubt
would have reinforced the
noble standing of the
patrons of this work.

I n northern Europe during the Middle Ages, architecture
was the dominant art form: it gave Romanesque and Gothic
art their formal vocabularies, their aesthetic and spiritual
orientation. This is true in the sense that stained glass painting
and monumental sculpture were often made to fit into architec-
tural forms (windows, columns, and doorways), and in the sense
that simple architectural frames continued to surround small-
scale paintings and sculpture throughout the fourteenth century
(see FIG. 17, right-hand page). During the fifteenth century in
northern Europe, painting on a two-dimensional surface became
the dominant artistic medium. To an extent, this is due to a lack
of change or innovation in architecture. For instance, the basilica
of Our Lady at Tongeren in Burgundy (now eastern Belgium)
was begun in the mid-thirteenth century but was not completed
until 300 years later; and the western tower and eastern bays of
the nave were built in the mid-fifteenth and early sixteenth cen-
turies in a style basically homogeneous with that of the rest of
the church (see FIG. 64, page 99).

A painting done in the thirteenth or early fourteenth cen-
tury and one done in the fifteenth and sixteenth centuries are
clearly different, not stylistically homogeneous (compare FIGS. 16

and 17). North European painting style underwent a dramatic transformation in the fourteenth and fifteenth centuries. Like much else in northern European culture at that time, that change was based on a closer observation of the physical world. For a number of reasons hard to pinpoint precisely but found in areas of study as diverse as philosophy, botany, and geography, people in general felt they could and should give more time and attention to the particulars of their earthly existence.

Thus, from the moment of its inception, the most admired feature of northern European fifteenth-century painting was the visual realism that became the hallmark first of Netherlandish art and which then exerted a strong influence on artists in all the northern lands. This style of painting was immediately judged as vital and new – an *ars nova* – because of its uncanny ability to mimic, on a two-dimensional surface, the myriad effects of colour and light to be seen in the visible world. Contemporary accounts give the impression that the eyes of artists and their observers had suddenly, as if by a miracle, been opened.

Many observers, from the fifteenth century to the present day, have accepted the apparent visual truth of the imagery unquestioningly. But to what extent is it justifiable to take this artistic realism literally? Was it meant to certify exactly the way something looked at a particular moment or was it, like today's photography and documentary film, essentially shaped by the artist? We will look at this remarkable development of artistic realism from several different perspectives, concentrating on the fifteenth-century Netherlandish origins of realism.

Fact, Symbol, and Ideal

While one of the aims of this art must clearly have been to evoke wonder in the viewer, the subtlety and sophistication of its realism must also be acknowledged and explored. It is not simply the embodiment of a modern objective view of reality, replacing the time-worn mystical and subjective bent of the Middle Ages. In the fifteenth century, reality, and its representation in art, was still viewed as magical, capable of being manipulated by both God and humankind. Thus, an art that might initially seem to be a naive record of visual experience revealed ultimately a reality that was highly conventional, simultaneously factual and emblematic. With the benefit of modern critical distance, the strands that these artists wove together so seamlessly in creating their worlds can be unravelled; and, at least in general terms, the meanings it was meant to convey may be ascertained.

Fortunately, there is at least a small amount of documentary evidence to serve as a guide. By the middle of the fifteenth century, contractual agreements made between artists and their patrons specified that, in religious scenes such as the *Annunciation* or the *Nativity*, contemporary furniture found in the homes of the "*seigneurs et bourgois*" was to be included. Thus, one may be reasonably sure of, for example, the fifteenth-century authenticity of the lush red bed depicted in the *Arnolfini Double Portrait* (see FIG. 3, page 12). This phenomenon can be called "a descriptive realism of particulars."

Immediately, a further possibility arises. Were not only individual still-life details but entire interior settings meant to be accurate or specific records of contemporary reality? There is no documentary evidence to support this supposition; no contemporary contract dictates to an artist that he portray accurately some particular domestic or ecclesiastical interior. What seems rather to be the case is that artists freely wove together details from different environments in order to make stereotyped wholes. This is difficult to prove absolutely in the case of domestic interiors, since so few survive intact from the period, but it is easy to demonstrate in the case of church interiors where the vast majority of models available to the artists survive – for none was copied or recorded exactly.

One initial conclusion that can be drawn from this situation involves the contradiction of a theory of realism growing incrementally over time. If realism developed in such a linear fashion, aspects or details of visible reality would, over time, be progressively assembled in order to create an ultimate or total image of truth. In fact, the episodic, puzzle-like nature of northern European realism was never abandoned. This is not to say that, over the course of the fourteenth and early fifteenth centuries, artists did not improve their ability to portray aspects of the physical world, but images from this earlier time demonstrate that a linear developmental theory of realism is much too literal and single-minded a concept to describe the complexity of the art.

Manuscript Illumination

Working in Paris in the first quarter of the fourteenth century, the artist Jean Pucelle (fl. 1319-43) accomplished some of the most remarkable feats of realistic representation in northern Europe at that time. In one tiny, personal prayerbook that he painted for the Queen of France, Jeanne d'Evreux, Pucelle

17. JEAN PUCELLE
Arrest of Christ and Annunciation to the Virgin, c. 1325. Manuscript illuminations from the *Book of Hours of Jeanne d'Evreux, Queen of France,* fols. 15v and 16r. Each folio 3¹/₂ x 2⁷/₁₆" (8.9 x 7.1 cm). The Metropolitan Museum of Art, New York, The Cloisters Collection.

The two angels holding up the Virgin's dwelling at the right probably refer to the miracle of the Holy House of Loretto. According to medieval legend, when the house in Nazareth in which Mary received the Annunciation was threatened by Saracens, angels carried it first to Dalmatia and then to the north Italian town of Loretto, where it remains a pilgrimage site to this day.

included a scene of the *Annunciation* (FIG. 17), setting it in a remarkably convincing two-part interior; a small antechamber for the angel and a larger room with bench, pitcher, window, and skylight for the Virgin. Below, the queen kneels praying in the large initial D, while a different kind of contemporary reality – young couples playing a game of tag – is acted out in the lower part of the page. On the opposite page, emotional expression is systematically explored in a portrayal of the *Arrest of Christ in Gethsemane*. Pucelle's technique here is that of *grisaille,* shades of grey – making the figures resemble sculpture, with touches of colour added for faces, haloes, and some still-life details. The technique alone emphasises a certain aspect of painted realism: three-dimensional modelling and relative placement in space. Yet there is also a certain tension between what might be called "levels of reality," partly because of what must be an intentional dialogue between religious and secular narratives (main miniature v. bottom of the page) and partly because the *grisaille* technique suggests a kind of half-life or emergent life, as sculptural ideal becomes incarnate in living flesh. Although Pucelle could certainly have painted in full colour had he or his patron so desired, he chose rather to exploit the simultaneously heightened realism and timeless idealism that the *grisaille* technique afforded him.

A little less than one hundred years later, another great manuscript illuminator was working in Paris. This artist probably came from the Netherlands, attracted by the artistic centre of Paris, which was soon to be outshone by Flemish cities such as Bruges and Ghent. This painter is called the Boucicaut Master after his most famous work, a prayerbook done for the French nobleman Marshal Jean II le Meingre, called Boucicaut. One particularly attractive scene in this manuscript illustrates the Virgin Mary's visit to her cousin Elizabeth, soon to be the mother of John the Baptist (FIG. 16, page 24). The foreground landscape is molded to frame the elegant and over-sized religious figures: trees are chopped off or shrunk to the size of bushes so as not to

interfere with the sacred personages. In contrast to the highly stylised foreground, the background landscape is populated by a peasant traveller, shepherd, and fisherman; it presents a marvel of fresh, naturalistic observation, including a very early use of atmospheric perspective – the lightening and greying of sky and land toward the horizon. One again has a feeling that fragments (or levels) of reality have been carefully interwoven or juxtaposed by the artist.

The work of the Franco-Flemish manuscript illuminators known as the Limbourg Brothers reached the epitome of this manipulative realistic imagery in book illustration just prior to the flowering of early fifteenth-century panel painting. Their most famous painting was found in a very ornate prayerbook (the *Très Riches Heures*) made for Jean, Duke of Berry; its production was cut short in 1416, when both artists and patron died, probably of the plague. In a book replete with detailed architectural portraits, perhaps none is more spectacular, or more telling, than the one which illustrates the text of the Mass of St. Michael depicting Mont St.-Michel, the greatest shrine to the saint in northern France (FIG. 18). Comparison with the church as it survives today demonstrates one interesting fact: it could not have looked in the early fifteenth century (and it does not look today) as the artists portrayed it. The west entrance including two flanking towers was planned but never completed in reality, although the Limbourgs clearly wanted to portray its ideal finished state. A recognisable portrait of a prominent architectural monument has been enhanced and idealised through artistic discretion.

There is a similar distillation to essentials in the portrayal of the city of Bruges in the background of a late fifteenth-century panel by the Master of the St. Lucy Legend (see FIG. 5, page 14): only the towers of the most prominent church, Notre Dame, and the belfry are easily recognisable. Although the realism is detailed and particular, it is also ideal and propagandistic: peace and prosperity seem to reign in both city and country, belying the reality of the political and economic crisis that Bruges experienced at that time and in the years following, as the Holy Roman Emperor Maximilian I tried to subdue the struggling city. Such images as the Limbourgs' Mont St.-Michel and the Master of the St. Lucy Legend's city of Bruges are fact, symbol, and ideal all at once. When this realism is exact or accurate, it is also distilled and archetypal. More often, it is not strictly accurate but, again, reconstructed or generalised. In addition, it is no doubt meant to embody certain social, political or religious ideals, and all these things in the end increase its appeal as art.

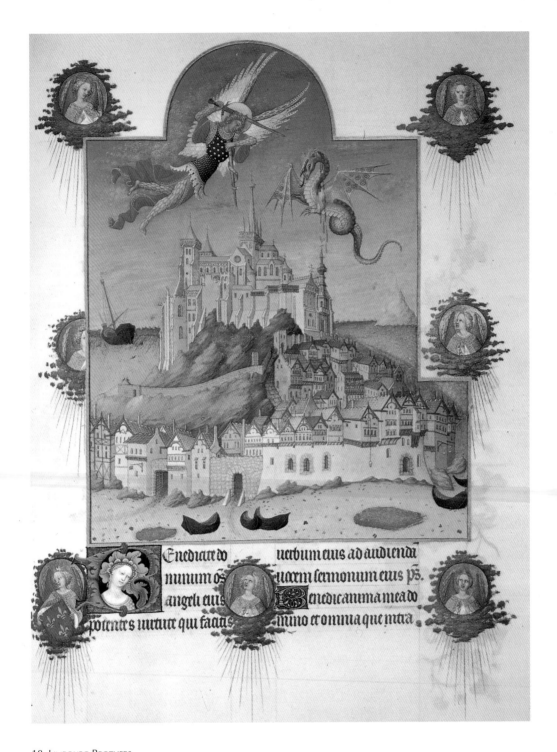

18. Limbourg Brothers
St. Michael Battling the Dragon of the Apocalypse above Mont St.-Michel, c. 1415. Manuscript illumination from the *Très Riches Heures du Duc de Berry*, fol. 195r, 11³⁄₈ x 8¹⁄₄" page (29 x 21 cm). Musée Condé, Chantilly.

Style, Technique, and Scale in Panel Painting

Lack of attention to the particular artfulness of fifteenth-century northern panel painting has been one of the main obstacles to a fuller, more sophisticated understanding of its realism. These paintings are finely gauged psychological and artistic statements. In comparison with those manuscript illuminations that immediately precede them, these works do not suddenly become reportorial, as opposed to highly pictorial and visually calculated. Take, for instance, the masterpieces by the two early fifteenth-century Netherlandish painters, Jan van Eyck and Roger van der Weyden, discussed in the introduction in the light of the artists' personal self-consciousness. Van Eyck's *Arnolfini Double Portrait* might give the initial impression of representing "a simple corner of the real world," yet nothing could be further from the truth. The image is composed heraldically: each object or detail is carefully positioned so that on the surface of the panel they form a shield-like pattern, a frozen puzzle of artful precision. This is most apparent in the manipulated spatial composition. At the painting's core is the convex mirror, nestled into a valley in deep space between the couple's outstretched arms. The mirror itself is hung too low on the wall to use comfortably; the chandelier, too, has been dropped to a level at which heads and hats would hit it. All this, and more, is done to create a compact zone of interaction and meaning, both on the surface and in depth, at the centre of this work. Formal, artistic and psychological consideration weigh heavily here. (We will return to analyse the meaning or symbolism of this work at a later point.) Roger van der Weyden's *St. Luke*, by contrast, is composed as much, if not more, in depth as on the panel's surface (see FIG. 1, page 6). Bands of space – foreground, middleground, background – are sharply delineated. This discussion could easily be extended to the works of other artists. The point is quite simply that these powerfully real-seeming images have an equally compelling internal artistic sensibility that molds and shapes their peculiar brand of illusionism – style, it is often called.

Style is a feature much more often singled out in the work of contemporary Italian artists. This seems to be so for several interrelated reasons. In the first place, contemporary Italians were more self-conscious about their art, their personal style. Italian artists were sooner and more often written about and applauded because of their individual artistic style. Secondly, Italian artists approached the problem of artistic realism in a more orderly fashion, emphasising regularity and clarity, the

19. Domenico Veneziano
*Madonna and Child with
Saints (St. Lucy Altarpiece)*,
c. 1445. Panel, 6' 10¼ x
6' 11⅞" (2.09 x 2.13 m).
Uffizi, Florence.

The saints in this holy
conversation are (left to
right) Francis, John the
Baptist, Zenobius, and Lucy.
The complete altarpiece
contained small scenes from
their lives at the bottom.

sense and the theory of perspective, more consciously. For example, a typical mid-fifteenth-century Italian production, Domenico Veneziano's (c. 1410-61) *St. Lucy Altarpiece* (FIGS. 19 and 20), displays several striking factors. The painted representation of space is so neatly defined that apparently it exists (or, at least, can exist) separately, as a real entity in and of itself. It is in fact constructed using a mathematical theory according to which all lines perpendicular to the picture plane converge toward a single vanishing-point, and figures or objects are placed in regular and diminishing scale along those orthogonals. Thus both Veneziano's space and the figures placed in it are carefully charted, firmly establishing what has been called the "authority of the pictorial

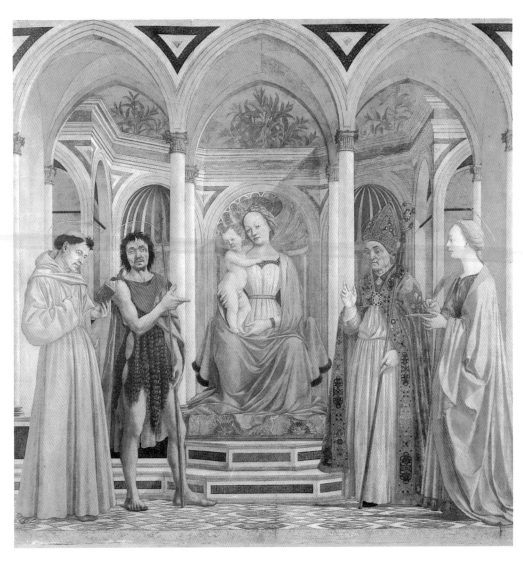

order." This is a third reason for deeming Italian art style-conscious.

The concept of the "authority of pictorial order" needs to be invoked more often in the study of northern European art. True, the grand, open clarity of form and environment found in Italian art cannot often be detected in the north; in its place is found expressive and even, at times, distorted introversion – spaces, private and enclosed, rarely the comfortable extension of our own. Perhaps the *dictum* must be modified to something like "authority of the artist's pictorial purpose," for the northerners' manipulative artistic skills, striving for their own kind of ideal representation, are present in their art as they are in Italian paintings. They have simply been overshadowed to some eyes, certainly from an Italian-based perception, by the northern love of minutiae, texture, and illusion.

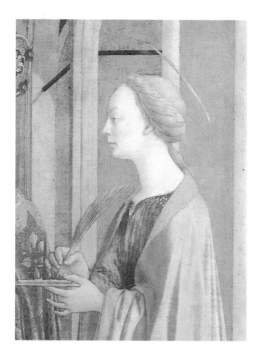

20. Domenico Veneziano *Madonna and Child with Saints*, c. 1445, detail of St. Lucy. Uffizi, Florence.

The scale of northern works is certainly an element in the viewer's evaluation of their visual realism. Not only are the paintings full of minute details but their overall size is small as well, certainly by comparison with contemporary Italian production. In Italy public wall paintings and panels that portray figures on a near life-size scale are the rule; Veneziano's *St. Lucy Altarpiece* is seven feet (2.13 m) high; the *Arnolfini Double Portrait*, a rather large painting in van Eyck's career but an average-sized painting for the north at this time, is just under three feet (0.9 m) high. As one modern critic has remarked, it would take a very brave Alice in Wonderland to think that she (or he) could easily enter the northern painted world. Northern works are more often meant to be viewed in the privacy of the home; in that sense too, the northern world is magical and enticing.

The oil-glaze technique contributes greatly to this. Carefully applied layers of translucent pigments – the tiny particles of colour suspended in an oil-based binding medium – allow one actually to look *through* van Eyck's carefully modulated, finely textured surfaces. The opaque tempera technique – pigment mixed with egg yolk – favoured in Italy produces a quite different result, emphasising quite different aspects of the visual experience. In Veneziano's work, for instance, the use of this technique focusses the viewer's attention on large-scale modelling of figures in space, simplified surfaces and lack of differentiated

textures giving the painting an innate physical power and monumentality in keeping with its size and its scientific perspective (see FIG. 20).

Climate, geography, and human psychology were at work here. An introspectiveness, an attention to peculiar imaginative and personal experience, seems more dominant in northern than in southern European experience. Artistic realism is both molded by and a determinant in this kind of cultural experience, yet there is also little that is absolute or necessary about this artistic skill. Even within the northern tradition, it was very differently exploited. Jan van Eyck's world is marvelously microscopic; Roger van der Weyden's is physically more spare but emotionally more varied. Again, our delight is not in any simple or standardised sense of recording but in watching the artists' subtle and puzzle-like process of reordering experience.

Space, Perspective, and Architecture

Northern European artists were not, in general, attracted to the mathematical system for the construction of the illusion of three-dimensional space on a two-dimensional surface developed and widely used in Italy from the 1420s on. By about 1440 they were clearly aware of this theory, and it did appeal to some of them. Their use of it, however, was often more expressive than simply illusionistic: it helped them create strong grid patterns on the surface of their works, thus at times flattening or stylising their compositions; it also helped them emphasise devotional confrontation alongside illusionistic involvement. An example of this is the mid-century *Melun Diptych* by Jean Fouquet (see FIGS. 61 and 62, page 96); here a deep inhabitable space is established for the donor, whereas the Virgin and Child are hieratically presented in a flat, artificial environment.

Clearly, by the fourteenth century, northern artists were interested in creating a believable representation of both interior and exterior space in their images. Jan van Eyck and his contemporaries portrayed objects as smaller when they became more distant from the spectator, and the parallel lines of architectural ornament and design do converge toward a vanishing area, or areas, in the picture. However, no theory of perspective was written down in northern Europe, as it was in Italy, in the fifteenth century. In the *Arnolfini Double Portrait* van Eyck's use of numerous vanishing "points" within at least four general vanishing areas, circling around the mirror in the background, defies the kind of simple, systematic analysis embedded in Italian examples.

The critical problem here has been that modern observers have often assumed that the northern approach is a rather incomplete, even primitive version of the Italian. The more clearly the system was defined verbally (in written texts in Italy), the more it became the reference point against which all else was measured. But it was not lack of knowledge of the Italian system that kept northerners from employing it: they simply did not have the same sensibility about the relation between different spaces, and between figures and space, that governed much Italian art and culture. In place of the clear, open, even, and often symmetrical Italian representation (see FIG. 19), northerners envisioned subtly modulated, veiling and revealing light effects, intriguing nooks and crannies, enclosed worlds of privacy and preciousness (see FIG. 3, page 12). Although this difference might be defined through a set of detailed north-south comparisons, there is a better way to describe the northern achievement: by an examination of the means through which the representation of space in panel painting mirrors or relates to the actual construction or articulation of space in contemporary northern European architecture.

One of the best surviving examples of domestic architecture from this time, the house built between 1443 and 1453 by a powerful financial minister to the king of France, Jacques Coeur (FIGS. 21-25), can show the link between built architecture and the depiction of space in fifteenth-century painting. This great monument in the central French city of Bourges has a number of features typical of contemporary northern architectural design. The ground plan of the house (FIG. 21) fits the site – along a narrow,

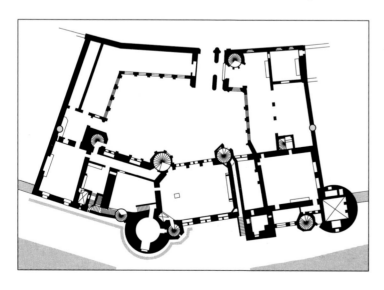

21. Groundplan of the House of Jacques Coeur, built 1443-53, Bourges, France.

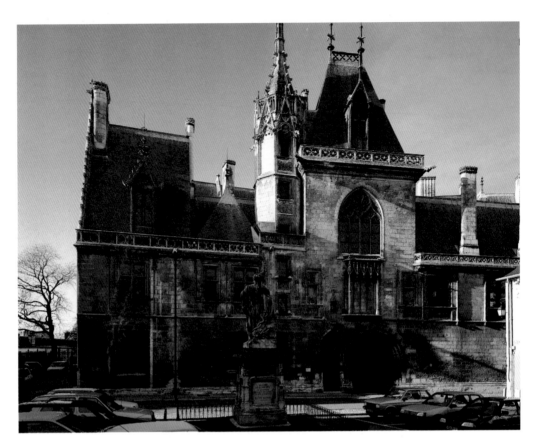

22. Facade of the House of
Jacques Coeur, built 1443-
53, Bourges, France.

winding street at the perimeter or walls of the city. It does not
attempt to remap or reorder what is already there. The plan
might be called organic, rather than, as was typical in Italy at the
time, symmetrical and abstract. Individual rooms, all serving
quite different functions, are different sizes and shapes. Narrow,
cramped passageways lead to large, cavernous chambers. Numer-
ous stairways are tucked into various parts of the building. This
is a floor design through which one would pass in almost fun-
house fashion, constantly surprised, delighted or intrigued by
changing spatial and light effects.

The facade gives a similar impression (FIG. 22). Windows are
not consistently arranged in neat, regular rows, up and down
and across, as they were at that time in Italy, where the influence
of classical principles of order in architecture was stronger.
Rather, they reflect the engaging variety of interior function –
chapel, passageway, staircase or kitchen. The roof line is varied
in height and variously decorated with delicate carving. Perhaps
nothing is more telling than the carved window openings with
sculpted servants leaning out, seemingly talking to passers-by

below (FIG. 23); fully polychromed, as they were originally, these devices provided a remarkable illusion. This is an architecture that attracts us by fits and starts, virtuoso in its detailing, illusionistic, intuitive, and somewhat capricious in its over-all impression.

Inside the building, similar observations can be made. Deeply set windows have multiple shutters that can easily be adjusted to provide subtle and enticing light effects. The rich carving and painting of surfaces – ceilings, overdoor reliefs, and fireplaces – constantly draw us on (FIG. 24). The carving itself contains a remarkable combination of the stylised and the real; the decorative conventions perfected in late-medieval art are set alongside a fresh sense of natural observation (FIG. 25). In all these ways, fifteenth-century northern architecture is a perfect guide to the principles that govern the representation of space in contemporary painting. Lighting that is subtly modulated, spaces that are partial but organically interrelated, illusionistic effects that compete with idealising sensibilities – all these characterise both the painted and the built world.

The very nature of this kind of spatial articulation precludes exact definition or reproduction. This is another good reason for abandoning the search for the precise "real" architectural model that an artist presumably copied in one particular painting. In

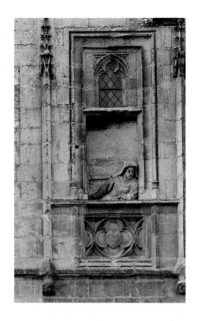

23. Detail of the facade of the House of Jacques Coeur, built 1443-53, Bourges, France.

24. Interior of the House of Jacques Coeur, built 1443-53, Bourges, France.

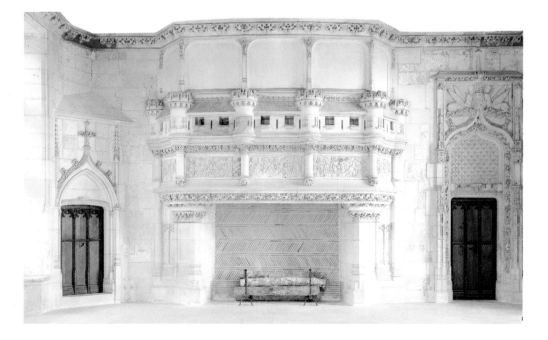

25. Detail of fireplace from the House of Jacques Coeur, built 1443-53, Bourges, France.

northern Europe, an experience of the environment was not, in principle, thought to be so carefully or precisely defined that it could be turned into a mathematical system and consistently imitated or reproduced. It was by definition more fluid, flexible, and mysterious than that – a principle of creative fragmentation and reconstruction was followed. Looking at a fifteenth-century northern European painting, we are not meant to be able to imagine, absolutely clearly and mathematically, the relation between the fragment we see and the world beyond the picture frame. Visual intrigue and a personal, imaginative experience of the environment played too big a role in the culture for that to be the case.

Fragmentary Realism

Northern architecture and spatial experience were not in an immanent state of dissolution, held together by only the most fragile of glues. Rather, in an imagined system of priorities, absolute or overriding unity was not highly valued by northern architects and artists. Unity was not so much imposed from without as sensed, arising out of puzzle-like details, from within. Thus, Italian observers thought northerners were intent on doing too much: they refused to simplify and focus their endeavours from the start.

Illustrating this, Roger van der Weyden's three part *St. John Altarpiece* (FIG. 26) did not use the usual triptych format, in which half-size wings were subordinate to, and could be folded protectively over, the central panel: here he used an equal-sized, nonmovable, three-part arrangement. Each scene from John's life is framed by a Gothic archway, or is placed neatly in the archivolts (curved moldings) of these arches. Behind each major foreground scene a mixture of interior, landscape, and cityscape is partially revealed. Typically, Roger van der Weyden's large foreground figures have a balletic grace, appearing reminiscent of the dramatic tableaux that the artist and his contemporaries no doubt saw performed in front of and inside cathedrals. The pictures' fore- and background architecture reinforces this effect: these theatrical scenes are also scenes from life, from the experience of contemporary life both in its contrived theatrical form and in its directly observed reality. This work represents, above all, a typically northern understanding of spatial form and its expressive or artistic manipulation. The architectural fragments tie the painting together at the same time as they clearly differentiate its multiple stages. They draw the viewer into an imagined world and make the viewer aware of its illusionistic – rather, illusory – nature. Real and emblematic at once, this architecture reveals a northern sensibility, a love of detailed description, at its core. It is as though one is always catching sight of something out of the corner of the eye. The ideal is not simple harmony but complex polyphony.

Why is the realism of fifteenth-century northern art so insistently fragmentary? That is, of course, a far-reaching question that can be answered only somewhat speculatively. The architectural and artistic parallels and precedents for this painting characteristic that have already been noted here were widespread, as is revealed by contemporary architecture. Earlier northern painted examples show that it was ingrained in the culture. Thus, the analytic frame of mind that, in the fourteenth century, treated different aspects of reality on different parts of the manuscript page (see FIG. 17) was not contradicted in the fifteenth century – certainly not by the unifying vision of an antique classical revival such as was found in Italy. Even in the sixteenth century, when a classical revival sporadically penetrated the North, it did not overcome the northern love of fragmentation and detail (see FIG. 117, page 163 and FIG. 120, page 166).

Over and over again, we find that the particular, the small-scale, lovingly observed, finely crafted detail was a characteristic of northern European realism. This refusal to generalise or

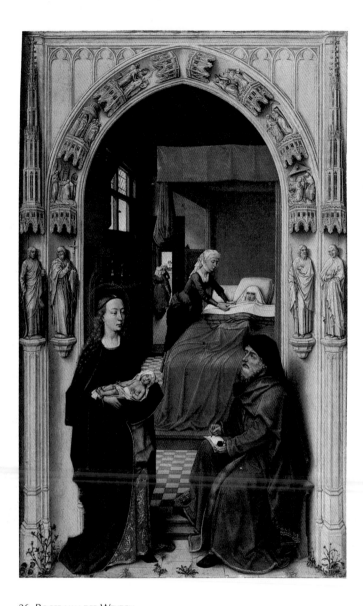

26. ROGER VAN DER WEYDEN
St. John Altarpiece, c. 1450-60. Panels, 30³/₈ x 18³/₈" (77 x 48 cm). Staatliche Museen zu Berlin, Preussischer Kulturbesitz, Gemäldegalerie.

The three major scenes from John the Baptist's life portrayed here are the *Naming of John*, the *Baptism of Christ by John*, and the *Beheading of John*. In the first scene, the Virgin Mary presents the baby to his father, Zacharias, who had been struck dumb when he did not believe that his elderly wife would in fact bear him a son; but after he wrote on a tablet "His name is John," his speech was restored (Luke 1:57-64). In the baptism scene, the following words issue from God the Father in Heaven: "*Hic est filius meus dilectus in quo michi bene complacui ipsum audite*" ("This is my beloved son with whom I am well pleased; listen to him," Matthew 17:5). In the last scene, Salome collects the head of the Baptist in order to present it to her stepfather and mother, Herod and Herodias (Mark 6:21-28).

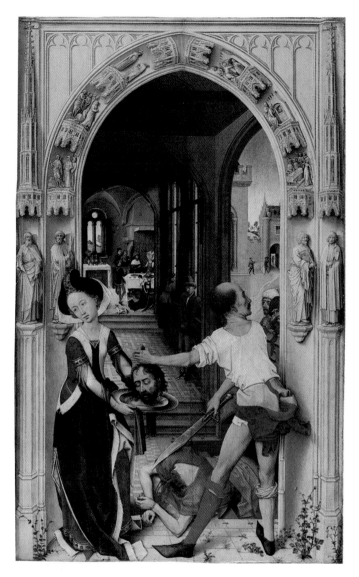

simplify more, to focus more on large internal structural princi-
ples, and this insistent interest in the individual, with all its
quirks and peculiarities, were hallmarks of northern works. In
Italy, artists accepted the need to learn from many examples in
order to create their own, ideal pictorial representation; but
whereas, in some ways, northerners also idealised and gener-
alised, there was always, underlying the northern ideal, an obses-
sion with the particular, maintaining a strong sense of the indi-
vidual within any ideal representation. This feature of northern

art may be better understood through reference to general cultural and philosophic developments.

One of the most important European intellectual currents of the fourteenth and fifteenth centuries was philosophic Nominalism, originated by the English philosopher and theologian William of Ockham (c. 1285-c. 1349). Ockham and his followers were weary of medieval Scholastic attempts to develop and support a rational, natural theology. According to Thomas Aquinas and other philosophic Realists, the truth of Christian doctrine could be rationally proven on the basis of human perceptions: universal concepts were philosophically demonstrable. Ockham disagreed; he cut the tie between reason and theology. For him, humans had to accept the fact that all they could know with certainty were those things directly perceivable by the senses – individual objects, the *nominal*. Thus, in a very general sense, the emphasis of fifteenth-century painting on particular details of the physical world can be said to coincide with the thrust of this new philosophic position. Whether a philosophy caused an artistic style would be difficult, if not impossible, to say absolutely. More surely, we can say that both were expressions of a new way of seeing and understanding the world.

Sculpture

Fifteenth-century northern European sculpture also contributes to a definition of the type of realistic sensibility found in this period. In the last years of the fourteenth and early years of the fifteenth century, a Netherlandish artist by the name of Claus Sluter (1360-1406) carved a series of six monumental Old Testament prophets meant to form the base for a *Crucifixion* group and the whole ensemble was placed in the middle of a well (FIG. 27). The six patriarchs are posed against a relatively simple hexagonal base and interspersed with crying angels at their heads, which were obviously meant to relate to the missing Crucifixion above. Indeed, from a symbolic point of view the prophets do, too: their words, painted in bold Gothic script on the large scrolls they hold, predict the coming and the sacrifice of the Messiah. The well for which this giant sculptural group was intended as the centrepiece thus became, symbolically, a fountain of life, the blood of the Saviour flowing over his predecessors, redeeming them and also those coming after, who took water from the well. However, it is not the symbolism of this monument that is so striking, for that had featured in earlier medieval art. Like Roger van der Weyden at a slightly later

time, Sluter enhanced his work by what might be called, literally and figuratively, theatrical references. The medieval religious dramas, called mystery plays, commonly featured the commentary of prophets on events in Christ's life. Sluter's commentators are particularly involved and communicative, their faces fiercely individualised, their gestures distinct and exaggerated, and the folds of their drapery, deeply undercut, as expressive as any

27. CLAUS SLUTER
Well of Moses, c. 1395-1406. Stone sculpture with the addition of polychromy and gilding, height of figures approx. 6′ (1.8 m). Chartreuse of Champmol, Dijon.

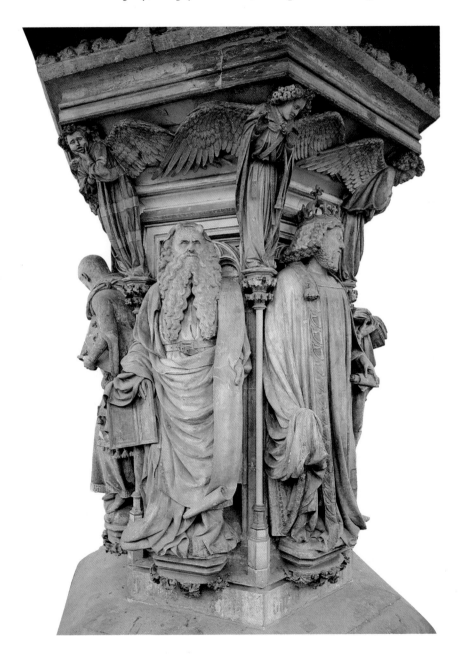

28. ROGER VAN DER WEYDEN *Deposition*, c. 1435. Panel, 6′ 14⅝″ x 8′ 7″ (2.20 x 2.62 m). Prado, Madrid.

The inverted "T"-shape of this large painting was probably meant to reinforce the shape of the church with its higher central nave and lower side aisles. As Roger van der Weyden's *Seven Sacraments Altarpiece* shows (see FIG. 59) the priest's elevation of the host/body of Christ over the altar is also reflected in this shape. In its solemnity and ritualised appearance, the *Deposition* is certainly meant to refer to this essential church liturgy.

human arms or legs could be. This group was originally fully polychromed, the particular textures and features of costume distinguished in bright colours and gold, and the eyeglasses worn by one prophet were separately commissioned from a local craftsman. This must have been a display of vivid, detailed realism that pulled the spectator from one figure, monologue or conversation to another.

With the compelling and actual, three-dimensional realism of sculptors such as Sluter, panel painters were almost invariably going to compete. Roger van der Weyden again provides the most telling illustration of this, in his startling *Deposition* (*Descent from the Cross*), in which he presented the ultimate painterly illusion of sculpted contrivance (FIG. 28). Ten almost life-size figures (Sluter's figures were life-size, too) have somehow found themselves encased in a golden box. If Roger van der Weyden had been a sculptor, he would probably have been forced to contain his carved figures in such a narrow, relief-like bank of space, but he was a painter: he could easily have painted

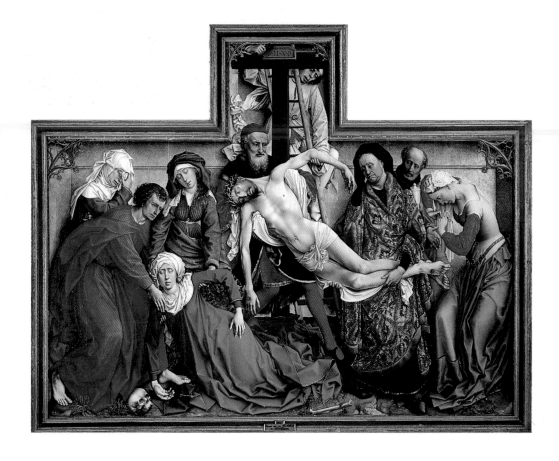

them against an expansive landscape or given them more breathing space above or at the painting's sides. Here the painter's realism seems to be an aspect of his rather focused study of the powerful, expressive (and realistic) purposes of contemporary sculpture. Of course, for the sculptor the creation of an illusion of real life, of figures moving and interacting with the emotion and purpose that Roger van der Weyden portrays, would have been desirable but limited. Sculpture would have remained sculpture. Roger van der Weyden paints something that, in its pretentions to realism, is extraordinary – something like sculpture that by this painter's power has become living, breathing, dying, and crying flesh. (It is no accident that six out of the ten participants in this scene are crying.)

A close look at details in this work is essential, for here is a union of opposites that controls the whole work, and indeed so much of northern art. The hands of the Virgin and Christ (FIG. 29) suspended beside each other are undeniably tangible in their sculpted presence. They are differentiated enough, but not too much. They are individualised – woman and man, fainting and dead – but they are also stylised by the artist, they have this artist's own elongated stylistic characteristics. They refer to a timely theological doctrine – the compassion of the Virgin and her Son – at the same time as they embody this artist's technical skill. The movements of the figures as a whole respond to both psychological and artistic needs. Mary's and Christ's bodies faint or fall in unison; mourners at either end of the painting form parentheses enclosing the whole composition. Roger van der Weyden's realism is the perfect embodiment of both detailed artistic vision and penetrating religious sentiment. It is also a perfect complement to the emphasis on personal prayer and contemplation found in the contemporary religious reform movement known as the Modern Devotion.

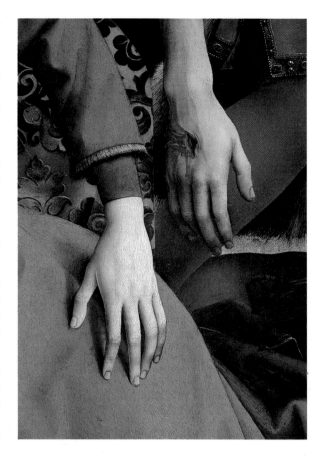

29. ROGER VAN DER WEYDEN *Deposition*, c. 1435, detail of Virgin Mary's and Christ's hands. Prado, Madrid.

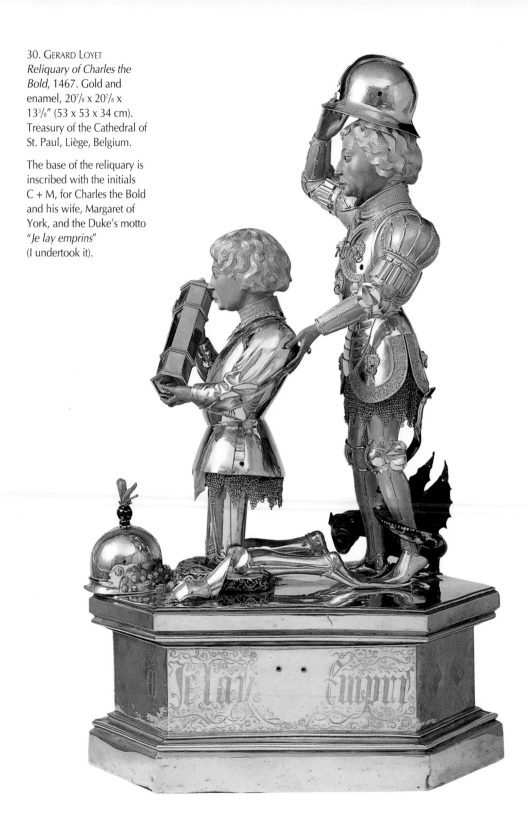

30. GERARD LOYET
Reliquary of Charles the Bold, 1467. Gold and enamel, 20⅞ x 20⅞ x 13⅜" (53 x 53 x 34 cm). Treasury of the Cathedral of St. Paul, Liège, Belgium.

The base of the reliquary is inscribed with the initials C + M, for Charles the Bold and his wife, Margaret of York, and the Duke's motto *"Je lay emprins"* (I undertook it).

Fifteenth-century northern sculpture, like fifteenth-century painting, could be small-scale, precious and pretentious in its presentation. One good example of this is the small, solid gold *Reliquary of Charles the Bold* (FIG. 30) by Gerard Loyet (fl. 1466-77), which the Burgundian duke presented to the cathedral of St. Paul in Liège, after he had crushed the city's rebellious impulses. Loyet adapted the figure of St. George and a donor from a painting made thirty years previously by a court painter to Duke Charles' father, Jan van Eyck. By the time Loyet was working, sculpture was seen as subservient to painting. What had been the chief medium for devotional art in the Middle Ages now took second place to two-dimensional imagery; it was even at times, as in the case of this reliquary, derived from earlier painted examples.

Realism and Social Class

Only the nobility could afford the kind of production that Loyet provided. It is perhaps little wonder that the Burgundian house, and its attendant aristocrats, continued to insist throughout the fifteenth century on materialistic ostentation, flaunting the ability to pay for the costly carving and finishing of objects of gold and silver, plates, cups, crowns, and jewellery. Court documents repeatedly mention their being given as gifts or passed down in wills. Miniatures of court life illustrate their constant display. Likewise, tapestry, the most expensive movable artistic production of the period, was also a prerogative of nobility (FIG. 31). What was left for the rising middle class, notably those prosperous bureaucrats, merchants, and traders in the burgeoning cities of northern Europe, were panel paintings, the illusion of all the wealth and beauty that only the nobility could afford, in any quantity, in reality.

Today the realism of fifteenth-century art appeals to men and women, rich and poor, devout and secular. Whether or not that was true from the beginning cannot with any certainty be determined. Contemporary documents – commissions, letters, wills, etc. – do not demonstrate that a particular group or kind of person had an overriding attraction to realistic imagery. In general, northern European literary sources do not deal with issues of artistic taste or style at any length. Is it possible to detect patterns in patronage that might suggest that certain people bought certain kinds of art more than others? The small, inconclusive evidence available here is interesting.

31. Workshop of Pasquier Grenier, Tournai (?)
The Story of Alexander the Great – Military Exploits and Fabulous Deeds, c. 1459. Wool, silk, gold, and silver thread, approx. 13' 11³/₈" x 28' 4¹/₂" (4.25 x 8.65 m). Palazzo Doria Pamphili, Rome.

The Burgundian court, for which this tapestry was probably made, was fascinated by the exploits of Alexander the Great, one of the ancient Nine Heroes whom the knights of Europe sought to emulate. Using a combination of contemporary costume and other detail, with the legend, the designer of the tapestry sought to please ducal taste and stimulate courtly imagination. Among the deeds portrayed here are, from the left, the siege of a town, complete with efficient fifteenth-century mortars; Alexander's ascent into the sky in a metal cage (which is carried aloft by four griffins, spurred on to flight by two hams held aloft on poles by Alexander); Alexander's descent into the watery depths in a glass tube held by chains attached to his attendants' boats; and his battle against dragons and hairy monsters.

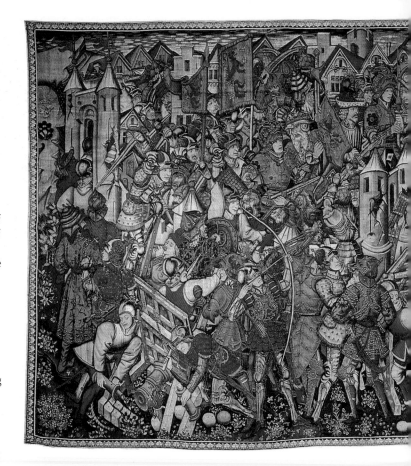

In the first decades of the great popularity and success of panel painting, from 1425 to 1475, about twenty patrons can be identified by name in, to take a prime example, surviving early Netherlandish panel paintings. Among them, members of the nobility are outnumbered by those of the upper middle class, by a proportion of two to one. What is more, most of the noble commissions were for portraits; members of the nobility were clearly intent on establishing and preserving a genealogical record – their family tree. The only known documented panel that Philip the Good, Duke of Burgundy, commissioned from one of his court artists, Jan van Eyck, was a portrait of his wife-to-be, Isabella of Portugal. Otherwise, in ducal circles, van Eyck seems to have been employed decorating castles and contriving ephemeral displays, such as floats for ducal processions and food designs for banquets. Among the middle, and upper-middle-class patrons, one particular group stands out: the newly created Burgundian court bureaucrats, known as functionaries, hun-

dreds of whom assisted the dukes in administering their lands, from the later fourteenth century. Drawn from the bourgeoisie, rather than from the clergy and hereditary nobility, they formed a new social group, seemingly above the middle class but, owing to ducal rewards, beneath the aristocracy in rank although perhaps not in financial position. They could be, and often were, richly rewarded, but if they brought ducal disfavour on themselves, their fall could be precipitous. They seem to have aroused both the envy of the bourgeoisie they left behind and the resentment of the nobility with whom they now rubbed shoulders.

Members of this court functionary group predominate among our prime sample of the identifiable patrons of early Netherlandish panels. In a position rather similar to that of the functionaries were merchants, traders, and bankers, such as Giovanni Arnolfini who, having lent the Duke money and bought him costly tapestries and fabrics for the court, was allowed by the Duke to make a fortune collecting taxes on goods coming

32. ROBERT CAMPIN
(attributed)
Virgin and Child before a Firescreen, c. 1425. Panel, 25 x 19½" (63.5 x 49.5 cm). National Gallery, London.

An early copy of this painting showed a humble porridge bowl on the cabinet at the far right. This is more appropriate to the tenor of the work than the modern restoration of the right four inches of the panel, which added the liturgical chalice and cupboard.

through the port of Gravelines. Such men, newly rich, no doubt proud of their success, wanted to display it to the world. Panel paintings could help them do that. These individuals could not routinely afford the luxury tapestries, goldsmith's work, and precious manuscripts that the nobility still favoured, but they could have, in a panel, the illusion of such wealth and prestige. Maybe they were not aware of, and could not delight in, the parallel between the pretension of their lives and that of this new realistic-seeming imagery, but there was no other social group to whom this illusionistic art bore such a personal and poignant relation. As envisioned by van Eyck, Arnolfini's dwelling is packed with intriguing objects that imply that he was a trader and would-be courtier to be trusted – an Anatolian rug, elaborate mirror and brass chandelier and costly oranges from Spain. These individuals were portrayed by painters whose skill lent the kind of prestige to their patrons' image that they no doubt longed for. Unsurprisingly, this new art found congenial patrons in these social-climbing, *nouveaux riches* circles.

In the first place, then, we must avoid simplistic distinctions, especially when treating as complex a relation as that between artistic realism and society. Realistic imagery in manuscripts could and did record court ceremony, deliberately recreating the display of gold- and silversmiths' work, rich tapestries, and costumes that characterised upper-class life, as a private historical record for the nobility themselves to treasure and admire. Different groups could adjust the format, nature, and purpose of realistic imagery to their own perceived needs. Nevertheless, although the nobility did not at first light upon *panel* painting as a vehicle for telling complex stories about their lives, especially in the first decades of its expansion and development in the fifteenth century, middle-class patrons did.

The Vocabulary of Bourgeois Realism

An important centre for bourgeois Flemish art was the prosperous manufacturing and trading city of Tournai in the county of Hainault to the south of Bruges and Ghent (in modern Belgium). In the second quarter of the fifteenth century, Tournai was home to Robert Campin (c. 1375/80-1444), one of the great founders of Netherlandish painting. Campin was decidedly a painter of the city, its middle- and upper-middle-class inhabitants, traders, merchants, and prosperous craftspeople. Probably in the 1420s Campin, or a close associate, painted an image of the Virgin and Child, seated on the floor before a fireplace shielded by a woven

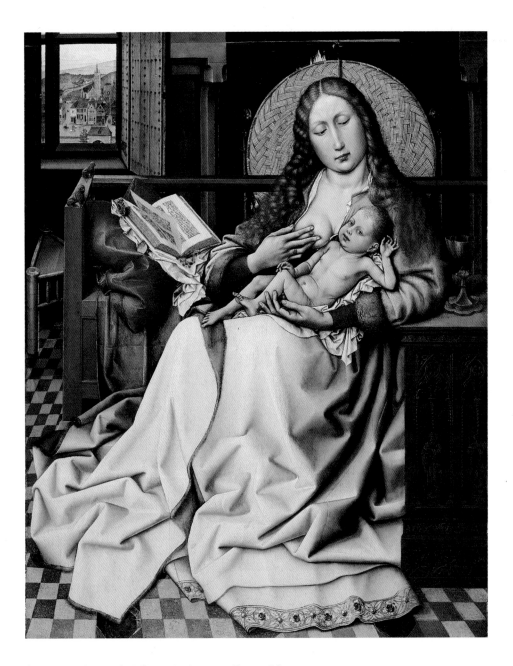

firescreen (FIG. 32). The painting recalls a mid-century contract for another work that specified the inclusion of furnishings like those found in the homes of "*seigneurs et bourgois*."

The kind of domestic imagery carefully created and assembled by the artist for a painting like this is one of the most often-heralded features of fifteenth-century art. Artists (and patrons) were concerned to place the holy figures firmly in their own

world, to share, as it were, or at least to be present at, the events in Christ's life. To some critics, the audacity of portraying the Virgin Mary as a Flemish housewife whose window looked out onto a city at least vaguely like that of Tournai necessitated what was initially dubbed "disguised symbolism." According to this theory, in order to protect the Holy Family from being mistaken for mere middle-class city-dwellers, still-life details were introduced that, when properly understood, gave the painting an unmistakable religious aura. Thus, the firescreen, complete with a wisp of flame above the parting in the Virgin's hair, was a substitute for a halo and the Pentecostal fire of the Holy Spirit. Humble realism was, in this way, thought to be excused or justified by a partially hidden symbolism. Really, the use of "hidden" and "disguised" here is relative, meaning hidden in comparison with the more blatant, antinaturalistic symbolic attributes that had been used in some medieval art.

Such symbolic references are not the most telling and important feature of this imagery. What strikes a viewer, first and foremost, about the *Virgin and Child before a Firescreen* is its insistent emphasis on the everyday world, materialistic, full of singular objects, adroitly chosen. The painting did refer to the orthodox religious view of life, but above all it incorporated this with emerging secular issues and concerns. These were increasingly viewed as worthy of attention in their own right, though, at least initially, apparently not by the Church, for such panels were small and not appropriate for public display in large-scale chapels, churches, or cathedrals. Nor does anything about the imagery, its ownership or patronage, suggest noble interest or appeal. It is not necessary to posit a dramatic class conflict in order to perceive that this kind of imagery would almost certainly have had a particular social appeal to the rising middle class.

In this sense, the identity of the particular creator or originator of such bourgeois religious imagery takes on special interest. Careful stylistic analysis has raised serious doubt that Campin, the leading painter in Tournai, was responsible for the *Virgin and Child before a Firescreen* and other paintings similar to it. It is more likely the work of a less famous, less prominently placed associate of Campin's, someone who did not work for the powerful or wealthy of the city and who unfortunately remains anonymous to this day. Thus, important artistic developments may not always be the prerogative of the leading masters, especially if they touch upon sensitive issues of social and economic standing. Domestic religious imagery and with it the sometimes

clever adaptation of symbolic devices to their new, everyday surroundings may well be the invention of "little masters."

The *Virgin and Child before a Firescreen* bears an interesting relation to the Boucicaut Master's realist vocabulary from about fifteen years earlier. In the Boucicaut miniature (see FIG. 16, page 24), the realistic elements of the image seem almost to amount to a social class distinction: peasants were stubby and naturalistically observed, holy figures and their immediate environment were gracefully elongated and ennobled. The painter of the *Virgin and Child before a Firescreen* went further. Apparently working outside the courtly and ecclesiastical hierarchy that governed the production of sumptuous books of devotion such as that of Marshal Boucicaut, he was able to imagine a role for realism fully grounded in the life of his patrons. The social class distinction is in ways more subtle in that it is embedded more fully in the image. At the very least it may be concluded that the avenues artists explored through their realistic vocabulary were at times charged with social significance. Realism in the fifteenth century commented on, perhaps even derived from, its social setting.

The Portinari Triptych

One particularly intriguing and complex early Netherlandish painting may be used to summarise the nature and function of realism in northern European art. In May of 1483, a large triptych, paid for by the head of the Medici bank in Bruges, Tommaso Portinari, was delivered to the church of Sant' Egidio at the hospital of Santa Maria Nuova in Florence (FIGS. 33-35). It had been painted by Hugo van der Goes (c. 1440-82) in Ghent probably about eight years previously. The triptych is one of the most startlingly realistic, as well as psychologically penetrating, works of its time. From the *grisaille* exterior to the minutely rendered floral still-life at the centre of the interior, the painting runs the gamut of realistic observation charged with personal, artistic, social, and psychological meanings – not to mention religious ecstasy.

On weekdays, the triptych's exterior would usually have greeted the spectator (FIG. 33). By the time this work was completed, it was traditional in the Netherlands to paint *grisaille* imitations of sculpture on the exterior of altarpieces (see also FIGS. 51 and 52, page 82). Sculpture had been the chief medium for devotional art in the Middle Ages and, even in the fifteenth and early sixteenth centuries in some areas of Germany sculpture

33. HUGO VAN DER GOES
Portinari Altarpiece, exterior,
c. 1475-76. Closed, each
panel 8′ 3⅝″ x 4′ 7½″ (2.53
x 1.41 m). Uffizi, Florence.

still retained pride of place at the inner core of a folding altar-piece (see FIG. 113, page 159). Like many other fifteenth-century northern artists, Hugo van der Goes put the sculpture on the outside – the ordinary or everyday view of the altarpiece; the inside, reserved for viewing on Sundays and special holy days, reveals a transformation to a full-colour display of the magnificent, perfected oil-glazed painting technique.

Hugo van der Goes could paint a painting and, at the same time, paint sculpture – or, at least, an illusionistic imitation of it. His realistic talents were economically beneficial: the patron need contact only one craftsman for a large and complex commission, and Hugo van der Goes could keep all the work in-house, for himself and his assistants. His abilities also allowed him to set priorities, to elevate his painter's medium at the expense of the sculptor's. As the example of Claus Sluter has shown, sculptors could and often did polychrome their work, making it powerfully illusionistic and theatrical. Hugo van der Goes wanted to control his painted sculpture more carefully,

emphasising through it the levels of reality to be traversed in order to reach the glowing painted core, or holy vision. Another explanation for the use of *grisaille* exteriors in fifteenth-century northern altarpieces relates them to Lenten practice. In some churches, then as now, holy images were covered with grey or white lenten cloths for the 46-day period of mourning preceding Easter. Whether or not this actual practice was somehow reflected in this artistic convention, it forms an interesting commentary on both the realism and possible symbolism of the art.

Hugo van der Goes' *grisaille* Annunciation scene is in one sense quite typical of his times: the Annunciation was a very common theme for the exterior of a triptych, since it announced the Incarnation of Christ, whose life was then further described on the triptych's interior. But in Hugo van der Goes' work, what at first glance might be taken to be sculptures of the Virgin Mary and Angel Gabriel are not simply that. They do not, for instance, have the carved polygonal bases to be expected on actual works of the sculptor's art. In fact, they might well be real people who have suddenly been frozen into their stony shapes. The realism of this work defies easy analysis or categorisation. Its level of reality is hard to define with precision.

The uncertainty of Hugo van der Goes' work was personal as well: a few years after painting this triptych, he went to live in a monastery near Brussels, as a lay brother. One of the monks later recorded the artist's deteriorating mental and emotional state, his collapse, suicide-attempt, and early death. Although the intrigue of Hugo van der Goes' art cannot lightly be passed off as an illustration of his troubled psyche, his artistic and personal self-consciousness is exhibited here.

When its wings are opened, the triptych presents a panoramic view of religious narrative and pious meditation (FIG. 34). Small background vignettes on the inside wings include landscape that is real, in northern terms at least, barren and grey, as it would be in Flanders in the winter. The triptych's interior view contains a remarkable aberration in the artist's realistic vocabulary: Tommaso Portinari and his sons kneel at the left, his wife and their daughter on the right; behind them loom their giant patron saints. Suddenly, Hugo van der Goes has reintroduced into his art a hierarchical scale, still found in the early years of the century (see FIG. 16, page 24) but rarely seen since: the holy figures are almost twice the size of the human. Thus, Hugo van der Goes' realism, like that of most fifteenth-century northern artists, is deceptively consistent; given the dramatic need, the seemingly neat, accepted conventions of realism are willingly broken.

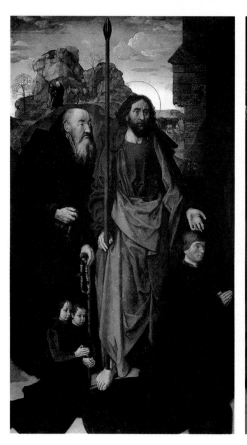

However, Hugo van der Goes was not working from a master realist plan or image. An ideal of absolute accuracy, perfect illusionism, was not, like a Platonic form, somewhere in his or his contemporaries' mind, waiting to be tampered with or violated at the right moment. This is a modern, twentieth-century point of view, engendered by our need to break out of what had been perceived in our time as the shackles of a long, entrenched, and academic-realist tradition. This is not the situation that Hugo van der Goes faced. Just as the plan of the Jacques Coeur house did not consciously violate some classical rules of order and proportion but followed its own internal logic, enlarging some elements, shrinking others in its search for a telling visual experience, so did Hugo van der Goes. Part builds upon part; figures grow or shrink, are flattened or suspended in space, in order to be both impressively real and oppressively ideal.

The central panel of the *Portinari Triptych* seems also to reflect contemporary (religious) theatrical practice. The stage floor has been tilted up so that the participants, as they recede in space, do

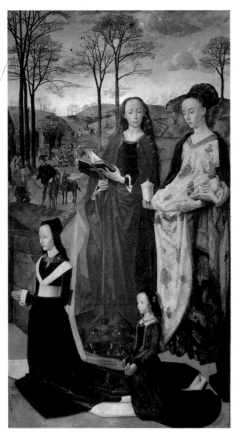

34. Hugo van der Goes
Portinari Altarpiece,
interior, c. 1475-76.
Central panel 8′ 3⅝″ x 9′
11⅝″ (2.53 x 3.04 m), each
side panel 8′ 3⅝″ x 4′ 7½″
(2.53 x 1.41 m). Uffizi,
Florence.

The words "SANCTVS,
SANCTVS, SANCTVS" (Holy,
holy, holy) are embroidered
in pearls on the edge of the
vestment worn by the
central, most richly clothed
angel. These are no doubt
meant as the opening words
of the first prayer of the
canon of the Mass, in which
the consecration of the Host
takes place: in Hugo van
der Goes' work, Christ's
body is being consecrated
from the moment it enters
the world.

not block each other but are rather artfully arranged on the
panel's surface. Angels are clothed in various priestly robes, as
was the custom in medieval mystery plays. The whole scene tran-
spires under a partially hidden, shed-like structure tacked onto a
masonry building; this type of temporary wooden structure
attached to a more permanent building may reflect theatrical
practice as well. Certainly the prominence given the shepherds
does. In fact, whole shepherds' plays survive, focusing on the
variety of human response to Christ's birth that such humble
observers could be made to embody. For Hugo van der Goes, the
shepherds were also realistic in the way their behaviour reflected
their social position: they have the only open mouths, awkwardly
grasping hands and visibly straining muscles; they alone break
through the code of dignity and formality that all other partici-
pants and observers exhibit. Here realism might again be said to
be reflecting social class distinctions. The artist's realism allowed
him to ponder a rich variety of human emotional and physical
response – not one ideal but many realities.

35. Albarello (drug jar), Spanish c. 1435-40. Earthenware, tin-glaze, lustre, height 12" (32.1 cm). The Hispanic Society of America, New York.

This Spanish drug jar was in use throughout northern Europe in the mid to late fifteenth century. Hugo van der Goes painted one just like it in the foreground of the *Portinari Altarpiece* (FIG. 36). It thus provides a perfect example of the specific, detailed realism for which northern artists were so famous. This is also a realism that could, on occasion, be bent to symbolic purposes, as when Hugo van der Goes no doubt intended the viewer to recognise that the stylised grape clusters and leaves on the jar could recall Christ's sacrifice (blood), a message reinforced by the rest of the Portinari still-life.

Throughout the interior of this complex triptych, space is once again experienced by fits and starts; fascinating vistas and vignettes float in and out of view. Perhaps none is more compelling than that found in the deep recesses of the stable, just above the head of the ox. Here, hardly visible, is a luminous monster, the devil. Its fang-filled mouth gapes open as it extends a taloned claw toward the foreground: the talons of the dove on the triptych's exterior seem to have grown large and undeniably threatening. Evil lurks in the shadows from the moment of Christ's birth, making his sacrifice inevitable, to protect humankind from the power of the devil, or sin. Realistic details – the devil, Christ's tiny body on the bare floor, the angel's priestly garments – suggest both the literal and the figurative dimensions of this sacrificial scene, its eventual transformation into the Church's Sacrament of Communion. Realism is not simply an excuse for liturgical or sacramental symbolism: it is the embodiment of it.

Nowhere in this work is this more apparent than in the foreground still-life (FIG. 36). This painting was originally displayed above the high altar of a small hospital church in Florence, the altar area raised several steps above the rest of the church. Thus, for most viewers of this work, the foreground still-life would have been at just about eye-level; it would have formed the painting's main visual draw, pulling the spectator, ineluctably, into its overwhelming drama. The perspective here is remarkable. The still-life literally seems to exist in a space of its own. The way the jar and glass holding flowers cast shadows on the ground suggests that the surface they rest on is an almost direct extension of the altar table just below and in front of the painting. Just beyond the still-life, somewhere around, behind, or under the sheaf of wheat, the ground plane bends, tipping sharply up as it recedes to infant, Virgin, and angels behind and above. If Hugo had employed one-point perspective here in the thorough-going way that Domenico Veneziano did (see FIG. 19, page 32), he would have robbed the work of its physical and concomitant psychological ambiguity.

In the midst of this cold, wintry scene, this still-life is the most perfect indication of the painter's realistic powers: ahead of the botanists of his day, he could describe the actual look of the species he chose. On another level, each blossom, its number, colour, and variety can be seen to make a comment on the religious significance of Christ's birth, life, and death: violets for humility, lilies and iris for the passion, columbine for the Holy Spirit, and three red carnations (called nail flowers) for the nails

36. HUGO VAN DER GOES
Portinari Altarpiece, c. 1475-76, detail of the foreground
still-life. Uffizi, Florence.

of the cross. Probably, such associations and meanings could be multiplied and should ultimately include the stylised grape design on the Spanish earthenware jar (wine = blood) and the sheaf of wheat (bread = body of Christ). From his other works, it is apparent that Hugo van der Goes had a passion for flowers, herbs, and plants of many sorts. They embodied the suffering of, and brought healing to, a troubled world – perhaps to the artist himself. Certainly then, many complex conditions governed the kind and meaning of realism in Hugo van der Goes' art. Social, artistic, psychological, and religious motivations were all at work here, as throughout north European painting of the fifteenth century.

Sixteenth-Century Developments

This first chapter has focused on the development of visual realism in the fifteenth century. There are several justifications for this. First, it is important to understand how the principles of this new art were from the start made apparent, what predictions of fifteenth-century attitudes there were in the previous century, and how they were initially and, to a great extent, consistently embodied in the works produced in the fifteenth century. Second, much, if not all, of what can be said about the fifteenth century applies also to the sixteenth. A dramatic new artistic vision was not apparent at that later time, as it had been in the early fifteenth century. For example, space was still usually treated in a fragmentary, additive, and puzzle-like fashion, molded to the wider (psychological, social, economic, religious, etc.) resonances of the work. Realism was detailed, individual, expressive, conventional, and constantly manipulated. In the sixteenth century, as in the fifteenth, an overriding and unifying, Italianate realist ideal was only rarely imposed in the North.

Several distinct qualities of northern realism did emerge in the sixteenth century. Three are most significant: a new love of the casual or incidental in terms of the accuracy of the image, a new sense of playfulness in the relation between the two-dimensional format and the three-dimensional illusion of the image, and a new variety of realistic genres, or types of imagery – portrait, landscape, and still-life.

In the fifteenth century, a painted cityscape background might appear to be accurately recorded from life, and all its details might be generally believable, but only a few, stereotypical ones would be copied from precise, known models. Increasingly, in the sixteenth century, this sense of the emblematic

power of the particular was dissipated, and the casual, everyday appearance of things was recorded, without any great significance being attached to it. Such was the case, for instance, with Albrecht Dürer's landscape drawings from life (see FIG. 94, page 137), which cropped up as models for the backgrounds of his religious images.

The fifteenth-century *Portinari Altarpiece* played with the perspective of an image, tilting and distorting it for expressive ends, but that is not the first thing one thinks about when looking at the work. Its manipulation grows incrementally from within the image. In contrast, the exaggerated perspectival effects in Hans Baldung's 1544 woodcut of a *Bewitched Groom* (see FIG. 11, page 19) were dramatically, even somewhat artificially, imposed from without. The confrontational and contrived predominated in a new way in the sixteenth century.

New developments in sixteenth-century realist vocabulary are perhaps best seen in the creation of specialities – artists becoming specialists in one particular kind of painting. Thus for the first time they might be called, as Joachim Patinir (c. 1480-1524) was, "good landscape painters." They voluntarily, and perhaps at times involuntarily, gave up religious painting in order to pursue their talents more fully in specialising as landscape painters or portrait painters. Some artists, such as the great portraitist Hans Holbein (1497/8-1543), suffered the adverse effects of the Protestant Reformation in their religious production. As secular imagery emerged, in fields as diverse as portraiture, landscape, and still-life, there was a significant interaction between the new sense of realistic observation that such paintings embody and contemporary social, economic, and religious concerns. As in the fifteenth century, artistic realism was intensely sensitive to, and an important influence on, contemporary northern European culture.

Physical Production and Original Location

37. DIRC BOUTS
Resurrection, c. 1455.
Distemper on linen,
35 x 29¹/₄″ (89.6 x 74.3 cm).
The Norton Simon
Foundation, Pasadena.

This canvas formed one half of one wing of a triptych showing scenes from Christ's life and Passion (the centrepiece was probably the *Crucifixion*). One of Bouts' most compelling effects in the *Resurrection* is the rising sun in the background gently illuminating city, country, and cloud-streaked sky. The rising sun was no doubt also meant to reinforce the idea of the new day ushered in by the rising Saviour in the foreground.

The intriguing interplay between the conventional and individual that imparted to northern realism much of its visual appeal is more readily understood through an examination of the physical conditions under which and for which this art was produced. It had a formulaic quality, growing from the collaborative conditions of the artists' workshops: regularity and control, not individual inspiration and genius, were essential ingredients. On the other hand, works were carefully, lovingly crafted and were created largely for particular locations and purposes, fulfilling, in varying degrees, site-specific calculations particular to each commission. What unites these apparently divergent qualities in the imagery is the idea of adaptability. These artists were subject to external demands, not free to explore purely artistic problems. This is an art that is individual in its functionalism.

In the fifteenth and sixteenth centuries in northern Europe, art was both a craft and a profession. It was highly regulated and structured both internally and from without. Artists did not dabble in their art on the side while holding down other demanding jobs. Painters, it is true, did paint many things – not just high-class panels but sculptures, decorative work, and temporary displays. Master painters made a good living, sometimes

even becoming wealthy from their occupation. This was a result partly of their being well-organised and versatile, partly of their careful control of any competition. The chief surviving kinds of painting from this period in northern Europe – indeed the chief surviving art altogether – is painting on wooden panels. To some extent this is due to climatic factors no doubt recognised at the time: in a moist, dark climate, panels are relatively durable and flexible, whereas wall paintings are fragile, more subject to fluctuations in the weather. Panels were also portable, relatively inexpensive, and appealing to a growing middle-class clientele. Still, wall painting probably was important, especially in the fifteenth century, in both ecclesiastical and aristocratic contexts. Unfortunately, the Reformation wiped out, usually by painting over with white paint, great numbers of religious murals, while noble productions have been lost as castles have been demolished or refurbished.

The Power of the Guilds

At the beginning of the fifteenth century, if a potential patron wanted a work of art, he or she would most likely go to the artist's studio or shop (see FIG. 7, page 16). The number of artists able to have workshops and produce and offer works for sale was strictly regulated by the artists' guilds in the cities in which they lived. In order to practice a craft and sell work, a person had to join a guild. In order to become a master in a guild, an artist had to pay a substantial fee (equivalent to at least several months' earnings), after having completed a period of training, sometimes culminating in the production of a trial work of art, a "masterpiece," certifying him as a fully proficient craftsman. Artists from cities other than the one whose guild they were applying to enter were charged a higher fee; artists' sons were favoured with the lowest fee. The results of such stipulations were strong local artistic traditions and relative uniformity of production. Local artists could thus protect themselves from a sudden influx of practitioners from other cities.

Artists could, and did, also control the competition within the town. Panel painters were the wealthiest and most powerful painters of their day, and they wanted to maintain that position. They promoted regulations that allowed them to paint on canvas or linen but prohibited the reverse situation; canvas painters were not allowed to branch out onto panels. Because of the cost of materials and the time for completion, panel paintings were the costliest single two-dimensional images. Linen was a less

expensive material and was painted with thin washes of tempera, making the final product's price only one-twentieth to one-thirtieth that of a panel painting. It is certainly true that some artists, especially notable panel painters such as Dirc Bouts (c. 1410/20-75), exploited canvas to great effect: the medium's thin washes infused Bouts' atmospheric sunrise landscapes with great subtlety (FIG. 37). Yet over-all, painting on canvas remained a popular, less ostentatious form of art, especially useful for temporary displays – as banners, or for decorations designed for processions and triumphal entries (FIG. 38). It was not until the seventeenth century in the North, when a more painterly, heavily textured style was favoured, that canvas became the preferred support.

Although great numbers of works on canvas were no doubt originally produced in the fifteenth century, not many have survived, and those that have are, understandably, in poor condition. They are often evaluated as inferior to contemporary panel paintings, in part due to the competitive guild conditions under which they were produced. Panel painters managed to limit the status of canvas painters, maintaining their own superiority and prerogatives. It is interesting to realise that the first securely documented work by a female artist in the Northern Renaissance is on canvas (FIG. 38). This fact reinforces both the lowly status of canvas painting and the generally inferior position that female painters occupied at the time.

38. AGNES VAN DEN BOSSCHE
Flag of the City of Ghent,
1481-82. Canvas, 9′ 1″ x
3′ 5″ (2.77 x 1.04 m).
Bijlokemuseum, Ghent.

Painted in oils on canvas, the Maid of Ghent, resting her hand on the lion of the city, stands on a flowery patch of grass. The letter G, for Ghent, is painted at the end of the lion's large, flourishing tail. The artist, Agnes van den Bossche, the daughter and sister of other Ghent painters, received numerous commissions from the city, more than her brother in fact. She produced mainly flags; there is no evidence that she painted altarpieces or other religious works.

Commissions and Contracts

Before about 1450 most panel paintings were specifically commissioned; there may have been a few standard models for sale in an artist's shop, but the expense involved in their production alone dictated some specific request from a patron. This would usually have been made known in a contract, legally binding, signed by both parties and sometimes by witnesses. Contracts were meant to guarantee value: patrons were concerned that quality materials be used and that the master himself be involved in the execution of the work. The patrons also wanted to set a completion date and a final price (as well as a payment schedule) and have some say about the subject-matter of the work. In the case of commissions of works for private individuals, such stipulations about subject were usually of a very general nature, a simple naming of story or theme to be represented – the Nativity, Adoration of the Magi, or Crucifixion. Perhaps the inclusion of details in the image that would have particular religious sig-

39. ENGUERRAND CHARONTON *Coronation of the Virgin*, 1453. Panel, 6' x 7' 2⅝" (1.83 x 2.20 m). Musée St. Pierre de Luxembourg, Villeneuve-les-Avignon.

The patron, a Carthusian priest by the name of Jean de Montagnac, kneels along with another man in the extreme lower right of the painting.

nificance for the individual patron was accommodated on an informal basis, through conversation, as work on the painting progressed. Alternatively, perhaps there was only a small amount of personal intervention in the area of religious symbolism or meaning. Specific social meaning and setting were of demonstrable concern to patrons, but they may also have valued a certain conventionality in religious subject-matter and its treatment, in terms of recognisable motifs and details that carried standard symbolic meanings, perhaps emulating those on pictures the patrons had already seen and admired. An example is the flowers in the *Portinari Triptych* (see FIG. 36, page 59): although rarely found in quite such profusion, various typical flowers (the lily, iris, and rose) recur in northern Annunciations, Nativities, and Adorations throughout the fifteenth and early sixteenth centuries and were no doubt meant to convey a standard message or symbolism.

Several surviving contracts demonstrate that, in large public commissions, funded by ecclesiastical or civic authorities, the subject-matter, and even its specific details, was of real concern. In 1453 a priest ordered a panel depicting the *Coronation of the Virgin* from Enguerrand Charonton (or Quarton, fl. 1447-61), a painter born in Laon but working in southern France; the painting was destined for the Carthusian monastery at Villeneuve-les-Avignon, where it remained until quite recently (FIG. 39). The surviving contract for this work contains twenty-six brief paragraphs stipulating the items to be represented; it included, for instance, a reference to the fact that "there should not be any difference between [God] the Father and the Son," shown crowning the Virgin. This unusual specification responded to rather abstruse contemporary speculation on the nature of the Holy Trinity; obviously the painter needed a theological adviser in order to make him aware of this situation.

40. ENGUERRAND CHARONTON *Coronation of the Virgin*, 1453, detail of the landscape showing Montagne Ste.-Victoire. Musée St. Pierre de Luxembourg, Villeneuve-les-Avignon.

On the other hand, this contract also repeatedly included the phrase "according to the judgment of Master Enguerrand," and certain features of the agreement were altered in the final work, presumably on account of the painter's "judgment." It was also apparently due to the painter's judgment that a realistic rendering of a prominent local landmark, Montagne Ste.-Victoire, was included in the landscape at the bottom of the painting (to the left of the Crucifixion, just above the angel helping people out of Purgatory, FIG. 40); at least, this feature is not mentioned in the agreement. Although such contracts show the rather obsessive need that those in authority felt to control works of art produced under their direction, the artist was granted some control, as when Charonton tied his work to the southern French countryside in which it was placed.

The Open Market

Increasingly, toward the end of the fifteenth century, works of art were produced speculatively, for the market. Artists' shops were apparently stocked with a variety of images of different sizes and subjects, available for the growing number of middle-class patrons walking in off the street. Workshops thus became, more and more, commercial enterprises, attuned to issues of economic survival. Fairs (open-air markets with stalls for rent) were also a growing feature of art distribution and trade. Initially they took place for a short span of time at a particular season; gradually the time span was extended and their quarters were made more permanent. The fairs were a chief forum for the export of northern works to southern lands, through traders and collectors from both sides of the Alps. One intriguing feature of the Bruges and Antwerp fairs called *pands* is that prominent, well-documented painters of the period, such as Gerard David (c. 1460-1523), are not recorded as renting stalls there. Apparently, as in the case of canvas painting, there was a kind of class distinction at work here. David, for instance, was no doubt favoured with enough demand for his work that he did not need to go out onto the street to hawk his wares. Other painters increasingly did, and the burgeoning market accommodated them.

More information is available about the production of Netherlandish sculpted wooden altarpieces for this growing market. Works of varying quality made speculatively for the open market, were widely exported over northern Europe, to Germany and Scandinavia, as well as finding a ready patronage at home. Prefabricated scenes or figures made by several differ-

ent craftsmen were used, cutting costs and therefore making the finished product more financially accessible to more potential buyers. Sometimes the results were crude (FIG. 41); others were as elegant and polished as any individually contracted commission. Adaptability and collaboration were crucial. Sculpted altarpieces made for the open market could be adjusted to individual patron's needs; above all, they represented a more economical use of labour than a specifically commissioned example. They therefore managed to capture a larger share of the contemporary demand for this art.

41. ANONYMOUS LATE 15TH CENTURY ANTWERP WORKSHOP *Altarpiece of the Passion and Infancy of Christ.* Polychromed oak, 9' 6⅛" x 7' 6⅛" (2.90 x 2.29 m). Stedelijk Museum, Louvain.

Scenes from the *Infancy of Christ* (the *Annunciation, Visitation, Nativity, Adoration of the Magi, Presentation of Christ in the Temple,* and *Circumcision*) run across the bottom of this work. They are surmounted by the *Carrying of the Cross, Crucifixion* and *Lamentation.* Some of the figures in the *Crucifixion* are out of scale, suggesting that they were prefabricated and that the altarpiece was mass-produced.

The Production of a Panel Painting

Since panel painting seems to us to be the most innovative and creative artistic medium of the time, we will treat its actual production as a typical example; quite analogous procedures were employed in the case of polychromed sculpture. The artist's first step was to procure a wooden panel, or panels, usually of a hard wood such as oak. Since different locations traditionally favoured different woods, the nature of the panel can now be used in determining its origins. The panel was carefully prepared, sometimes given a stamp or seal from the city in which it was produced, presumably certifying the level of its craftsmanship.

Working with the master painter in his shop were several men who were responsible for such jobs as panel preparation and the grinding of pigments. These included a limited number of apprentices, usually one or two, who, after paying guild fees, would be trained in the master's studio for two to four years (sometimes more); then they would become journeyman painters, remaining in the studio to broaden their experience and capability. In addition, depending on his needs at the time, an artist

42. ANONYMOUS GERMAN ARTIST
Modelbook of fifty-six drawings on paper mounted on small wood panels, early 15th century. Size of drawings 3³⁄₄ x 3¹⁄₂" (9.5 x 9 cm). Kunsthistorisches Museum, Vienna.

Some of the drawings of heads in this pattern book are clearly meant to be combined to form images such as the *Crucifixion*; almost all could have served several purposes.

could hire various assistants to help with more menial tasks or temporarily on larger commissions. One master might also sub-contract work to another master, who thus was presumably willing to paint in accordance with the first master's style and directions. Again, collaboration was the rule.

Three kinds of preparatory drawings existed in a northern European artist's studio: composition and motif studies, drawings of heads and hands, and records of other artists' work. In the first category, complex or complete compositional sketches were rare in northern Europe. In fact, the most common type of drawing surviving from the fifteenth century is the modelbook study, forming an encyclopedia of heads, hands, animals, plants, etc. (FIG. 42). Images in such books often have the appearance of having been drawn, originally, from nature, but they also seem, by the time they have been abstracted and entered into a pattern book, to have taken on a certain decorative, ideal character: they have become discrete, pleasing stereotypes that can be combined at will to form various standard religious scenes such as the Nativity and Crucifixion.

Some pattern books, such as the famous early-fifteenth-century example now in Vienna, are rather obvious in the additive nature of their realism. One element follows another and can be added to or subtracted from it, in order to make any particular whole. A work such as Dirc Bouts' silverpoint *Portrait of a Man* (FIG. 43) apparently presents a very different kind of study from life, but in fact, the drawings are not as different in origin and function as it might at first appear. Bouts was not simply spontaneously recording the looks of an individual from life, but probably creating his own ideal model, which could well be used as the pattern for several different portraits. His contemporaries used exactly the same underlying design of body and head for several sitters.

It is tempting to regard this as a "modelbook mentality," even when it was not as rigidly or obviously expressed as it was in the Vienna example, and this was in accordance with the contemporary attitude toward realistic representation already outlined. The "modelbook mentality" is perfectly exemplified by the work of a prominent artist in

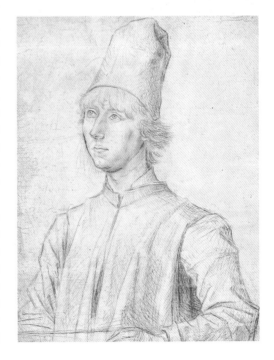

43. DIRC BOUTS (attributed) *Portrait of a Man*, c. 1460. Silverpoint on prepared paper, 5⁷/₁₆ x 4³/₈" (14 x 10.7 cm). Smith College Museum of Art, Northampton, Massachusetts.

The technique of silverpoint is a very deliberate and delicate one. It is done on coated paper and is indelible; for this reason, various small "mistakes" (at the figure's own right shoulder, for instance) can be seen in the finished drawing. This is the technique used by Roger van der Weyden's St. Luke to make his drawing of the Virgin and Child (FIG. 1).

44. MEISTER BERTRAM
Creation of the Animals
(from the "Grabow
Altarpiece"), c. 1378-83.
Panel, 33⅞ x 21⅝" (86 x
54.9 cm). Kunsthalle,
Hamburg.

This panel is one scene of a
large polyptych executed
for the church of St. Peter in
Hamburg. Covering a
central carved shrine were
twenty-four scenes in two
tiers on two sets of wings.
There are scenes from
Genesis as well as the
Infancy of Christ. When
opened, the altarpiece
measured twenty-four by six
feet (7.3 x 1.8 m). Meister
Bertram headed a large
workshop in Hamburg and
was no doubt the leading
painter of his day in north
Germany.

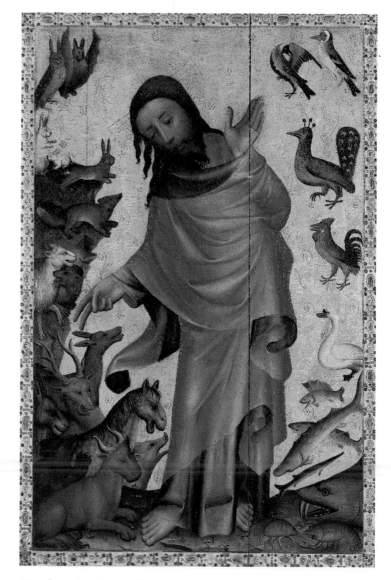

Hamburg in the late fourteenth century, Meister Bertram, (1340-1414/15). In a scene of the *Creation of the Animals*, he showed his modelbook sources quite clearly, lining up fish, fowl, and mammals against a gold ground, along either side of God the Creator (FIG. 44). Later, fifteenth-century artists became more clever at juxtaposing and at times integrating the fragments of reality that went into making up their images. Jan van Eyck's *Arnolfini Double Portrait* is not, at first glance as easily deconstructed as Meister Bertram's work, yet it is actually a series of calculated still-life details composed, with obsessively puzzle-like treatment of the image, in a manner similar to Meister Bertram's.

This approach continued into the sixteenth century as the following incident which took place in 1519-20 shows.

Because of a large debt owed him by another artist, Ambrosius Benson (fl. 1519-50), Gerard David impounded several boxes of patterns, including some of heads and nude figures, which Benson had taken or borrowed, for a fee, from other artists; Benson took him to court. David agreed to return the patterns if Benson would help him in his studio for a certain number of days. The value these men placed on the patterns underlines the extent to which the production of new imagery – compositions, faces, hands, bodies, drapery – depended on or derived from older models. Artists at this time simply did not go directly to nature each time they began a new work: they consulted their patterns or stock of modelbook images. Knowledge of this physical practice fleshes out an understanding of the works' realism and affirms that the creation of a painting was a deliberate, carefully coordinated professional operation, participated in by patrons (who could presumably look over an artist's patterns, too), painters, and their various assistants. Again, in such a set-up, personal spontaneity and inspiration were at a minimum. The subsequent stages in the physical production of a panel painting reinforce this point.

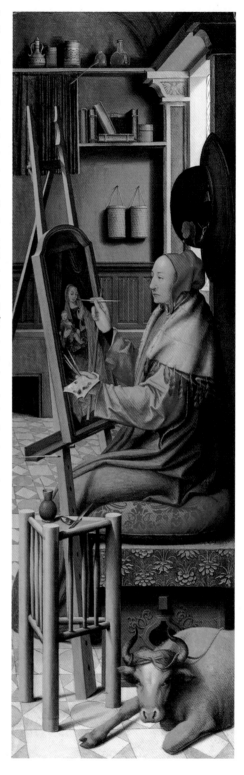

45. QUINTEN MASSYS (follower of?)
St. Luke Painting the Virgin and Child, c. 1530. Panel, 44³/₄ x 13³/₄" (113.7 x 34.9 cm). National Gallery, London.

This panel shows the continuation of a tradition represented earlier by Roger van der Weyden (FIG. 1) well into the sixteenth century. The artist of this panel adds a number of interesting still-life details to his scene. Especially important is the convex mirror placed on the wall over St. Luke's head. In northern art, such a mirror became a virtual attribute of the painter. (They did not have flat mirrors in northern Europe at the time.) These bulging mirrors helped the artist learn how to compress large spaces onto the typically small northern panel (see FIGS. 3 and 4).

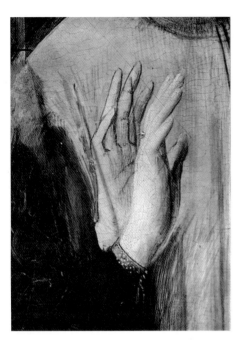

46. Infrared reflectogram of
JAN VAN EYCK
Arnolfini Double Portrait,
1434, detail. National
Gallery, London.

An infrared reflectogram
allows us to see through the
layers of pigment to the
original white surface of the
prepared panel, on which
the artist did an initial
sketch, or underdrawing.
Like most fifteenth-century
northern artists, van Eyck
made careful and complete
underdrawings and there
were few, if any, changes
between the drawing and
finished painting. In many
cases, the patron had no
doubt approved the
drawing and expected it to
be followed closely.

The panel was carefully coated with a white plaster ground, giving the painter a highly polished and light-reflecting surface on which to work. On this surface, rather than on a separate piece of paper, he made an elaborate preparatory drawing, which is called an underdrawing (FIG. 46). In northern Europe, underdrawings seem often to have substituted for elaborate composition drawings on paper. This does not mean, however, that they show the artist constantly adjusting and changing his ideas as he worked from drawing to finished painting; in fact, the underdrawings are over-all remarkably like the finished products. Even as he made the preliminary drawing, the artist knew what he or his patron wanted in the final work. In the oil-glaze technique, and the elaborate underdrawings that preceded it, control and deliberation were at a premium. Nevertheless, often fascinating and subtle adjustments were made between underdrawing and completed painting. These can help reveal where the artist was placing emphasis. For instance, the fact that Jan van Eyck fine-tuned the upraised hand of Giovanni Arnolfini seems to indicate that artist and patron thought this a significant gesture. Today its meaning is controversial – does it have legal or religious significance? – but its importance is generally agreed. (Specifying exactly the meaning of particular gestures is extremely difficult in this "modelbook culture.") Careful study of underdrawings reveals that paintings in one artist's style do not necessarily have underdrawings executed by the same hand. In some cases, that was due to standard images being repeated in the same studio, probably at least initially mapped out by assistants. At other times, it seems to have been the result of the generally collaborative nature of the endeavour: if the master was away or otherwise engaged, an apprentice could be delegated the task.

The length of time it took to paint a panel, laboriously applying one thin layer of oil-glaze on top of another, obviously depended, to some extent, on how many layers were required. For one relatively large and sumptuous work, Jan van Eyck apparently took two years, though of course he may have been distracted with other duties and, as far as is known he did not have a large shop but insisted on his own, personal involvement in all stages of the painting's creation. Artists who applied fewer

layers of pigment could complete a panel within several months. Drying agents were certainly a topic of concern; the make-up of the glazes would obviously affect the final texture of the work and was no doubt a carefully guarded secret. Sufficient drying time was essential for all works and thus, at any one time, artists' studios were no doubt full of a number of paintings in various stages of completion. Again, the image is one of slow and methodical, stage-by-stage production.

Printmaking

A simple, cheap reproductive medium was developed for the printing of images on paper in the first few decades of the fifteenth century: woodblock printing. A drawing was made on a wooden block and then carved, so as to leave only the lines standing; all that would eventually be white on the paper was cut away. The lines were then coated with ink and the block pressed against a piece of paper. Sometime in the second quarter of the fifteenth century, craftsmen who had engraved designs on a metal plate started printing them, putting ink in the gouged-out grooves and then pressing the plate, with great force, against a sheet of damp paper. Woodblock printing generally produced a simpler design than could be achieved by carefully gouging multiple, overlapping series of lines out of a metal plate (compare FIGS. 11 and 15, pages 19 and 23). As with woodblock printing, the engraving process could be repeated over and over, making the resultant image available in great quantities for an ever-increasing number of collectors, and also for other artists, who no longer had to make their own hand-drawn copies of admired artists' works. Now, too, great numbers of images were within the reach of hundreds of middle-class patrons. The development of fine art printmaking in the fifteenth century reinforces the democratic trend we have witnessed in the case of panel painting further eroding the exclusive power of elite, noble patrons.

Both of these procedures, technically known as intaglio (metal plate engraving) and relief (woodblock) printmaking, were extremely important for the dissemination of artistic ideas and information in the last years of the fifteenth century. They were the pictorial equivalent of Johannes Gutenberg's invention of movable-type in about 1450 which led to the printing press – and, in fact, their exploitation was intimately connected with the developing of printing in general. Not only were early printed books illustrated with woodcuts but the whole idea of

47. MARTIN SCHONGAUER
Virgin and Child in a Courtyard, c. 1490. Engraving, 6½ x 4¾" (16.6 x 10.4 cm). British Museum, London.

Schongauer's Virgin sits on the ground in an enclosed courtyard, probably meant to suggest her virginity or seclusion.

sharing information on a wide scale was obviously a crucial, common cultural one.

Early prints were often deliberately made by artists for use as patterns, both decorative and figurative. Some early prints were themselves derived from artists' modelbooks. Soon, however, individual printmakers developed a distinctive graphic style. One of the most brilliant was the German Martin Schongauer (c. 1430-91), working in the last quarter of the fifteenth century. Schongauer came from a family of goldsmiths, which is no doubt how he learned his craft. In an image such as that of the *Virgin and Child in a Courtyard* (FIG. 47), he demonstrated a number of distinct aesthetic sensibilities, all relating to the use of line. Line can stand out alone, silhouetted against a neutral background – the white paper – and yet by sensitive maneuvers and changes of direction, black lines alone can radically alter the meaning of – and the viewer's feelings about – those carefully calculated blank spaces. Schongauer knew the value of the interval. He also sensed the power of visual contrast: open and airy versus dense and tightly compacted. The Virgin's robe is a fascinating display of the designer's, and the engraver's, art. Numerous hairpin turns fold back against each other, articulated by series of parallel lines that subtly swell or contract in width. Each line itself becomes a metaphor for the breathing, organic, but also highly contrived nature of the whole. Schongauer's are patterns with a difference: he made his own skill count while training others to follow his increasingly sophisticated, even painterly use of a graphic, linear medium.

Function and Content

Panel paintings of the fifteenth century were often not merely the generic, formulaic productions of artists bound to the use of the modelbook: there were also carefully considered individual works that had quite specific and varied functions, reflecting not so much a strong sense of individual artistic creativity as a desire or willingness to tailor a work to a particular context or function. A northern work's functionalism is not often understood as

making it a simple continuation of its environment but rather a distinct and useful addition to – or object in – it.

Works that were clearly meant to function in a domestic context (see FIG. 3, page 12 and FIG. 32, page 51) no doubt responded to certain details of the patrons' homes, reflecting their proud new possessions. Thus both private religious devotion and social pretension took on new immediacy. Several further physical characteristics of such domestic images shed further light on the contemporary experience of them. Typically, these panels were provided with finely crafted frames; the framing devices could be box-like, with a separate covering panel, or panels, sometimes in the form of wings. Frames could carry long explanatory inscriptions. At times, especially in the case of portraits, the backs of the panels were painted as well, with either a simple marble pattern or a more elaborate scene or coat-of-arms (see FIGS. 83 and 84, page 125). These factors indicate that the panel was treated as a precious object, part of the spectator's world but at the same time set off from the mundane world of everyday existence. The paintings were specific to their environments but also portable: they could be easily carried from room to room, stood up on a table, handled, admired from all angles. There is something here both intimate and flexible – love of the small scale and the precious, mingled with a sense of the ideal, the timeless. Framing devices, referred to in literary sources but which have unfortunately rarely survived, distinguished these domestic works in noticeable ways.

In the context of framing and physical presentation, what are we to make of the works of one of the most original and enigmatic masters from this period, Hieronymus Bosch? Bosch (c. 1450-1516), whose family came from Aachen (in present-day Germany) lived all his life in the somewhat provincial city of 's-Hertogenbosch (now in the southern part of the country of the Netherlands). There he was a respected, orthodox citizen of the community, a long-time member of the important lay religious Confraternity of Our Lady, and repeatedly patronised by the nobility of Holland and Flanders. Many of Bosch's works employ the standard religious format of the day, the three-part folding triptych. This is true of his most puzzling painting, today referred to as the *"Garden of Earthly Delights"* (FIGS. 48-50), which has a *grisaille* exterior like so many other Netherlandish triptychs, opening onto a spectacular full-colour interior. Some modern observers have assumed that this format implies that the work had a primarily religious function, being hung over a Christian altar. But in the 1960s it was pointed out that

Bosch's large triptych was seen in the Brussels palace of Henry III of Nassau, Regent of the Netherlands, in 1517, one year after Bosch died; and it remained in the private possession of the Orange-Nassau family until 1568 when it was seized by Spanish troops and taken to Madrid. If, as seems most likely, this painting was commissioned for private use by a nobleman, then the overall theme of the work, marriage and resulting sexual relations between men and women – takes on pointed significance, probably coinciding with some particular wedding.

Bosch's discussion begins in primordial times since on the exterior of the triptych God the Father is shown floating in the clouds bringing the world below him into existence (FIG. 48). The spectacle moves from the primeval to the paradisiacal on the left wing of the interior (FIG. 49). Here we find illustrated in the foreground God's command to Adam and Eve to "be fruitful and multiply and fill the earth and subdue it" (Genesis 1:28). By contrast the right wing clearly represents Hell where, as was typical of several of Bosch's works, the torments are specifically

48. HIERONYMUS BOSCH
Garden of Earthly Delights triptych, exterior view, c. 1505-10. Panel, side wings each 7'2⅝" x 3'2⅛" (2.20 x 0.97 m). Prado, Madrid.

At the upper left God the Father floats on clouds above the earth, blessing the progress of his creation. At the top of these two panels are the words: "Ipse dixit et facta su[n]t," and "Ipse ma[n]davit et creata su[n]t" (For he spoke and it came to be; he commended and it stood forth [Psalm 33:9]).

49. HIERONYMUS BOSCH
Garden of Earthly Delights
triptych, interior view,
c. 1505-10. Panel, central
panel 7' 2⁵/₈" x 6' 4¹/₈"
(2.20 x 1.95 m), side wings
each 7' 2⁵/₈" x 3' 2¹/₈"
(2.20 x 0.97 m). Prado,
Madrid.

gauged to the sin. Perhaps most striking in this sense is the so-called "Musicians' Hell" where bodies are strung up or impaled on giant lutes, lyres, and hurdy-gurdies. Between the two extremes of Eden and Hell is the raucous central panel which must, at least in part, have been meant to show how God's initial blessing of sexual union was turned by later generations into an excuse for sensual excess and indulgence (FIG. 50).

There is also an undeniably paradisiacal quality to the central panel: the cavorting figures themselves look innocent and unselfconscious, and the background landscape with its four fountains and rivers leading toward a central structure is strangely reminiscent of such scenes as the *Adoration of the Holy Lamb* in Jan van Eyck's *Ghent Altarpiece* (see FIG. 52, page 82). But Bosch and his contemporaries no doubt also felt that the central panel of the triptych represented a false paradise of love where mermaids and sea-knights (in the distance) engage in illicit love, wild and lustful men encircle a pool of seductive women (in the middleground) and (in the foreground) the sensuousness of nature blots out reason and restraint.

50. HIERONYMUS BOSCH
Garden of Earthly Delights
triptych, c. 1505-10, detail
of central panel. Prado,
Madrid.

Bosch's painting is like a medieval tapestry, covered with amazing detail from corner to corner. Some of this detail may contain precise symbolism, some may have grown from an artist's sensibility about the power of provocative juxtapositions taken from observed reality, and some may finally be the result of a fertile imagination untrammelled by specific conscious intention. If in fact this triptych was meant to address issues of sexuality and sexual relations for a noble family, then such a combination of motivation and meaning would be entirely appropriate. It is only when we try to imagine the *"Garden of Earthly Delights"* hanging over a Christian altar that a need to provide a rational theological explanation for every detail in the work arises – and has ultimately frustrated and eluded modern observers. The original palatial setting of this Bosch work provides a surer justification for the originality of the art.

The most important public religious context før works in this period was as an altarpiece, above one of the many communion tables that had multiplied throughout medieval churches. In the *Portinari Altarpiece* the artist clearly related his imagery to this context, especially in the way in which the foreground still-

life, as well as the Infant Christ's body, can be seen as either a real or a metaphoric offering on the altar directly below and in front of the painting. Roger van der Weyden's figure of Christ in his *Descent from the Cross* could also be thought of, metaphorically, as being lowered onto the altar above which this painting was originally placed. Many other northern European religious images are similarly tied to their physical proximity to, and function in, the Church's major rituals.

Rarely is this conceived of as a literal or illusionistic proximity. Even in the *Portinari Altarpiece*, as we step from altar into painting the ground rises suddenly and steeply. There is one prominent exception to this rule that northern art is not meant as an illusionistic continuation of its surroundings, and that is the *Ghent Altarpiece*, completed in 1432 by Jan van Eyck. The exterior of this work is particularly telling in this respect (FIG. 51). It was originally, and in fact for much of its life since its creation, displayed in a chapel in which the natural light from windows entered from the painting's right. The chapel's real daylight is used, illusionistically, to cause the frame in the four-part *Annunciation* scene to cast shadows to the left on the chamber's painted floor. All the figures on the first level of the exterior – the donor Joos Vijd and his wife, Elizabeth Borluut, and the *grisaille* imitations of sculptures of the two Saints John – are also consistently and strongly lit from the right.

The situation is not as simple as it might at first appear. In the *Annunciation*, light also enters the depicted space from behind, through various windows that look out onto a street below (which some modern scholars have wishfully identified as a street in Ghent, the city in which the painting was located). Light streams in these windows at a strong raking angle from the *left*, suggesting a divine illumination entering the Virgin's chamber at the moment of Christ's incarnation; it is strong enough to cast shadows on the Flemish street below. Whatever its significance, van Eyck's use of light cannot be defined simply as an illusionistic device: it is multiple and mysterious, suggesting complicated levels of reality.

The same might be said about the various perspectives and light effects displayed on this great polyptych's interior (FIG. 52). On the upper tier a selection of figures, almost six feet (1.8 m) high, is arranged on seven separate panels. There are three different perspective systems employed for the floors of these panels, one for the three central holy figures, another for the two flanking panels with musical angels, and a third, the most intriguing, for the outermost images of Adam and Eve. In a very

51. JAN VAN EYCK

Ghent Altarpiece, completed 1432. Exterior panels closed, approx. 12′ 3⅝″ x 8′ 6³⁄₈″ (3.75 x 2.60 m). Church of St. Bavo, Ghent.

Prophets and sibyls above the scene of the Annunciation allude to the coming of the Messiah. The Angel speaks the words: "*Ave gracia plena d(omi)n(u)s tecu(m)*" (Hail, thou who art full of grace; the Lord is with you); and the Virgin replies: "*Ecce ancilla d(omi)ni*" (Behold the handmaiden of the Lord). Mary's words are written upside down, in order that they may be read by God in Heaven.

52. JAN VAN EYCK
Ghent Altarpiece, completed 1432. Interior panels open, approx.
12′ 3⅝″ x 17′ (3.75 x 5.20 m). Church of St. Bavo, Ghent.

More than twenty inscriptions run throughout the interior of the
altarpiece, elucidating the large characters above: from the left,
Adam, musical angels, Virgin Mary, God the Father, John the
Baptist, more musical angels and Eve – or the small hordes below,
again from the left, the Warriors of Christ, Just Judges, apostles,
angels, prophets, patriarchs, female saints, confessors, martyrs,
holy hermits and pilgrims. All join to worship the Lamb of God.

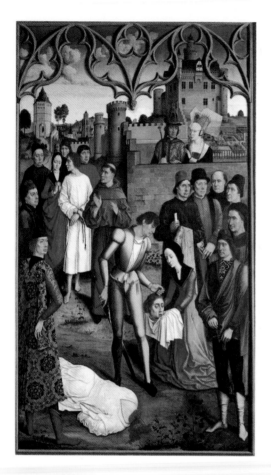

Above left 53. DIRC BOUTS
*Justice of the Emperor Otto
III* (*Wrongful Beheading of
the Count*), c. 1470-75.
Panel, 10' 7½" x 5' 11⅝"
(3.24 x 1.82 m). Musées
Royaux des Beaux Arts de
Belgique, Brussels.

rare instance, van Eyck has here, in the Adam and Eve panels, taken the position of the spectator into account. They are to be viewed from below – a worm's eye point-of-view, as it is sometimes called, emphasising Adam and Eve's humanity. Adam's body is selectively tanned on hands, face, and neck, Eve's swelling belly follows contemporary fashion. The First Parents do not appear to rise gently, into an ethereal realm, as do the sacred personages beside them, but are bound, like the spectator, to the earth. Again, then, the artist responded in a selective way to the panels' original placement, a way that allowed him to make a whole both real and ideal, connected to and surpassing the vagaries, as well as the specifics, of daily human existence.

In northern Europe in the fifteenth century, paintings served important functions in contexts other than the church and the home, notably in central civic edifices such as a town hall. For the great judgment chamber of the Louvain town hall, Dirc Bouts was commissioned in 1468 to paint a series of four scenes

Opposite right

54. DIRC BOUTS
Justice of the Emperor Otto III (Trial of the Count's Wife), c. 1470-75. Panel, 10′ 7½″ x 5′ 11⅝″ (3.24 x 1.82 m). Musées Royaux des Beaux Arts de Belgique, Brussels.

The kind of judicial ordeal portrayed by Bouts was officially abandoned by the Catholic Church in the early thirteenth century. Although ordeals continued to occur in German lands in the fourteenth century, the pressure against them was great. Ordeals were replaced by both jury trials and torture. In Flanders, "the truth of the aldermen," a judgment made by a group of men such as those who commissioned Bouts' work, often ruled.

illustrating the *Justice of the Emperor Otto III,* a tenth-century German tale. Only two of these panels, the last two, were even partially completed by the time of Bouts' death in 1475 (FIGS. 53 and 54); the panel showing the *Wrongful Beheading of the Count* was completed by an assistant, presumably after Bouts' demise. These paintings illustrate the notion, found in several other important works from this period, that history should be combed in order to find a good *exemplum justitiae* – a timeless example of justice being worked out in human affairs. Such scenes were hung in town halls behind the judges' seats, reminding all who swore oaths and gave evidence before them, to tell the truth. (The original paintings are today in the Brussels museum; painted copies hang in their place in the Louvain town hall [FIG. 55].)

Several features of Bouts' works seem both curious and noteworthy in relation to their intended setting. He depicted the exercise of justice according to recorded medieval custom: in order to exonerate her husband, who had been wrongly accused of sexual harassment by the Empress, a noblewoman undergoes a trial by ordeal, holding a red-hot metal block. As she cradles her husband's head in one hand, she remains unscathed by the glowing metal in the other. The Empress's treachery is thus miraculously revealed, and the Emperor rightly condemns his wife to the stake (shown in a small background vignette). The administration of justice had become more rational by Bouts'

55. The Judgment Chamber of Louvain Town Hall, Belgium, showing the original location of Bouts' panels (copies there today).

time; perhaps the original spectators were to think on that fact, too. Incidentally, Bouts received professional advice in order to illustrate these scenes properly.

Bouts' paintings are also tied to their environment through the inclusion of a series of contemporary portraits, as well as by reference in their traceried frames to the original architectural setting. The use of group portraits in a civic setting – for religious confraternities, urban militias, charitable volunteers – became a distinctive feature of Dutch and Flemish art in the succeeding centuries. Here Bouts' contemporaries – presumably powerful civic leaders, whose idea it was to commission this work – are shown wedged in around the count's execution in the first panel (see FIG. 53), their impassive faces and postures not impeding the harsh denouement of the narrative. Analogously, the Gothic tracery at the top of the panels does not correspond exactly to that in the town hall; but it does create a feeling of stylistic continuity that, like the portraits, helps bring the message of the paintings into Bouts' own time. This medieval drama of justice is thus both a timeless archetype and a timely, insistent reminder witnessed but hopefully also updated by the contemporary world.

The Isenheim Altarpiece

One distinctive physical environment is, at least to many people today, particularly moving. Perhaps the most striking work ever executed for such a context is Matthias Grünewald's (1470-1528) *Isenheim Altarpiece* (FIGS. 56 and 57). Grünewald's triple-transforming polyptych was completed in 1515 for the chapel of the Antonite house at Isenheim, in the region of France now called Alsace. The house was, in effect, a hospital, and that is the dreadful but transfiguring context into which the artist's work was thrust. Hugo van der Goes' earlier *Portinari Altarpiece* could also be considered, at least in part, as a response to a hospital context. Grünewald's almost unrelieved depiction of pain and suffering suffuses his painting of the Crucifixion (FIG. 56). In the enormous, horribly lacerated body of the crucified Christ the patients in the hospital might see suffering, beyond even their imagining, and pain subsumed in and justified by a divine plan. Since John the Baptist predeceased Christ, his presence here, to the right of the cross, must be explained in ahistorical, supernatural terms, pointing to, literally, the superhuman nature and effect of Christ's sacrifice. Behind St. John there lies a green, translucent body of water, possibly a reference to the cleansing power of baptism that John first instituted and Christ approved. When this

56. MATTHIAS GRÜNEWALD *Saints Sebastian and Anthony Flanking the Crucifixion* (closed view of the *Isenheim Altarpiece*), 1515. Panels, 8′ x 10′ 1″ (2.4 x 3 m). Musée d'Unterlinden, Colmar.

In large red letters in the V of John the Baptist's outstretched arm are the words "ILLVM OPORTET CRESCERE ME AVTEM MINVI" (He must increase, I must decrease), which are attributed to the Baptist in John 3:30.

panel is opened, folding it out on its hinges at the right, the scene of Christ's Resurrection appears on its reverse (FIG. 57). Grünewald's image of the resurrected Christ, probably one of the most colouristically brilliant in art, shows his body washed clean, his spotless porcelain skin now translucent, his neat red wounds radiating golden light. This great painting was displayed on the high altar of the Antonite canons' church and was thus hidden from general view by an altar screen marking off the choir from the rest of the church. No doubt the painter's imagery was meant to help the canons – as much as their terminally-ill patients – face, and ultimately explain, the agony that surrounded them.

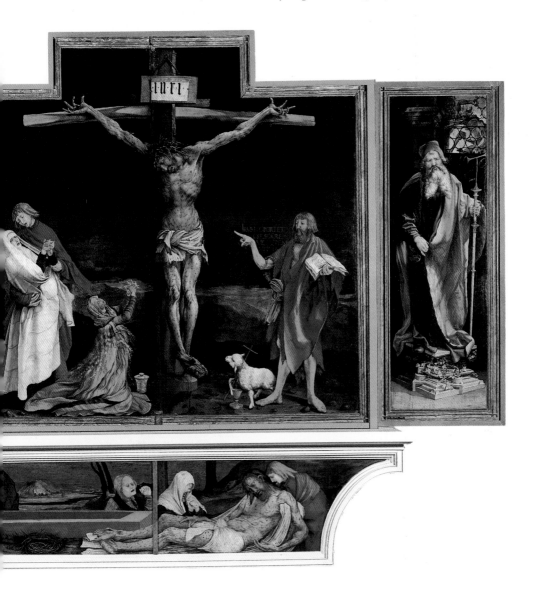

57. MATTHIAS GRÜNEWALD
Annunciation, Angel Choir,
Nativity, and Resurrection
(second transformation of the
Isenheim Altarpiece), 1515.
Panels, wings each 8′ 9⁷/₈″ x
4′ 7⁷/₈″ (2.69 x 1.42 m),
central panel 8′ 8³/₈″ x 9′
11⁷/₈″ (2.65 x 3.04 m). Musée
d'Unterlinden, Colmar.

To many if not most people in the sixteenth century, physical illness was a sign of sin, the physical disease reflecting an internal, spiritual malaise; and so, to a great extent, the sick and dying in the Isenheim hospital would have been lectured to about the ever-presence of sin in their lives, corrupting their minds and their bodies. Grünewald probably alluded to such thinking by inserting a malevolent, feathered musician into the central scene of the polyptych's second transformation. This large, greenish creature, just above and behind the foreground angelic cellist's head, also helps explain some details of the scene to the right. It seems the Christ Child has just had a bath (baptism?) in the tub at his mother's feet. His mother wraps him in a ragged swaddling cloth (recalling the loincloth on the crucified Christ), while the baby plays with a chain of prayerbeads, interspersed with pieces of coral. Veins of coral were taken to refer to Christ's blood, the redeeming power of his sacrifice, and were therefore used as magic charms to ward off the power of the devil.

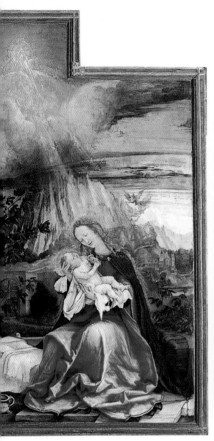

In a work as complex as Grünewald's, many things could, and probably do, refer to many different ideas and issues, simultaneously. This might be expected in such a complex religious system as Christianity, elaborated and refined over many centuries. In its torment and anguish, for example, Grünewald's work seems a possible prediction of the religious crisis about to surface in Europe – the Reformation. However, throughout much of his life Grünewald was a devout and traditional Catholic artist; he repeatedly worked for Catholics like the Antonites at Isenheim. His expressive power is also individual and unique. No one else ever painted the intense, rippling shivers and tears of Mary Magdalene at the foot of the Cross as compellingly as Grünewald. The power of this art is intimately bound up with the specifics of its setting. Some other hospital works radiate a paradisiacal calm; for Grünewald, the tragedies of this hospital's patients, and the sacrifices that their nurses made daily, could not be passed over with such equanimity. Grünewald painted *his* vision of suffering in order to justify the lives of its intended viewers.

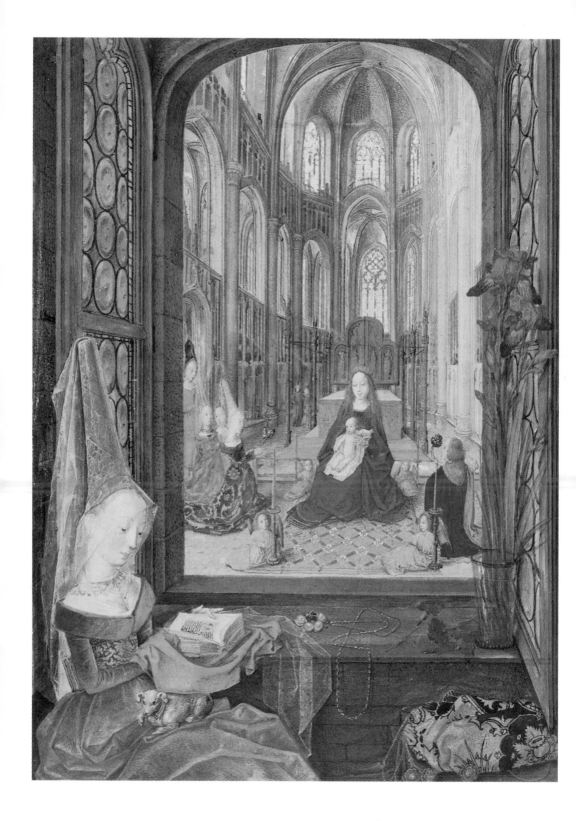

THREE

Religious Behaviour and Ideals

58. MASTER OF MARY OF
BURGUNDY
Mary of Burgundy at Prayer,
c. 1480. Manuscript
illumination from the *Book
of Hours of Mary of
Burgundy*, cod. 1857, fol.
14v., image size approx. 7³/₈
x 5³/₈" (18.7 x 13.5 cm).
Österreichische
Nationalbibliothek, Vienna.

A comparison of the tortured imagery of Matthias
Grünewald (see FIG. 56, page 86) with the superficially
placid painting of the Bruges Master of the Legend of St.
Lucy (see FIG. 5, page 14) might suggest that the fifteenth century
was a time of security and calm, contrasting with the tumultuous
and revolutionary sixteenth century. However, just as the St.
Lucy Master's work glossed over a dire economic decline in the
great Flemish trading centre of Bruges, so the religious history
and imagery of the fifteenth century were far more complex and
even troubled than an initial judgment of the St. Lucy painting
allowed. Under a sometimes disarmingly peaceful facade, fif-
teenth-century religious imagery contained within it intimations
of, even if it did not overtly condemn, many of the issues and
ideas that led to the Protestant Reformation: the selling of salva-
tion through indulgences, clerical waste and abuse of power, and
the clergy's insistence on Church ritual, especially the veneration
of the Eucharistic host, performance of penitential exercises, and
the importance of saintly and priestly intercession.

The official Seven Sacraments of the Catholic Church are shown filling the aisles and nave of a Gothic cathedral (looking very much like the cathedral of St. Michael in Brussels); from the left are baptism, confirmation, confession, the eucharist (alone in the centre panel), ordination, marriage, and extreme unction. The presumed patron of the work, Jean Chevrot, Bishop of Tournai, is shown confirming youths in that sacrament. Angels with banderoles float above each scene, providing explanatory verses.

Controversy and Corruption

In the fifteenth century, religious controversies were not so much doctrinal as political. In 1309 the papacy had moved from Rome to the southern French city of Avignon. There followed a period of French domination, known later as the Babylonian Captivity of the papacy, which ended in 1377, when the pope returned to Rome. A new Italian pope was elected in 1378, but within four months of his accession to the throne of St. Peter, the French majority in the College of Cardinals declared that their earlier allegiance to this pope was coerced. They elected their own pope, who again took up residence in Avignon. These two rival popes continued to compete for legitimacy over the next thirty years. Then, to make matters worse, in 1409 a council of Church leaders who had defected from both the Roman and Avignon leaders elected a third pope. All three popes remained in

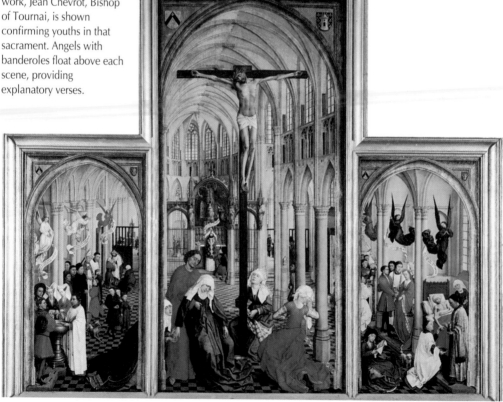

power for the next six years, and a single, universally agreed successor was not elected until 1417. A further antipope was subsequently chosen in the 1430s, and open conflict continued to rage between the College of Cardinals and the Roman pope. In the meantime, serious heresies arose in Bohemia, and negotiations to heal the rift between the western (Catholic) and Eastern (Orthodox) branches of the church proceeded by fits and starts. By mid-century a final union of east and west had failed, and Constantinople had fallen to the Turks.

In western Europe the chief cause and effect of all this turmoil was obsession with political power within the Church. This was a wealthy and influential institution that various political factions sought to control for their own purposes, notably to benefit from the assignment of the constantly growing number of appointments to office in the papacy's power. A key to the problem was the secular clergy: often from wealthy and influential families, these were men who were appointed to various salaried but nonresident ecclesiastical positions throughout Europe – they simply had to swear loyalty to pope and church and perform minimal duties. Money for these benefices came from the Church's growing practice of selling "indulgences," certificates that were originally understood to relieve the purchaser from the temporal punishment of his sins but which came to be understood as a release from purgatorial torment in the afterlife. Since a person's sin might result in an almost infinite number of penitential years spent in Purgatory, the need to ensure a more rapid salvation was unending.

Thus as a result of the Great Schism, as this period of rival popes and councils is called, church leaders constantly tried to exploit a system of selling both political influence and personal salvation. Even without internal conflict, this would have led to the disillusionment of many lay people. Records often show that attendance at church ceremonies was low, many people going to confession and taking communion only once a year, at Easter. Clerical complaints about lack of lay participation in the sacraments were recorded in the city of Tournai in the late fourteenth century; at a slightly later time, in an effort to rouse the faithful the Bishop of Tournai, Jean Chevrot, commissioned from Roger van der Weyden a portrayal of the canonical Seven Sacraments of the Church, taking place in orderly succession throughout the aisles and nave of a giant Gothic cathedral (FIG. 59). This painting makes the point quite clearly that the overwhelming vision of salvation brought by Christ's crucifixion is made available only within the confines (indeed, the prescribed rituals) of the

Church. Many works destined to be displayed above church altars refer to the Sacrament of the Eucharist celebrated there (see FIG. 28, page 44 and FIG. 34, page 56): the repetitive message of this imagery takes on greater urgency in the light of laymen's laxity in observance of church ritual.

Personal Religion

There is much evidence to show that the majority of Roger van der Weyden's contemporaries throughout northern Europe relied not on church Sacrament and ceremonial for their path of spiritual enlightenment, but on more personal resources. In surviving Netherlandish religious paintings, lay patrons outnumber clerical by a ratio of two to one; and the religious art these lay people bought illustrates quite simply an ideal of private prayer and devotion that can be read, in part, as a conscious reaction against the contemporary turmoil within the church. Various popular reform movements in the late fourteenth and fifteenth centuries, such as the Brethren of the Common Life, stressed the power and importance of true personal piety. Increasingly, private prayerbooks were produced to enable those who were wealthy and literate enough to perform their own devotions in the intimacy of their homes, as well as in public, ecclesiastical locations. Stress on private devotions did not have to weaken Church authority: there is no evidence that clerics complained about lay people saying their prayers privately, only that the laity did not, routinely fulfil their public, parochial obligations.

In the fifteenth century use of the personal prayerbook accustomed the laity to an appreciation of religious art. The "books of hours," containing the offices, prayers and Bible readings for the canonical, monastic nine hours of the day, and stories of the saints' lives, combined with panel paintings of religious subjects to reflect the laity's religious needs and experiences and raised the value of the pictorial image in devotional life. For a monk or nun, who had consciously withdrawn from the blandishments of the physical world, the ideal might be "imageless devotion," purely spiritual, otherworldly experience. However, some traditional religious orders, nuns in particular, also provided models for an increasingly common practice that characterises lay piety in northern Europe: the use of paintings to stimulate and record the path of religious experience.

In a magnificent full-page miniature from a late fifteenth-century Flemish book of hours belonging to Mary, Duchess of Burgundy, the Duchess herself (or perhaps one of the other illus-

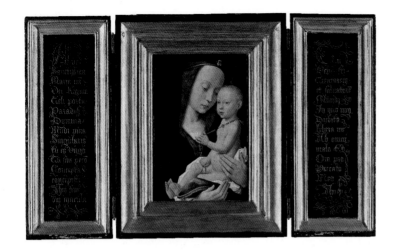

60. STUDIO OF GERARD DAVID (after Hugo van der Goes) *Virgin and Child with Prayer Wings*, c. 1490(?). Panel, centre panel framed 19 x 15" (48.3 x 38.1 cm), each wing 19 x 7½" (48.3 x 19.1 cm). National Gallery, London.

trious and pious women in her family) is depicted seated in the foreground, reading from her prayerbook (see FIG. 58, page 90). Through an open window can be seen a noblewoman with three attendants kneeling before the Virgin and Child, who sit calmly before the altar of a great Gothic cathedral. Vision seems piled on vision: Mary, in the foreground, apparently predicts her heavenly state, in the background, where she perpetually adores a vision of the Virgin. Obviously no earthly intercessor, no priest comes between the Duchess and the object, or vision, of her veneration.

Many such private devotional images functioned quite securely within the system of monetary payments to the clergy – and rewards to the patron – mentioned above. Certain paintings and prayers (in particular, the saying of certain prayers before certain images) were granted indulgences by the pope, sometimes allowing up to 11,000 years' release from purgatorial fires. Saying certain prayers was also claimed to guarantee certain visions: if the devout said certain prayers regularly, the Virgin would appear to them in various ways and in various scenes from her life. In a painting of the *Virgin and Child with Prayer Wings* (FIG. 60), this use of the image is brought dramatically alive. Unfortunately, prayer wings such as this, recording special indulgenced prayers, were often removed in later centuries, when the painting left its original religious context and entered the world of art collectors and museums. The original frames, now often lost or stolen, had at least the beginnings of such prayers or hymns inscribed on them. Such, for instance, was the case with the original frame, stolen in the nineteenth century,

61. JEAN FOUQUET
Etienne Chevalier ("Melun
Diptych"), c. 1450. Panel,
36⅝ x 33⅞" (93 x 86 cm).
Staatliche Museen zu
Berlin, Preussischer
Kulturbesitz,
Gemäldegalerie.

Etienne Chevalier came
from humble middle-class
origins, rose dramatically in
court circles, and in 1452
was named Treasurer of
France by King Charles VII.
He occupied a number of
other important posts and
was sent on various
diplomatic missions.

for Jan van Eyck's *Virgin in a Church* (see FIG. 63). The painting
with its inscribed frame was like an incantation, calling on the
visionary powers of patron, artist, and spectator.

Fifteenth-century religious art focused on the visions and
meditations of the laity. Sometimes the object of the patron's
devotions was a timeless image of divinity, as when Jean Fou-
quet, a mid-fifteenth-century French court artist, imagined the
king's powerful minister, Etienne Chevalier, praying to the Vir-
gin Mary (FIGS. 61 and 62). Chevalier is depicted being presented
by his patron, St. Stephen; the two male figures exist in a con-
trived, sharply angled perspectival space full of contemporary
classicising ornament, their warm hues contrasting glaringly
with the cool silver tonality of the Virgin's panel. The Queen of
Heaven and her charge exist in an airless space, precisely mod-
elled and hieratically composed, with cherubim and seraphim
stacked around them. The two levels of reality are obvious. The
irony of the situation is highlighted by an old tradition that in
dress and appearance the Virgin resembles King Charles VII's

62. JEAN FOUQUET
Virgin and Child ("Melun
Diptych"), c. 1450. Panel,
37¹/₄ x 33³/₄" (94.5 x 85.8 cm).
Koninklijk Museum voor
Schone Kunsten, Antwerp.

mistress – and Chevalier's associate in running the kingdom –
Agnes Sorel. Such juxtapositions of worldly and heavenly aims
and ambitions seem fitting in an increasingly lay-dominated reli-
gious imagery.

The laity were also invited to meditate on, or envision, spe-
cific historical events in Christ's or the saints' lives. Contempo-
rary handbooks were aids to imagining or reliving the Passion in
all its mundane detail and human emotion. Thus, the Portinari
family seem to re-enact in their minds the birth and adoration of
the Christ Child. Artists, when portraying these scenes, often
relied on saintly visionaries' experience of them. In the late four-
teenth century, St. Bridget of Sweden wrote an exhaustive series
of *Revelations* about the events in Christ's life of which she had
had visions, sometimes based on paintings she had previously
seen. Artists, like Matthias Grünewald, in turn read Bridget's
visions and subsequently included details from them in their
paintings (such as the way Christ's hands and feet are bent around
the nails in the Isenheim *Crucifixion* [see FIG. 56, page 86]).

Religious Behaviour and Ideals 97

The terms vision and visionary are used rather loosely here. The fact that Etienne Chevalier and Tommaso Portinari had "visions" of the Virgin or the Nativity of Christ does not mean that they claimed to embody the kind of piety usually reserved for the saints. At times, such images might be thought of more as indicating the patrons' invocations of, or desires for communication with, the divine. Such paintings could also serve a purpose for the future: not only to show off the patron's (presumed) piety, but also to remind his successors to pray for him, just as they in turn would want to be prayed for by their children and their children's children. Paintings can be visions of the here and now but also quite personal visions or prayers for the future.

The Pilgrimage

In the fifteenth century the concept of sin, and the pious layperson's consequent penitence and penance, was a powerful force in a Christian's life. Ideally, the sinner went to a priest and confessed, was granted absolution and told to perform certain acts in penance for the sin. The penance might merely involve saying prayers; more dramatically, it could entail going on a pilgrimage, saying more numerous prayers along the way and ultimately before the statue or relic worshipped at the pilgrimage shrine.

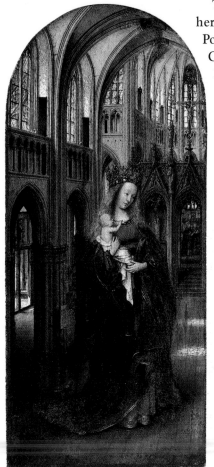

63. JAN VAN EYCK
Virgin in a Church, c. 1440. Panel, 12¹/₄ x 5¹/₂" (31 x 14 cm). Staatliche Museen zu Berlin, Preussischer Kulturbesitz, Gemäldegalerie.

The Church attached indulgences to certain shrines: travelling to see a miraculous statue or relic and saying prayers before it relieved the pilgrim of later torment. However, sinners were not the only pilgrims, for pilgrimages were among the most popular forms of religious expression in late-medieval Europe. Aristocrats classed pilgrimages with jousts as pleasant noble pastimes: one had the chance to see the countryside and be wined and dined at others' expense.

When the pilgrim arrived at his or her destination, the most sought-after experience was a vision. Through repeated prayer and meditation, a relic might seem to bleed or a holy statue be seen to come alive, nodding, crying, or moving in the pilgrim's direction. Van Eyck's small painting of the *Virgin in a Church* (FIG. 63) reflects such a hope, as do many other fifteenth-century paintings. Van Eyck's panel is almost certainly only the left-hand half of a devotional diptych, the right side of which con-

tained a portrait of the donor. Two later fifteenth- and early-sixteenth-century copies of this work have donor panels, each representing the person who commissioned the copy. Just beside the Virgin's left shoulder, far behind her on the choir screen, is a cult statue of her flanked by two lit candles. It is as though the foreground Virgin is that statue grown large and come to life in the donor's mind. Within the depicted church structure, on the foremost compound pier at the left, hangs a two-column prayer tablet. A simpler one is viewed by a man at the right side of the central panel of Roger van der Weyden's Seven Sacraments Altarpiece; another, written in two paragraphs, hangs on the wall outside the shrine of the Virgin of Einsiedeln, carefully recorded in an engraving by Master E.S. (fl. 1440-68; see FIG. 66). The presence of van Eyck's prayer tablet was intended to reinforce the prayer or hymn originally found on the frame of his panel which in turn was no doubt meant to bring the statue of the Virgin to life.

64. Basilica of Our Lady, Tongeren, view of the nave, mid-13th to early 16th century.

Van Eyck's panel may seem a subtle and sophisticated affair. He cleverly used aspects of actual nearby pilgrimage churches, famous for miraculous statues of the Virgin, in order to form his ideal Gothic edifice. The basilica of Our Lady at Tongeren has upper passageways and windows (the triforium and clerestory) remarkably like van Eyck's painted example (FIG. 64), but Tongeren has columns, not compound piers, supporting the nave arcade. Van Eyck's raised choir (but not raised triforium and clerestory) is found at another location, and so on. This painting is therefore an example of the representation of the believable but idealised – contemporary but timeless – result of a pilgrim's most fervent prayer. The painter's light – evocative and mysterious – recalls the fact that pilgrims bought small convex mirrors at pilgrimage sites in order to capture the holy rays emanating from the statue or relic.

Among other souvenirs bought by pilgrims to commemorate or document their journey were badges and popular prints. A typical contemporary pilgrim's badge shows a stylised version of a church atop a circle in which two smaller pilgrims bring offerings to Virgin and Child (FIG. 65). Similarly, Master E.S.'s engraving depicts two kneeling pilgrims at the foot of the shrine to the Virgin at Einsiedeln, in Switzerland (FIG. 66). Such humble productions viewed alongside the glowing panel of van Eyck, not only show similar themes and details but underline the interdependence of elite and popular means of artistic expression: van Eyck apparently incorporated into his own delicate illusion some features of popular devout culture. Typical fifteenth-century religious behaviour may not have been revolutionary or heretical but it certainly placed great emphasis on something both real and tangible to the layperson: not canonical doctrine or ceremony but the private ecstasy of the faithful Christian.

65. ANONYMOUS NETHERLANDISH ARTIST *Pilgrim's Medal*, 15th century. Height 4" (10 cm). Rijksdienst voor het Oudheidkundig Bodemonderzoek, Amersfoort.

66. MASTER E.S. *Large Madonna of Einsiedeln*, 1466. Engraving, 8¼ x 4⅞" (21 x 12.3 cm). British Museum, London.

This print commemorates a tenth-century miracle in which a monk witnessed Christ and a host of angels dedicating a chapel to a slain cleric. In 966 a papal bull confirmed this miracle and granted an indulgence to those visiting the shrine. Master E.S.'s print was commissioned in 1466, the 500th anniversary of the bull, by the monks at the shrine at Einsiedeln. In the print, on the arch leading into the shrine, is written: "Dis is die Engelwichi zu unser lieben frouwen zu den Einsidlen, ave grcia plena" (This is the angelic dedication of Our Lady of Einsiedeln).

Stereotypes and Originals

The religious subject-matter of fifteenth-century northern art was simultaneously individualised and standardised. As with realism, which was detailed and particular, clearly at times there was a need to adjust religious imagery to the particular context or patron for which it was intended. While images meant for people's homes could be required to portray details such as furniture, characterising that setting (see FIG. 32, page 51), other works, executed under strict clerical control, could involve contracts that specified details meant to make the image conform closely to theological doctrine (see FIG. 39, page 66). Nevertheless, as visual realism was conventional and idealised, so there was a startling homogeneity in fifteenth-century religious painting, especially in contrast to the variety of images during the sixteenth century.

In the fifteenth century, images of the seated, standing, or enthroned Virgin and Child were ubiquitous. Scenes from Christ's life were limited and stereotypical – the Nativity, Adoration, Crucifixion, Deposition, Resurrection. There are few surprises here, in either choice or interpretation. Clearly artists throughout northern Europe were striving for a timeless devotional ideal. The mid-fifteenth-century Cologne painter Stefan Lochner (c. 1400-51), painted a typical image of the Virgin and Child, seated in a stylised rose arbour, a time-honoured symbol of the Virgin's purity and holiness: "a rose among thorns" (FIG. 67). Lochner also placed Virgin, Child, and arbour against a delicately tooled gold ground, thus reiterating the timeless and eternal message of the divine pair. This is not just an example of a long-lived medieval style, employing old conventions (such as the gold ground for holiness) alongside a new realistic vocabulary: it was not lack of inspiration or revolutionary artistic fervour that kept fifteenth-century painters ready and willing to use traditional religious formulas and conventions alongside their new-found talents.

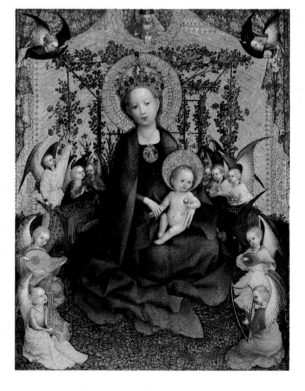

67. STEFAN LOCHNER
Virgin and Child in a Rose Arbour, c. 1440. Panel, 19⁷/₈ x 15³/₄ " (50.5 x 40 cm). Wallraf-Richartz-Museum, Cologne.

68. Italo-Byzantine
Artist
Notre Dame des Grâces,
14th century(?). Panel,
13¾ x 9⅞" (35 x 25 cm).
Cathedral of Notre Dame
des Grâces, Cambrai.

When Roger van der Weyden created an image of the ideal artist (himself) as St. Luke, he was using the legend that St. Luke began and subsequently provided legitimacy for the occupation of the Christian artist. St. Luke was credited with having created the first, archetypal image of Virgin and Child, an icon still at that time (and even today) being produced in the East, following ancient models, held to reflect Luke's original (FIG. 68). This explains why Byzantine icons were so unvarying in appearance: they represented and repeated the original artistic creation. In the fifteenth century, partly owing to renewed attempts to unite the Eastern and Western Churches, Byzantine icons were being imported into the West, faithfully copied and disseminated. The icon of the *Virgin and Child* now in Cambrai came to that city in 1440 and was given to the cathedral in 1450; in 1454 at least fifteen close copies of it were commissioned by local authorities. This was clearly a holy image thought to have descended from the hand of St. Luke himself. To repeat it was to venerate it.

Perhaps even more interesting is the way in which this principle of repetition was applied to works first created in the fifteenth century. Numerous religious images, such as van Eyck's *Virgin in a Church,* were copied throughout the century. This has often been read as a sign of honour for the famous artists who created these designs. Traditionally, great and powerful religious art received that kind of veneration. However, in the new realist and individualist mentality of the fifteenth century, an artist could also creatively adapt, rather than slavishly copy. The object was still to capture some essence or kernel of truth from the original but at the same time to embed that seed in a new and vital setting, which was sometimes just a result of the artist's personal style. Thus, the iconic type found in Cambrai was adapted in the triptych of the *Virgin and Child with Prayer Wings* (see FIG. 60). This is a particularly intriguing example of this problem, since the triptych seems to many modern eyes to be executed in Gerard David's painting style after a work which, due to facial type, might be attributed to Hugo van der Goes, who in turn depended compositionally on an iconic model, per-

haps that in Cambrai or one of its numerous northern copies. Here is copy upon copy, each slightly transformed through personal style and artistic feeling. Jan van Eyck's tiny *Virgin in a Church* (see FIG. 63) adapted the iconic pose somewhat more freely, and in reverse. Still the play between the Virgin's hands and the Child, the gesture and drooping swaddling cloth of Christ, and the gold-trimmed blue robe of the Virgin all find remarkable parallels in icon and van Eyck's panel. Northern realism drew strength and legitimacy from these earlier, much-honoured prototypes.

Other factors in the production of northern European religious art promoted homogeneity. One was the increasing importance of the open market, causing the production of works speculatively. As long as the work was not being created for a specific location or patron, there was little need or reason to give it unusual individual traits. This was a market with some of the characteristics of today's fashion scene: potential buyers wanted something their neighbours or friends had, a status symbol both familiar and declamatory. Foreign traders and buyers also sought the typical: a scene marked by its standard details and features as coming from the North.

One justification for homogeneity is related to personal religious developments. Popular devout movements of the day which emphasised personal prayer and meditation did not stress the *what* so much as the *how*. It was not important, for instance, to invent a new or unusual religious scene to meditate upon; what was crucial was how one approached that task, how the individual's consciousness was transformed by thought and prayer. It was the artist's job not to fabricate an unusual iconography or subject-matter but to imagine the traditional scene in as emotionally gripping and involving a way as possible. Thus, Roger van der Weyden packed the standard actors and actresses of a *Deposition* scene into a wooden box in order to control, all the more powerfully, the viewer's empathetic response to them (see FIG. 28, page 44); and he displayed various key participants in a saint's life in tableau-like fashion before a series of stylised arches, again to focus and concentrate the viewer's attention (see FIG. 26, page 40).

The power of theatrical performance in contemporary religious imagery, in both fifteenth and sixteenth centuries, is an influence that can be sensed in many works, not only that of Roger van der Weyden but Hugo van der Goes and Claus Sluter. Gestures, details, the very cast of characters have come into painting in different ways and at different times from con-

temporary theatrical experience. Although medieval plays survive, not enough is known about performance practice – set design, props, how the play related to its environment, the city street, town square, or church interior – to confirm completely the relation between medieval drama and painting. In one especially engaging contemporary portrayal of a religious play, Jean Fouquet's mid-century image, in a book of hours made for Etienne Chevalier, of the *Martyrdom of St. Apollonia* (FIG. 69), the play's director stands to the right, with text and directing stick in hand, while the terrible fate of Apollonia – having her teeth pulled out before she is burned at the stake – proceeds in mock form beside him. The spectators in a raised gallery (for nobility) and a lower pit (for the common people) all seem engaged in the spectacle. The grey-bearded ruler before whom this play is being performed is so involved that he has descended from his

69. JEAN FOUQUET
Martyrdom of St. Apollonia, c. 1452-60.
Manuscript illumination from the *Book of Hours of Etienne Chevalier*, 6¼ x 4¾" (15.9 x 12 cm).
Musée Condé, Chantilly.

throne to intervene personally on Apollonia's behalf. A court jester exposes his rear end at the left, while at the right a devil surmounts a Hell-mouth, awaiting his role in what will surely be a scene-to-come, about Heaven (the angelic musicians in the upper left gallery) and Hell. Theatre, like other popular religious practices, brought together various social elements and levels, thereby again providing both realistic and stylistic novelties. Above all, for painting, it provided a recurrent model for the common feeling these works exuded – that of a final, stylised tableau, a living drama, momentarily halted for the viewers' edification.

The Sixteenth-Century Reformation

If we want to imagine how the various religious currents of the fifteenth century resulted in the Protestant Reformation of the sixteenth, we must focus on the issue of the privatisation of religious experience. It was here that both the profane pretenses and deep piety of early Renaissance men and women met. At the same time that the Portinari family, Mary of Burgundy, and Etienne Chevalier exercised control over their religious devotions, they revealed their human pride and ambition, their inevitable sinful state. It was the aim of Protestant Reformers to read the relation of these two elements – self-determination and self-promotion – in a narrower, more moralising manner. Such different elements in a person's make-up needed to be clearly separated, not casually intermingled.

Many of the early sixteenth-century reformers in the Catholic Church were obsessed with sin, both their own and that of what they felt was a hopelessly distorted and wayward Church. For Martin Luther (1483-1546), the first great Protestant leader, a pilgrimage to Rome in 1510 only served to illustrate the worldliness of the Church's leaders. Distrust of the hierarchy could have been addressed by internal reform. What Luther felt was something more profound and more personal – distrust of himself. The Protestant Reformation he began was based upon a dual assumption: that the individual alone was helpless in the face of temptation and that God was all-powerful, incapable of being bribed by what must ultimately seem to him to be false human schemes (such as the sale of indulgences). Confronted with such a dilemma, how was an individual to achieve salvation? *Sola fide*, by individual faith alone, Luther declared. All that was required of the Christian was faith in the promise of salvation that Christ's life and death brought to the world.

70. Defaced portrait of Erasmus in a copy of SEBASTIAN MÜNSTER'S *Cosmographia*, 1550. 4⅝ x 4" (11.8 x 10 cm). Biblioteca Nacional, Madrid.

While it had remained largely an internal political issue in the fifteenth century, religious controversy burst into the open in the sixteenth. Everyone was expected to take sides at the time of the Protestant Reformation and feelings ran high. Annoyed with Erasmus because of his lack of support for Martin Luther, Albrecht Dürer cried out: "Oh Erasmus of Rotterdam, where will you stand? ... Ride on the side of the Lord Jesus. Guard the truth. Attain the martyr's crown." The owner of a copy of Sebastian Münster's *Cosmographia* obviously felt more negatively toward Erasmus. The defacing of the woodcut of Erasmus (the image is based on Holbein's 1523 painting – FIG. 87) is reminiscent of the way some pious souls in the Middle Ages had scratched out the eyes on representations of the Devil – only now the victim was a contemporary.

This proposal by Luther was single-mindedly and unflinchingly pursued. His despair at his own impotence before God led him not into ever-more-elaborate routines of monastic penitence but straight into the arms of a loving God, bypassing the whole apparatus of works and rituals that the Church had so carefully developed over the centuries. In opposition to the Church's insistence on the necessity of priestly ritual (and the canonical Seven Sacraments) in the process of salvation, Luther proposed the priesthood of all believers, and he declared that there were only two sacraments, the eucharist and baptism, in order to protect the faithful from further clerical abuse. The eucharist was also reinterpreted to be a mere remembrance (not a literal re-enactment) of Christ's crucifixion, and the baptism of infants became a way of indicating God's freely given grace to those who had a simple and innocent faith.

In 1520 Luther announced a new "Babylonian Captivity of the Church" in a treatise by that name. No longer was the papacy viewed as the victim of corrupt worldly powers, as supposedly had been true during its fourteenth-century exile in France. Now, for Luther, it was the Pope who had wrongly captured and enslaved the Christian Church and the true and perfect Word of God would triumph if it was only made directly accessible to the people. Therefore he translated first the New, and then the Old, Testament into his native German in 1521-22 and 1534, so that all would be able to judge for themselves. Thus the outbreak of the Reformation drew on many factors of religious life from the fifteenth century, among them anticlericalism, the value of personal faith and a growing literacy.

Art was immediately and repeatedly used as propaganda by all parties in the conflict. Prints in particular provided a popular forum for Reformation polemics. Visual art had played many and complex roles in the formation of fifteenth-century religious thought and action, and it continued to do so in the sixteenth. It could criticise past practices, suggest the need for change, or firmly outline a whole new doctrine. One of the most common jobs given to art was to critique behaviour, rather than doctrine. Complex theological issues required careful scrutiny and could lead to new, if somewhat picayune images. Easier to imagine and more appealing to a populace untrained in theological niceties were satirical images of individuals.

One of the most telling of these is a series of small woodcuts designed by the portraitist Hans Holbein in the mid-1520s. Perhaps because of their rather scathing treatment of the clergy, these images were not published until the following decade, in

the city of Lyons, in south central France. However, not only Protestants, the proponents of the Reformation, criticised clerical abuses: good Catholics, such as Holbein's friend the Dutch humanist scholar Desiderius Erasmus (1466-1536; FIG. 70), also criticised the Church, while remaining in it.

This set of prints was published in different editions aimed at both Catholics and Protestants. The series as a whole portrays the medieval conceit of the Dance of Death, the skeleton of Death coming to all, rich and poor, old and young, male and female, to make them join the dance that ends their life. Holbein combined such traditional death imagery with topical comments gauged to his own contemporary audience. Above all, to accomplish his end, Holbein portrayed the figure of Death not striking his victims directly but rather cleverly stealing the emblem of that person's worldly position – thus both revealing and ending the pretensions of his or her life on earth. For example, while a Cardinal sits amid spiralling grapevines (probably symbolic of the true vine of Christian teaching and/or the veritable blood of Christ's sacrifice), selling a signed and sealed bill of indulgence to a humble believer, Death removes the Cardinal's hat, symbol of his office (FIG. 71). As these are the indulgences that supposedly granted the believer release from purgatorial torment, in terms of contemporary criticism this cleric could not have been caught at a more awkward moment. As Martin Luther complained, the Church erected its great edifices by selling (false) hopes of salvation to an ignorant and unwary public; they also paid for the great Renaissance works of art. The true vine that should have been available, freely, to all was thus virtually the property of – to be sold, given, or withheld by – the powerful Church hierarchy. All this Holbein managed to suggest in a format just over two inches (6 cm) high. He was equally unsparing and clever when he turned his attention to the bishop, the abbot, the priest, and the nun in other scenes from this series.

Church abuses could be exposed, but in response the Church could present a strong facade opposing any inroads by rebellious heretics. Again this involved not the promulgation of complex doctrine but rather a depiction of the power and might of orthodoxy. The mid-century painting of the *Fall of the Rebel Angels* by Frans Floris (1519/20-70) is such a piece of Catholic propaganda (FIG. 72). Floris did not stoop to portraying specific Reformed leaders among those sent fleeing by St. Michael and

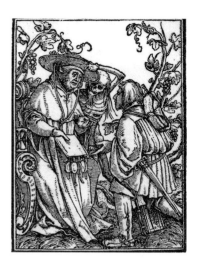

71. HANS HOLBEIN THE YOUNGER
The Cardinal from the *Dance of Death* series, designed c. 1523-26. Woodcut, 2¹/₂ x 1⁷/₈″ (6.3 x 4.8 cm). British Museum, London.

Another print in this series bears the initials HL, no doubt belonging to the master woodcutter Hans Lützelberger who did the actual carving of the blocks after Holbein's design. This was a common practice in woodcut printmaking at the time, although some artists, such as Albrecht Dürer, did insist on cutting their own blocks, at least at the beginning of their careers, when they were trying to establish their reputations.

72. FRANS FLORIS
Fall of the Rebel Angels,
1554. Panel, 9′ 11¼″ x
7′ 2⅝″ (3.03 x 2.20 m).
Koninklijk Museum voor
Schone Kunsten, Antwerp.

his virtuous cohorts. That sort of crude popular imagery was not
necessary in order to make what is, after all, a very simple point:
the Church defines orthodoxy, and heretical rebels will be dealt
with as summarily in life as they are in Michael's archetypal bat-
tle. In order to prepare his heroic image, Floris had travelled to
Rome to study the powerful High Renaissance artistic styles
current in the bosom of Catholicism. He emerged what today is
called a Romanist, taking inspiration from the physically impres-
sive imagery – the writhing, muscular bodies – of Michelangelo.

From one point of view, sixteenth-century artists were not
easily and freely able to respond artistically to issues raised by the
Reformation. For this was a revolution in which art was one of
the indicted parties. For some, the use and abuse of religious
imagery was a perfect example of wider problems, the Reforma-

tion in a nutshell. Art had been an integral part of the doctrine of good works that Protestant Reformers were determined to overhaul. According to the Catholic Church, a person could earn salvation not only by performing the canonical Seven Works of Mercy but also by doing other good deeds, such as supporting the Church financially and commissioning works of art to instruct and impress the faithful. Since patrons of art could commission paintings vaunting a piety, even visionary power, that they might not truly have had (see FIGS. 61 and 62, page 96), works of art could easily become pawns in a rather cynical – to the Reformers, at least – game of salvation. Once images were put in place within an ecclesiastical edifice, the problems were multiplied. Paintings and sculptures were virtually worshipped, even idolised. Some worshippers neglected to make a distinction between the holy person him- or herself and his or her representation in mere earthly materials. The representation did not just stand for something else: it became identical with the holy, taking on an aura and exhibiting the miraculous powers supposedly inherent only in the prototype.

Idolatry, the worship of images, was a perennial problem in medieval Christianity. From the beginning, many had questioned the need for images, fearing their persuasive power. The Church recognised the danger but also relished the great benefits that could accompany the use of images. The poor and illiterate might be taught the mysteries of the faith; and the glory of a divine, otherworldly realm might be at least hinted at, perhaps even predicted, by earthly, artistic beauty. There were many good reasons to try to harness the power of art for the purposes of the Christian religion. But popular imagination was not easily regulated, and the Church was not immune to pandering to it for monetary rewards. Indulgences were granted to those who visited some images, deemed particularly holy and effective, and pilgrimages to see those images were encouraged; local church leaders kept elaborate record books in order to convince growing masses of people to visit their relic or shrine and thus financially support their enterprise.

In the city of Regensburg in southern Germany great devotion developed to a supposed miracle-working image of the Virgin, a medieval Byzantine icon. This cult reached its apogee in the early decades of the sixteenth century, when local artists adorned the church and made woodcut reproductions of the holy image, as well as depictions of the whole shrine surrounded by hordes of fervent pilgrims. An indication of the fanaticism of these worshippers is provided by the fact that the

73. Michael Ostendorfer
Pilgrimage to the Church of the Beautiful Virgin of Regensburg, c. 1520. Woodcut, 25 x 15³/₈" (63.5 x 39.1 cm). Kunstsammlungen der Veste Coburg (with Albrecht Dürer's inscription at the bottom).

Regensburg church was built on the site of a Jewish synagogue that had been destroyed only a few months earlier, during an antisemitic campaign and systematic expulsion of Jews from Regensburg. Michael Ostendorfer's (c. 1490-1559) print (FIG. 73) was published in about 1520, shortly before the cult began to wither, as it was subject to mounting Reformed criticism. One particular impression pulled from Ostendorfer's block was owned by the great German printmaker (and early follower of Martin Luther) Albrecht Dürer. He inscribed it at the bottom: "1523. This spectre has arisen against the Holy Scripture in Regensburg and is permitted by the bishop because it is useful for now. God help us that we do not dishonour the worthy mother of Christ in this way but [honour] her in His name. Amen. AD [Dürer's initials]."

Although no doubt many contemporary artists would have joined Dürer in his outcry against such idolatry, they might not have been so critical of image-worshippers that they went to the opposite extreme and engaged in iconoclasm, the destruction of images (FIG. 74). Starting in the 1520s and erupting especially vociferously in the 1560s, there were instances of image-destruction by lay people throughout northern Europe, in Germany initially, then in the Netherlands, and, inspired by Calvinism, especially in Switzerland. There is only one documented case of an artist who turned so completely against his earlier profession, and that is the rather

74. Anonymous Artist
Iconoclasm in the Netherlands, c. 1583, from Baron Eytziner, *De Leone Belgico,* Cologne, 1583. Engraving approx. 10⁷/₈ x 7³/₈" (27.6 x 18.6 cm). British Museum, London.

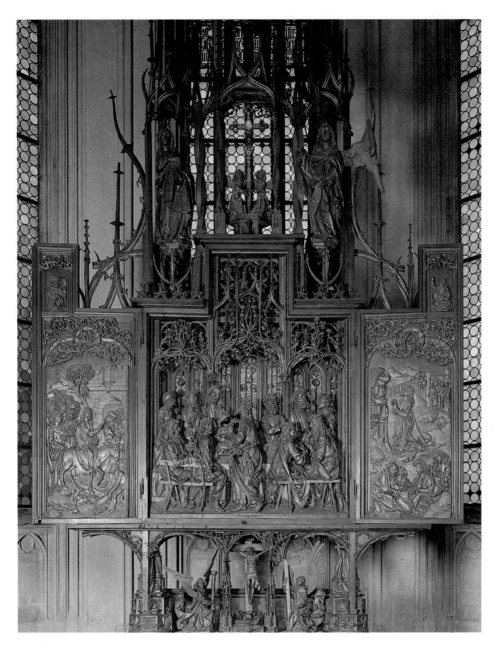

75. TILMAN RIEMENSCHNEIDER
Holy Blood Altarpiece, c. 1499-1505. Lindenwood, overall height approx. 29′ 6″ (9 m). Church of St. Jacob, Rothenburg, Germany.

Riemenschneider's altarpiece enshrines a relic of the Holy Blood, which is suspended in a crystal in the middle of a cross held by two angels directly above the *Last Supper scene*. Real but miniature bull's-eye leaded glass windows at the back of the shrine allow light coming in the chapel windows to play over the finely carved figures. The large central figure of Judas taking the sop from Christ can be removed, making the scene come to life even more.

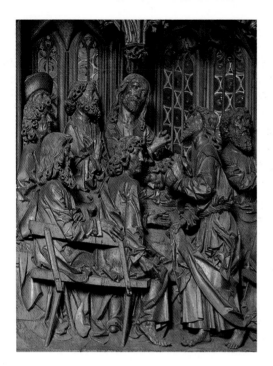

76. TILMAN RIEMENSCHNEIDER
Holy Blood Altarpiece,
c. 1499-1505, detail of *Last
Supper.* Lindenwood.
Church of St. Jacob,
Rothenburg, Germany.

wild and expressive Netherlandish painter Marinus van Reymerswaele (fl. 1521-52). Most artists, like Dürer, probably sought a middle way between the extremes of idolatry and iconoclasm. Dürer's position was that painting was like a weapon, a knife, that had to be used carefully. It could murder, but it could also preserve and enlighten. In the context of the Reformation, art could be an important tool for instruction. But artists had to think, they had to consider carefully both their medium and their message, both the style of presentation and the content or subject they were trying to communicate.

One of the most persistent criticisms levelled at religious art throughout the Middle Ages and into the time of the Reformation concerned its ostentation. Gaudy, carved, and gilded statues and multitiered, multicoloured panels showed off the artists' technical skills as much as their, or anyone's, piety. Already in the fifteenth century beautiful Virgin images similar to those of Lochner and van Eyck had been sharply criticised in Bohemia and southern Germany. For many observers, then, art needed to be reformed in the sense of purified, simplified, and focused on basic elements of form, structure, and narrative, rather than on distracting accessories, usually indicative of wealth and social prestige. This may be one reason why the German woodcarver Tilman Riemenschneider (c. 1460-1531) chose not to polychrome some of his altarpieces. Riemenschneider's altarpiece in a special pilgrimage chapel at the church of St. Jacob in Rothenburg-an-der-Tauber portrays various scenes from Christ's life in both relief and more fully three-dimensional sculpture (FIG. 75). Despite such typically late-medieval elements as its fantastic traceried framework, this work exhibits a new sobriety and restraint. Riemenschneider's carving was far cheaper than elaborately painted and gilded works by contemporaries. The simplicity and emotional honesty of his figures emphasised the instructive nature of the carved scenes, especially the central *Last Supper* (FIG. 76). This is an image to study and learn from rather than to kiss and adore. Perhaps this helps explain why the altarpiece was not destroyed or removed when the town adopted the Reformed faith in the 1520s.

Propaganda through Art

The primary artistic medium that expressed the sixteenth-century longing for non-idolatrous religious imagery was printmaking. Ostendorfer's image of the shrine of the Beautiful Virgin in Regensburg (see FIG. 73), for example, a piece of paper with a simple black linear design printed on it, was not something likely to be worshipped or adored. In Regensburg in the autumn of 1519, this may have served for some as a record of miraculous healings, but there is a new documentary, almost scientific quality (or claim) to the print that sets it apart from miracle-working images in the past. Prints were simple, cheap, and utilitarian illustrations; they conveyed information, along with the words they often accompanied. They were a perfect example of art as education for the masses.

In about 1510 the Dutch printmaking prodigy Lucas van Leyden (1489-1533), then probably in his early twenties, engraved an intriguing representation of the Baptism of Christ (FIG. 77). For the first time in his career, he arranged the compo-

77. LUCAS VAN LEYDEN
Baptism of Christ, c. 1510.
Engraving, 5⁹/₁₆ x 7³/₁₆" (14.2 x 18.2 cm). British Museum, London.

sition in a way that became something of a trademark in his later works. Lucas van Leyden "inverted" his composition, placing the traditionally prominent, main religious figures of Jesus and John in the background and populating the foreground with large, anonymous bystanders. This device makes the event – the baptism – seem incidental, part of a larger narrative or discussion. That this is not a presentation of doctrine so much as a conversation about its meaning and purpose is evident from a more careful analysis.

For example, in the engraving, there is no dove of the Holy Spirit, normally found in representations of the baptism in order to single out Christ and sanctify the Christian sacrament of baptism. Lucas van Leyden had obviously read the Gospel texts carefully, and since they do not mention the Spirit as descending upon Christ until later, he did not "mention" the Spirit. He was probably also attentive to contemporary discussion and questioning of the sacrament of baptism itself. Some Reformers believed that only adults were capable of appreciating the significance of such an act; others, like Luther promoted infant baptism. It may have been the artist's awareness of this growing controversy that caused him to portray, in the foreground, a child pointing to the baptism.

Visual imagery, printmaking in particular, could be a forum for discussion, especially in a time of flux and change, the years just before and at the start of the Protestant Reformation, when Lucas van Leyden's engraving of the baptism was done. He was not prescribing specific new ideas, so much as raising questions, through the inclusion of telling details and, above all, through challenging compositional developments. He analogously introduced a formal artistic innovation – compositional inversion – in order to attract the eye and mind of a potential buyer. In the Netherlands, around 1510, a sense of ambiguity and open-ended discussion in the image could be a positive selling-point on the open market. If Lucas van Leyden had been more doctrinaire (showing babies being baptised, for instance), this audience might have been more limited. For this printmaker, a narrative style stressing meditation on a current controversy might have been a marketing ploy.

As time went by, it was increasingly difficult not to take a stand. Although Martin Luther had formerly equivocated to some extent, in 1523 he firmly declared that the laity should take Communion in both kinds, bread and wine; they should especially be allowed to drink from the cup. Most important from a doctrinal point of view, the sacrament was now deemed com-

memorative, not miraculous. In taking Communion, the faithful remembered Christ's sacrifice; they did not repeat it. Albrecht Dürer alluded to all these issues in his *Last Supper* woodcut of 1523 (FIG. 78). Although he had been planning a new series of oblong Passion woodcuts for several years, only the *Last Supper* reached the printed page, and this was no doubt due to his desire to clarify his, and his contemporaries', thinking on this important issue. He took a time-honoured subject and gave it new focus and meaning.

In the lower right corner of the woodcut, Dürer showed both elements in the sacrament, loaves of bread and a pitcher of wine. On the table sits a single liturgical-looking chalice, from which Reformed Christians hoped to drink. In front of the table, on the floor, lies an empty metal tray. A viewer who knew either Dürer's own earlier portrayals of the Last Supper or typical examples by his contemporaries would understand this as a reference to the commemorative nature of this gathering. Usually such a charger had upon it the carcass of a slaughtered lamb, a reminder that for Catholics the Last Supper was the repetitive sacrifice of the Lamb of God. For Dürer and other Protestants, such literal slaughter was replaced by commemoration alone.

78. ALBRECHT DÜRER
Last Supper, 1523.
Woodcut, 8³/₈ x 11¹³/₁₆"
(21.3 x 30 cm). British Museum, London.

Dürer's technique here is extremely reduced and sophisticated. Although he clearly wanted to portray the scene in an elemental, stripped-down style, he has often subtly enlivened his clean, flat surfaces with small diagonal strokes.

One of Luther's main goals was to put the Word of God, the Bible, into the hands of the laity. Everyone should read and meditate on the Word. In order to produce his Baptism engraving, Lucas van Leyden, a forerunner of the Reformation in this regard, had done that. Dürer made similar implicit links between Biblical text and contemporary events, as when he chose to represent the moment at which the meal and the betrayal by Judas have passed (only eleven disciples are shown), and Christ institutes a new, evangelical community, governed by love, brotherhood, and discipleship (John 13:34), as the followers of Luther were attempting to do at that moment.

Dürer's woodcut *Last Supper* responded to the Reformation not only in terms of the particular details of its subject but in its overall style and technical prowess. In this way, it is analogous to Riemenschneider's slightly earlier carving. Dürer reduced his scene to the minimum. In a technique in which he had earlier emphasised contrasts of brilliantly lit and darkly shadowed areas, in which luxurious details had been previously piled freely on top of each other, Dürer now stripped the altar bare. Cool, clean angles, large, moving figures and expressive faces lay out the meaning of the scene in straightforward, unequivocal terms. Dürer's response to the first iconoclastic riots, like Riemenschneider's in his earlier carving, was to present his art with a renewed sense of human honesty, dignity, and craft. Dürer's image is about art and aesthetics, as well as theological reform. He intended to use his formidable artistic powers to present religious truth in a newly refined and austere simple style.

A third kind of propaganda image has often been said to represent the drying-up of artistic inspiration, the decline of art as a result of the Reformation. These are diagrams of religious beliefs, fulfilling a need to produce new and explicit didactic art. The claim is often made that, the more petty external demands are placed upon an artist, the less room there will be for personal creativity or, in general, aesthetic decisions. Stated this simply, there may seem to be little room for disagreement, yet the use of extremely didactic imagery in the sixteenth century is more interesting and complex than such a negative judgment would imply. Didactic prints were used routinely by all parties in the Reformation controversy. They show the near-universal agreement at that time that visual imagery was a powerful and useful means of communication. Far from seeking to cause a decline in art (and aesthetic values), didacticism often stemmed from the opposite perception. It is true that, at times, propagandistic art could be both crude and all-too-literal in its imagery; still, the underlying

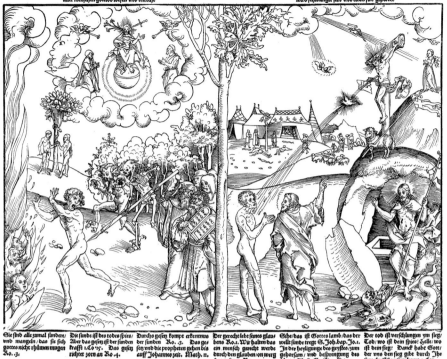

79. Lucas Cranach the Elder
Allegory of Law and Grace, c. 1530. Woodcut, 10⅝ x 12¾″ (27 x 32.5 cm). British Museum, London.

Cranach used elaborate inscriptions drawn primarily from the writings of Luther's hero, St. Paul, to explain the Protestant belief in justification by faith not works. This composition was often repeated or adapted in Cranach's workshop over the next two generations.

motivation, to capture a contemporary controversy in epigrammatic visual form, was a compelling one because it was based on the power of the image to move even ignorant or rigid minds.

The work of the early-sixteenth-century German artist Lucas Cranach (1472-1553) presents a prime example of visual didacticism in art. He has been called "the official artist of the Lutheran Reformation." Over the course of Luther's life, Cranach repeatedly painted his likeness and executed engravings and woodcuts portraying him, from his early years as a religious leader, through his marriage to his deathbed. Artist and theologian were close friends; each served as godparent to one of the other's children. In designing an image such as the *Allegory of Law and Grace* (FIG. 79), Cranach obviously received Luther's approval, if not in fact his close guidance. Cranach's image, divided neatly by a half-living, half-dead tree, presents some of the central tenets of the developing Lutheran cause, in essence the difference between (Catholic) reliance on good works and (Protestant) reliance on grace or faith. On the left the poor human sinner, subject to Adam and Eve's fall (Original Sin), is told to conform to the Law (represented by Moses' tablets), but at the time of the Last Judgment (in the sky) he is found want-

ing and thus consigned by Death and the Devil to the flames of Hell. This sense of inevitable damnation, man's inability truly to merit salvation by works, is contrasted with the Reformed emphasis on faith alone. At the right of the picture, Christ's blood is freely shed, and he easily rises from the tomb, trampling Death and the Devil, promising salvation to those who believe in him. In the background, in addition to a small scene of the angelic annunciation of Christ's birth to the shepherds, Cranach introduced the Old Testament episode of the Brazen Serpent, raised up on a cross in the desert by the Israelites, an unusual depiction cleverly reinforcing the message of Christ's Crucifixion. When the Israelites were being menaced by large snakes, God told them to raise a snake on a cross and to believe that that image would save them – and it did. Just so, it may seem contradictory to seek salvation from a naked, bleeding man on a cross, but such is the nature of God's promise.

Cranach's woodcut also contains a series of carefully chosen Biblical passages above and below that reinforce its message. Adroitly weaving together eleven different figural groups or scenes, Cranach's work clearly functions as a kind of symbolic puzzle, illustrating a typical and time-honoured northern obsession with intricate symbolism or meaning, made evident through a fragmented compositional design.

The Transformation of Religious Imagery

If the implications of Cranach's and Luther's thinking here are pursued, the value of religious art would be diminished; that is, in particular, its value as part of a scheme of good works. In addition, the rich variety of functions that a fifteenth-century devotional image could have served – as social and economic statement, personal pretension, religious indulgence – would be drastically curtailed. What is left is a simple outline, literally and figuratively, of earlier tolerance and permissiveness. For Protestants especially, the complex forces that had previously shaped religious art had to go elsewhere, into other kinds of artistic endeavour. In this sense it is legitimate to speak of the secularisation of artistic inspiration in the later sixteenth century.

Religious imagery of the fifteenth century was characterised by a promiscuous intermingling of what might today be labelled as, on the one hand, sacred and, on the other hand, profane spheres. Politics, religion, and sensuous pleasure were freely mixed; economic status, social class distinction, and personal family history also found their place in religious life and its artis-

tic representation. The sixteenth century increasingly witnessed a separation of such concerns into distinct aspects of life and corresponding types of artistic creation. Rather than existing as integrated details of larger religious works, still-life paintings were segregated, appealing to traders and merchants. Likewise, landscapes became a distinct category of art, drawing on people's experience of travel, exploration, or land ownership. Portraits of contemporaries, always popular, increasingly displaced portrayals of time-honoured saints and heroes.

In some ways, this seems a logical, progressive development. Once an artist such as Robert Campin had portrayed the Virgin and Child in a humble bourgeois setting in the fifteenth century (see FIG. 32, page 51), there was little to stop later artists from eliminating even the hints of symbolism and emphasising exclusively the human traits of Virgin and Child: Mary as nurturing mother, Jesus as a fumbling baby. Faced with a painting such as Gerard David's *Virgin and Child with a Bowl of Porridge* (FIG. 80),

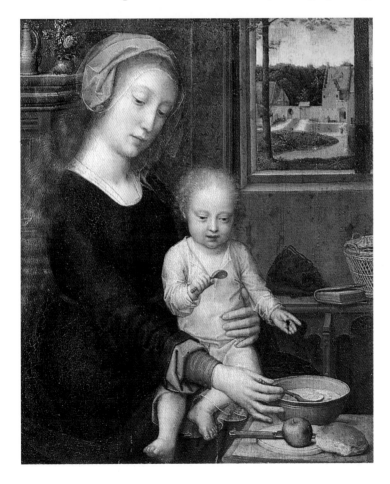

80. GERARD DAVID
Virgin and Child with a Bowl of Porridge, c. 1520. Panel, 13³/₄ x 11³/₈" (35 x 29 cm). Musées Royaux des Beaux Arts de Belgique, Brussels.

81. Hans Baldung Grien
Witches' Sabbath, 1510.
Chiaroscuro woodcut with
orange tone block, 14^{15}/$_{16}$ x
10^1/$_4$" (37.9 x 26 cm).
British Museum, London.

Baldung used a graphic
style much more primitive
and forceful than that of his
teacher, Albrecht Dürer (see
FIGS. 78 and 120). He did,
however, adapt several of
Dürer's devices, such as the
plaque with his initials
hanging from a tree branch.
The date 1510 appears as
though it were carved into
the trunk of the tree below
the plaque. These witches
are performing a black mass
as they raise a lizard, rather
than a wafer, at the moment
of consecration. Their
supposed sexual
perversions are indicated by
riding backward on a goat
(the devil).

one might well wonder if there is anything absolutely or neces-
sarily holy present. Within another hundred years, in the
Netherlands, such images were accepted for what they were,
portraits of a contemporary mother and her child. David's image
is so accessible, so secular, that it might not have been, inten-
tionally, holy – in the sense of otherworldly – at all. This is a
painting of the Virgin as a model for human behaviour, not as
the miraculous intercessor to whom one prayed when in need.
David's image is thus also protected from possibility of idolatry
or image worship.

When, in the sixteenth century, someone ceased to invoke
the Virgin Mary or the saints for help with natural disasters,

storms, and the plague, his or her feelings of fear and wonder did not vanish; everything was not suddenly neat, discrete, and controlled. The European witch craze of the sixteenth and seventeenth centuries is, in part, a demonstration of that. Unresolved questions about the overwhelming power of nature could, in this way, mingle with fears of the power of women; and these obsessions were not limited to the uneducated or lower classes of society.

Hans Baldung Grien, perhaps the most compelling artist of witchcraft subjects in sixteenth-century Germany, came from an academic family, most of whom converted to the Reformed faith. From early in his life, before the outbreak of the Reformation, until his last years, Baldung (the nickname "Grien" probably refers to his love of the colour green) lavished attention on the threatening and occult power of witches. Early in his career, he took the finely wrought woodcut medium that he had studied under Albrecht Dürer and romanticised it. By about 1510, both he and Lucas Cranach had begun to use not just one linear block printed in black ink on white paper but, in addition, a coloured or tone block printed first, creating what is now called a chiaroscuro woodcut. Baldung's chiaroscuro woodcut of a *Witches' Sabbath* (FIG. 81) erupts in a fury of fire and brimstone. Witches with broomsticks cavort, riding backwards on goats (the devil) and perform mock communions, while secretive cats lurk beside them.

Some of Baldung's images of witches are almost comic, a little sly and ironic. Even the *Witches' Sabbath* woodcut is hardly meant simply to terrify its audience; there is an element of playful titillation here as well. Issues of sexual power were being treated more openly in sixteenth-century religious imagery. The nude human figure was a recurrent part of Christian art, whether as adult Adam and Eve, Christ and selected saints (such as Sebastian), or as innocent child. In the sixteenth century, the relation of sexuality and religion was made both more forceful and more cunning. In some of Baldung's works, Adam and Eve make overt sexual advances toward each other. In Baldung's images of witches a disturbing relation between sex and the supernatural is further accentuated. Here sexuality and spirituality remain vital critics of, but also magnets for, each other. In some ways then, the reformers' attempts to isolate religious belief from daily human contamination – from the accumulation of good or evil deeds, from the specifics of human sinfulness – only increased people's obsession with the issue: personal fears often replaced institutional abuse.

ETATIS SVÆ·21

FOUR

Artistic Specialities and Social Developments

82. HANS HOLBEIN
*Portrait of a Lady, Probably
a Member of the Cromwell
Family*, c. 1535-40. Panel,
28³/₈ x 19¹/₂″ (72 x 49.5 cm).
The Toledo Museum of Art,
Ohio.

The woman wears a brooch
designed by Holbein
portraying Lot and his
daughters fleeing Sodom.
To the left of a central gem
is Lot's wife who was turned
into a pillar of salt because
she disobeyed God and
looked back to Sodom. Lot's
daughters subsequently
seduced him so that they
could bear children and
continue their race. Women
are thus viewed as
disobedient or temptresses.

M ost of the art produced in northern Europe in the fif-
teenth century was religious in origin and function.
This religious imagery satisfied the needs of an increas-
ingly prosperous and independent lay population and as such
was not always narrow or completely official in its presentation
of a Christian message. The inclusion of donors and of objects or
ideas of particular interest to them often gives the art a unique
flavour. Yet there was a great degree of religious homogeneity
and purpose here that was radically transformed in the sixteenth
century. "Secular satisfactions" are seen as coming to the fore;
portraits, landscapes, still-lifes, and genre or peasant imagery
emerged as newly important and independent artistic endeav-
ours. There is certainly some justification for the view that six-
teenth-century northern European art increasingly focused on
issues and ideas that had their origin and purpose outside the
confines of the Church – in the daily, worldly existence of con-
temporaries, in their intellectual life, and in their study and dis-
covery of the world through exploration and commerce.

To what extent do the developments of the sixteenth cen-
tury, in both art and culture, represent fundamental shifts in cus-
tom or perception? Is it possible that the art of the sixteenth cen-
tury represents only a subtle shifting and realignment of features
already present in the preceding era? A case can be made for
both points of view.

The impact of the Reformation, the extent to which the Reformation could be held responsible for a secularisation of art is perhaps most noticeable in Protestant wariness of the worship of images and widespread banning of them from Reformed churches. Although it might seem logical to invoke this dramatic religious conflict as at least an indirect cause of artistic change, leading to a greater focus on secular imagery as opposed to the suspect holy images, the situation was not quite so simple. While Protestant leaders criticised past abuses, they did not often recommend new forms of art to take the place of old, discredited ones. Artists and patrons were left to seek these out for themselves. Catholic artists also equally explored so-called secular imagery, which was, in turn, given a range of provocative, sometimes religious meanings by Catholics and Protestants alike. Thus, the sixteenth-century development or expansion of secular artistic specialities (for example portrait, landscape, and still-life) was as much a general cultural phenomenon as it was a response to Protestant criticism of the earlier misuse of religious imagery. Sixteenth-century images reflect a complex mingling of past traditions and new beginnings.

Portrait Imagery

Portraits of living people had served several important functions throughout the fifteenth century. At the beginning of the century, they were the chief, in fact sometimes the only, kind of panel painting commissioned by the nobility. Aristocrats wanted to be remembered and to become a documented part of their family's history. Portraits of long-deceased family members were also commissioned, to be displayed in galleries with portrayals of the living, in order to establish legitimacy and bolster prestige.

Portraits could be treated physically as they are today, being hung on walls, in a permanent setting. Many, however, were meant to be more portable memory images, allowing, or even encouraging, the viewer to take the painted likeness from room to room, or dwelling to dwelling, thus accommodating those wealthy enough to own, and live in, several homes. Portraits were often enclosed in painted boxes, with lids to protect the image during travel. Since portrait panels were not meant to be fixed to a wall permanently, they were often painted on both sides. The back of the portrait provided a convenient field for the noble person's armorial device, motto, name, and coat-of-arms. A striking example of this practice is found in Roger van der Weyden's portrait of the Italian nobleman Francesco d'Este

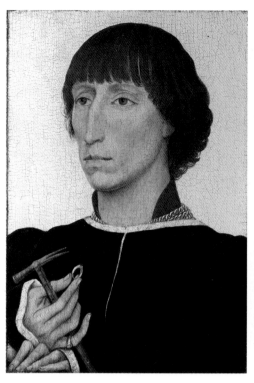

(FIGS. 83 and 84), an illegitimate son of Lionello d'Este, Marquis of Ferrara; Francesco spent much of his childhood and adult life at the Burgundian court.

Roger van der Weyden presented Francesco d'Este dressed in the height of courtly fashion, complete with the noble attributes of a hammer (an emblem of power associated with courtly tournaments) and a ring (perhaps a tournament prize). The perfect positioning of the hands, including the raised little finger, the fashionable hair, slightly weary eyes, and all-too-long, sinuous nose seem to capture both a man and an ideal, virtually a heraldic distortion and flattening of the image, making Francesco d'Este the human equivalent of the coat-of-arms that graces the panel's reverse. Here lynxes (punning references to his father's name, Lionello) support Francesco d'Este's coat-of-arms with his motto above, *"voir tout"* (to see all) and his name below, "Francisque," both written in French, the language of the Burgundian court. To either side of a blind-folded lynx (an ironic comment on his motto?), perched atop the coat-of-arms, are the letters m and e, standing for *marchio estensis* (marquis of Este). This is a world so perfectly stylised and presented that the tasselled cords that bind the m and e together resemble Francesco

Left 83. ROGER VAN DER WEYDEN
Portrait of Francesco d'Este, c. 1460. Panel, recto, painted surface 11³/₄ x 8″ (29.8 x 20.3 cm). The Metropolitan Museum of Art, New York.

Right 84. ROGER VAN DER WEYDEN
Portrait of Francesco d'Este (reverse: coat of arms of Francesco), c. 1460. Panel, 12¹/₂ x 8³/₄″ (31.8 x 22.2 cm). The Metropolitan Museum of Art, New York.

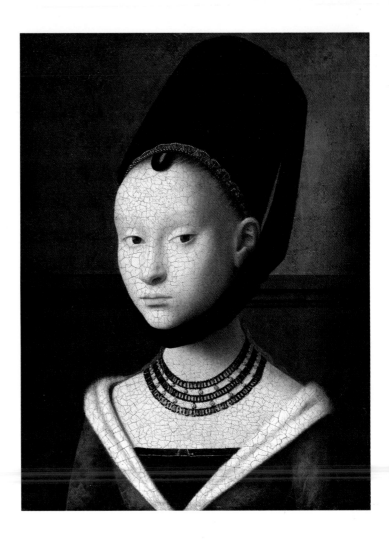

85. PETRUS CHRISTUS
Portrait of a Lady, c. 1470.
Panel, 11³/₈ x 8⁷/₈" (29 x
22.5 cm). Staatliche
Museen zu Berlin,
Preussischer Kulturbesitz,
Gemäldegalerie.

d'Este's locks of hair perfectly silhouetted against the portrait's unusual light ground.

The rather languid glance of Francesco, as well as the portrait's anonymous backdrop, are dramatically altered in the *Portrait of a Lady* (FIG. 85) by the Bruges artist Petrus Christus (c. 1410-1472/3). Christus's sitter has a slightly petulant mouth and a studied but sidelong gaze. Perfectly balanced eyes, nose, and mouth are rarely, if ever, found in nature, and Christus has not shied away from representing this particular woman's skewed eyelids and projecting brow. He has also taken pains to locate her physically, providing an illuminated rear wall complete with a wooden wainscoting. However haunting, this sitter is remarkably down-to-earth, especially in comparison to Francesco d'Este's well-bred aloofness. This should not be

understood as a chronological development moving, as the century went on, toward a portrait style more bourgeois, less timeless and remote. Both options seem to have been available from early in the fifteenth century and were favoured by different artists or patrons for their own, no doubt personal reasons.

Roger van der Weyden's portrait of Francesco d'Este might, with some license, be called an occupational portrait, the occupation being, in this case, the sitter's maintenance of his status among the nobility. Other fifteenth-century sitters, not of the nobility and still trying to succeed in their calling, used such portraits to propound their refinement, trustworthiness, or piety. Such is the case with Giovanni Arnolfini and Giovanna Cenami, who would probably have liked to have been thought to embody all these traits (see FIG. 3, page 12). Clearly, according to their portrait image, they were concerned about their worldly status. The fruit of kings, costly imported oranges, are found on windowsill and chest, and at their bedside rests a costly Anatolian rug. This is also certainly an image with genealogical significance: the Arnolfini and Cenami families were both from the Italian city of Lucca and were among the most important and successful Italian traders in the North, so a marital union between these two powerful lines was something to be commemorated and celebrated in art. This couple needed to produce children, causing the woman to be depicted as though pregnant and standing before a brilliant red bed. If the portrait was meant to act as a kind of fertility device, predicting or stimulating the birth of a child, it failed: the couple died childless. There is a hushed solemnity to the scene, perhaps signifying the Arnolfinis' piety. The mirror on the back wall has ten scenes from Christ's Passion painted on small medallions in its frame, and a beautiful set of crystal prayerbeads hangs on the wall just to the left of it. Whether these and other details in the painting add up to a conscious and thorough-going program of religious meaning will probably always remain a matter of conjecture. The documented lives of the couple indicate religious acts and concerns that were typical of many of their contemporaries, not unusually intense and constantly juxtaposed with worldly aims and ambitions.

Jan van Eyck's *Arnolfini Double Portrait* tells a particularly rich and intriguing story about the lives and interests of a pair of social climbing Italian émigrés, resident for almost all their lives in northern Europe. This may be an extreme example, but other portraits from the time might well be considered in an analogous light, as narratives not just commemoratives. Roger van der Weyden's portrait of Francesco d'Este (see FIG. 83) is simpler but,

in some ways, equally propagandistic, although, unlike some fifteenth-century northern portraits, it did not claim religious status for its sitter by its inclusion in a larger religious image. When Etienne Chevalier (see FIGS. 61 and 62, page 96), Tommaso Portinari (see FIG. 34, page 56), and Mary, Duchess of Burgundy (see FIG. 58, page 90) had themselves painted into a religious image, they were claiming ownership of the picture – or, to put it more politely, claiming to have both the ability and the desire to pay for such an image. Thus Chevalier had his name carved into his image, repeatedly. These patrons also wanted to say something positive about their ownership of faith, even their religious visionary powers, being portrayed among saints who were painted with almost the same portrait-like power given their own, still-living countenances. Patrons' portraits in religious images were complex negotiating devices, referring to both worldly and otherworldly status on many levels.

Gestures, body positions, and facial expressions were all overwhelmingly stereotyped and limited in fifteenth-century northern European portraiture. This is true in general terms; it is also true for the sub-sets or categories of portraiture, male versus female, for instance. Men were invariably given more dominating glances, gestures, and positions. In a triptych or other similar format, men are found at the place of honour, on the holy figures' own right (the dexter or good side), which for the viewer of the painting is to the left of centre. When accompanied by men, women are confined to the holy figures' left (*sinister* or bad side). A woman's hands, and at times even her whole body, are lower, subservient to the male. In the sixteenth century, most double portraits continued to subordinate wives to their husbands. This corresponds to the fact that over the course of the Renaissance women were, by and large, increasingly subject to fathers or husbands, limited economically, socially, and intellectually. Only in their occasional charismatic religious roles did they gain much independence or self-expression (see FIG. 58, page 90).

Among the changes effected by the Reformation, saints were almost universally excluded from Protestant art. Rather than venerating religious figures from the past, Protestants were encouraged to admire and emulate the leaders of their own day. This began in the late teens and early 1520s with a remarkable series of portraits by several artists of Martin Luther, sometimes even directly alluding to the Reformer's holy powers by portraying him as inspired by the dove of the Holy Spirit. When Albrecht Dürer decided to portray one of Luther's most intellectually accomplished followers, Philipp Melanchthon, he did not

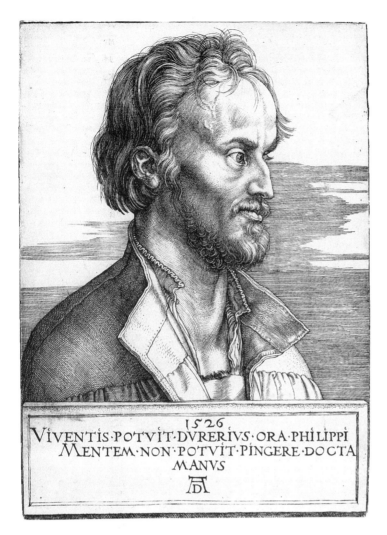

86. ALBRECHT DÜRER
Philipp Melanchthon, 1526.
Engraving, 6⅞ x 5¹/₁₆" (17.5
x 12.8 cm). British Museum,
London.

The inscription below the
portrait can be translated as:
"Dürer was able to depict
Philip's features as if living,
but the practised hand
could not portray his soul."

resort to such obvious tactics. His 1526 engraved portrait of
Melanchthon emphasises the man's abilities not through super-
natural radiance or emblem but by physiognomic insight and
concentration (FIG. 86). Poised against the sky, Melanchthon's
brow is slightly furrowed, the protruding veins of his temple
indicating his sense of purpose. In this Reformer's bulging eye,
a window is reflected, a device found in several of Dürer's por-
traits, probably alluding to light, insight, and the notion of the
eye as the window of the soul. The commemorative nature of
Dürer's Melanchthon portrait is indicated by the inscribed tablet
at the bottom, a device derived from Roman funerary sculpture,
signifying that, through Dürer's published and thus widely cir-
culated image, Melanchthon overcomes death and gains artistic
immortality.

87. HANS HOLBEIN
Portrait of Erasmus Writing,
1523. Panel, 16½ x 12⅝"
(42 x 32 cm). Louvre, Paris.

Dürer's engraving also conveys a message of timelessness in the position of the sitter, arranged in almost pure profile, like an ancient or Renaissance medal (see FIG. 90). In that sense, Dürer was, like Roger van der Weyden before him, representing an ideal (intellectual not courtly), as much as an individual man. In some ways, however, the sixteenth century gave evidence of a greater interest in the non-ideal, casual or immediate aspect of portraiture. This corresponds to the general development at that time of a more incidental and accessible kind of realism. By contrast, in the fifteenth century Dirc Bouts' silverpoint drawing of a man (see FIG. 43, page 71) almost certainly served as a general, stereotypical model for a number of men's portraits by this artist. It is not an individual portrait so much as a modelbook type, to be used and adapted repeatedly. In the sixteenth cen-

tury, Hans Holbein's use of what was usually a timeless profile view could address a scholar's personal idiosyncracies in a remarkably telling and sensitive way.

Born in the south German city of Augsburg at the very end of the fifteenth century, Hans Holbein the Younger was trained by his father, who was a quite competent but traditional religious painter. When the son moved to Basel, he soon found that, as Erasmus declared on his behalf, the arts were freezing there. Basel was, in fact, the scene of some of the worst iconoclastic riots in the mid-to-late 1520s. With a letter of recommendation from Erasmus, Holbein went to England, where he could practice his art unhindered by religious controversy. His early religious paintings gave way to a specialisation in portraits, especially during the last eleven years of his life (1532-43). Before Holbein left the Continent the first time he painted a portrait of Erasmus, viewed from the side (almost from behind, in fact), standing at his desk writing (FIG. 87). We are allowed to peer over the scholar's shoulders, an intimate prospect which would have been granted to only his closest friends. The image also cleverly preserved the essentially private nature of Erasmus' personality, his shying away from public demonstration and show.

88. HANS HOLBEIN
Studies of the Hands of Erasmus, c. 1523.
Silverpoint and chalk, 8⅛ x 6⅛″ (20.6 x 15.5 cm).
Louvre, Paris.

Erasmus is writing. But this is not meant as a timeless indication of his scholarship. The words he is writing are now rubbed and abraded in the original painting, but an early copy shows that he is painted at work on his Paraphrase of the Gospel of St. Mark, a task completed in Basel in 1523. Holbein has thus chosen to locate the portrait in a particular time and place. His sensitive chalk study of Erasmus' hands (FIG. 88) reinforces this point. We are now far away from either a literal modelbook study (see FIG. 42, page 70) or Bouts' modelbook-like drawing (see FIG. 43, page 71). Holbein's portrait and preparatory drawing are not types but particular views of a particular person whose sense of control and restraint must be shown to extend to the tips of his fingers, and to the tip of the pen which carefully moves across the page. Holbein's use of drawing here supports the immediacy and specificity of the portrait image.

A *Portrait of a Man with Glasses* by Quinten Massys (c. 1466-1530) presents this new sixteenth-century development in even more dramatic terms (FIG. 89). It is also an interesting com-

89. QUINTEN MASSYS
Portrait of a Man with Glasses, c. 1515. Panel, 27¹/₈ x 20⁷/₈" (69 x 53 cm). Städelsches Kunstinstitut, Frankfurt.

Although it does not seem to be evident here, in other works Massys, who was primarily a figure painter, openly collaborated with other specialists, such as Joachim Patinir, the landscape painter, who would paint the landscape backgrounds behind the other's large foreground figures. Such specialisation was increasingly common in the sixteenth century.

bination of old and new elements. The sitter is posed before an arcade giving onto an expansive landscape. Such a feature was found in Netherlandish painting from early throughout the fifteenth century. In the later part of the century it became a standard accessory for portraits. Massys also alluded to Eyckian tradition by having the man's eyeglasses held over a page of his book, thus portraying, in a virtuoso manner, various subtle transitory effects of light and optical distortion. But nowhere in the fifteenth century is there a prototype for the sitter's momentary gesture and odd, slightly peeved expression. The privacy of this individual's world, so carefully developed and protected by fifteenth-century artists, has been irrevocably invaded. Sixteenth-century painters might try to reassert the timeless, immemorial quality of the portrait in various cases and for various, sometimes very timely, reasons, but Massys' image stands as a clever and decisive break with the past. This is not only someone identified by dress, surroundings, and physical stature as a Renaissance man; this individual is alert and sensitive to the immediacy of his surroundings. This is Renaissance self-fashioning in direct response to external pressure and demand, in particular to the imagined approach of the viewer of the image.

Hans Holbein's *Portrait of a Lady* of c. 1535-40 (see FIG. 82, page 122) presents us with a portrait image both more timeless and more stylised. At one time it was thought to portray Catherine Howard, the ill-fated fifth wife of Henry VIII, King of England; the history of its ownership suggests rather that it represents a member of the Cromwell family. A finely crafted set of Roman letters, left and right of her head, reveal that she was twenty-one years old when Holbein painted her in the late 1530s. It is unclear if those letters are on the back wall of the room in which the subject stands or on the painting's surface. Portrait medallions were no doubt Holbein's source for such a design. Originating in ancient times and revived in the Renaissance, first in Italy in the fifteenth century and then in the North in the sixteenth, these medallions invariably displayed inscriptions relating information about the sitter (FIGS. 90 and 91), such as name and age, with a motto and the year in which the medal was made, and perhaps a longer phrase or sentence lauding the

sitter's accomplishments or status. These letters could run around the rim of the medal but, more importantly for Holbein's purposes, they could float on either side of the head of the sitter, acting like pincers, locking the individual into place. On the back of the medal was a design referring to some favourite idea or device of the sitter's. In the case of a medal of Erasmus of Rotterdam by Quinten Massys, the reverse shows the god Terminus, the scholar's personal emblem, indicating his obsession with pondering the end of his life, as both defining and limiting his achievement.

In a portrait such as that of *Portrait of a Lady*, Holbein managed to draw extensively upon this rich medallion tradition and at the same time incorporate significant elements of earlier painting traditions. During his English years, Holbein increasingly tempered the immediacy and expressive quality of his early work. His new sense of style and refinement was filtered through an experience and great love of Netherlandish art. Holbein met and stayed with Quinten Massys in Antwerp, and as Massys was studying and refining the Eyckian, early Netherlandish tradition, so did Holbein. The German did this with even more dedication and sense of stylistic manipulation than his Flemish contemporary. Holbein's is an art, like van Eyck's, of astonishing verisimilitude, minute, realistic detail piled on detail. Each stitch on the lady's cuffs, each tuck and decorative detail on her headdress, each hair in her eyebrows has been painted with exacting care. It is little wonder that contemporaries felt that Holbein's portraits made the absent person present.

Yet Holbein's art is, again like van Eyck's before him, a highly contrived and selectively staged, courtly realism. The gold leaf, that so mischievously insists on floating on the panel's surface is also used for the lady's jewellery; it is therefore both literally precious and somewhat unreal, detaching itself from the otherwise compelling illusion of satin and flesh. From preparatory drawings and sketches it is known that, during the later years of his activity in England (1532-43), Holbein often paid as much attention to details of costume and jewellery as to the sitter's face. He would make elaborate notations about colour and composition, sometimes even designing the jewellery himself. A separate

90. QUINTEN MASSYS
Portrait Medal of Erasmus, 1519. Recto, diameter approx. 4″ (10 cm). British Museum, London.

To either side of Erasmus' head are the letters .ER. and .ROT. for Erasmus of Rotterdam. Around the outside is an inscription in Greek and Latin, which can be translated: "The better image will his writings show; a portrait from life." Massys' medal is one of the most ideal and appealing portraits of Erasmus executed during his life, and the scholar gave casts of it to several friends.

91. QUINTEN MASSYS
Portrait Medal of Erasmus, 1519. Verso, diameter approx. 4″ (10 cm). British Museum, London.

A bust of the god Terminus is flanked by the words "CONCEDO NULLI" (I Yield to None). Around the circumference runs a combination of Latin and Greek phrases meaning "Death is the Ultimate Boundary of Things" and "Contemplate the End of a Long Life."

drawing by Holbein exists for the brooch worn by the woman in this portrait. For the English court, Holbein acted as a designer-in-residence, making drawings for everything from bookbindings to horse trappings. The *Portrait of a Lady* is a good example of the way in which Holbein managed to play the realism of the portrayal against the stylisation of the design. There is a tension here between the artist who almost erased himself from his work, using what at first glance might seem to be a naive photorealism, and the artist who wilfully controlled and composed, asserting on the two-dimensional plane of the work the power and skill of his craft. Whether this aspect of his art also represents a response – by deliberate avoidance of dramatic expression – to the religious turmoil of his times is a question that has intrigued modern observers. The artfulness of Holbein's late portraits bears interesting analogies to that we will find in contemporary landscapes, still-lifes, and genre scenes.

Landscape Imagery

Landscape imagery was a staple part of fifteenth-century northern art. It was very much manipulated throughout the century, and there was no such thing as an independent landscape painting. The main way landscape was used at the time corresponds to the period's "modelbook mentality": landscape was segmented or parcelled out into neat vignettes. In fifteenth-century painting, landscapes are often viewed through arcades or windows. The viewer, warm and cosy inside, is beckoned out but the view is restricted and clearly needs to be carefully controlled. This was a northern European phenomenon, contrasting with the brilliant, open, sunlit-piazza effect often conveyed by Italian art (see FIG. 19, page 32). Italian artists did not often see as far or with such precision as the northerners, but the transition between interior and exterior in their works was more easily made. The climate of different parts of Europe, the amounts of sunlight and warmth available throughout the year, had a direct impact on landscape imagery. The outside was just like another room to the Italians; it was different, intriguing but also challenging, to the northerner. Even sixteenth-century northern artists continued to be fascinated by window and arcade vignettes (see FIGS. 80 and 89); by the early sixteenth century such views function almost as trademarks of a northern style.

Hans Memling's (1435/40-94) painting of *Scenes from the Life of the Virgin and Christ* (FIG. 92) shows us another way that fifteenth century masters cleverly segmented their view of the nat-

ural world in order to stress narrative purpose. Memling has included no fewer than twenty-five scenes, stretching from the annunciation of Christ's birth to the Virgin (upper left) to her death and assumption (upper right), all set out in a panoramic landscape. Memling's painting draws inspiration from the fact that Passion plays were sometimes staged at different sites throughout a northern city. The image also seems reminiscent of a practice advocated by some followers of the Modern Devotion that the faithful make a mental pilgrimage to the Holy Land retracing in their minds the Virgin's and Christ's footsteps from one holy shrine to another. Memling's inventive bird's-eye point of view allows the spectator to travel the imaginary pilgrim's path simply by studying the carefully interrelated parcels of the natural and man-made worlds.

While much fifteenth-century northern landscape imagery was highly contrived, there are examples of descriptive realism both appropriate and uncanny in their accuracy. The Limbourg Brothers went to great lengths to locate Michael's archetypal battle with the dragon above one of the saint's chief shrines in northern Europe, Mont St.-Michel (see FIG. 18, page 30), and Enguerrand Charonton included a nearby geographic landmark, Montagne Ste.-Victoire, in his *Coronation of the Virgin* housed in a southern French church near the mountain (see FIG. 39, page 66). Perhaps the most vivid example of landscape portraiture in fifteenth-century northern art is Konrad Witz's (c. 1400-1445/6)

92. HANS MEMLING
Scenes from the Life of the Virgin and Christ, 1480. Panel, 31⁷⁄₈ x 74³⁄₈" (81 x 189 cm). Alte Pinakothek, Munich.

An inscription on the now lost original frame of this work stated that it was commissioned in 1480 by the tanner and merchant Pieter Bultnyc and his wife Katharina van Riebeke, for the chapel of the Tanner's Guild in the Church of Our Lady in Bruges. Bultnyc and his son are shown kneeling at the lower left outside the stable where Christ is born. Katharina van Riebeke kneels at the lower right in front of the scene of Pentecost.

93. Konrad Witz
Miraculous Draught of Fishes (from the "St. Peter Altarpiece"), 1444. Panel, 4′ 4″ x 5′ ⁵/₈″ (1.32 x 1.54 m). Musée d'Art et d'Histoire, Geneva.

This panel is the exterior of one of the wings of an altarpiece intended for the cathedral of St. Peter in Geneva; the other exterior wing showed an angel releasing St. Peter from prison (Acts 12:1-11), thus reinforcing the message of the *Miraculous Draught of Fishes* that Peter (the Pope) needed help.

Miraculous Draught of Fishes, painted for the cathedral of St. Peter in Geneva in 1444 (FIG. 93). Here the apostles' plentiful catch and Christ's subsequent walking on the waters take place on Lake Léman, Geneva's own lake. Witz's view, looking southeast toward the mountain of Le Môle, with the city of Geneva out of sight at the right, is still recognisable today. The painter used this local setting because this was a painting with a particular, local political purpose. Commissioned by a cardinal who was a strong advocate of the power of the College of Cardinals, this painting deliberately shows St. Peter, the first pope, in a compromised position: he has tried to imitate Christ's miracle but, losing faith, begins to sink beneath the water, exposing his genitals in an unseemly fashion. The pathetic Peter needs Christ's aid, just as the Pope in the fifteenth century needed his cardinals' advice and support – at least that was the point of view of the cardinal who commissioned the painting. The accurate portrayal of the landscape reinforced the immediate political message of the image. At the same time, the realism of Witz's view is not simple or photographic. He chose an angle or point of view that would locate the peak of Le Môle over the body of Christ, who is thus signalled as the real rock on which the Church was founded. Witz's view may be accurate, but it is not casual or incidental; it is deliberately structured and distilled to reinforce the work's political meaning.

Although such distillation was typical of most landscape imagery in the fifteenth century, it was not always employed in the later fifteenth and throughout the sixteenth century. As western European society grew and prospered, people's experience of the natural world grew increasingly casual, fresh, and direct. In about 1495 Albrecht Dürer drew a small country house perched on an island, which he no doubt observed in the countryside around his native Nuremberg (FIG. 94). A comparison with Witz's Lake Léman is telling. Both record a specific site but with almost totally different aims and results. Witz's image is highly structured, even architectural in its appearance. Dürer's is snapshot-like, attempting to recreate a passing moment, as the setting sun brings a flickering life to water and sky. Dürer's was also, initially, a private record, jotted down quickly in watercolour washes with highlights added in white, but soon after making the drawing, he used its design as the backdrop for an engraving of the monumental figures of the *Virgin and Child with a Monkey* in the foreground. The effect of this finished public work is much like that of the Witz but, typical of the sixteenth century, what went into Dürer's final product was much more poetic and casual than anything ever found in the preceding era.

Over the course of the fifteenth century, northern views of the natural world did, in some cases, become less constricted and conventional; the landscape gradually opened up and extended more smoothly from fore- to background. Interestingly, this development can in part be credited to artists hailing from the northern Netherlands, Haarlem, Leyden, and 's-Hertogenbosch, for instance, where the land itself is flatter and might have stimulated the artists to envision a more inviting, continuous prospect. Again, the sixteenth century gave a particular edge to this issue of general geographic accuracy. Toward the end of the first decade of that century Gerard David painted a triptych of the *Nativity* that, when opened, is remarkably traditional in appearance; in fact, it was probably copied or adapted from a similar composition painted by Hugo van der Goes about twenty-five years previously. The exterior of this triptych which is now unfortunately separated from the interior presents the viewer with something entirely new (FIG. 95). It is very tempting to call these exterior wings a pure landscape. That would be an accurate term if it meant a landscape without prominent human characters and storyline, but this exterior view is clearly

94. ALBRECHT DÜRER
A Small House in the Middle of a Pond, c. 1495. Watercolour, 8³⁄₈ x 8⁷⁄₈" (21.25 x 22.5 cm). British Museum, London.

In Dürer's handwriting below the drawing are the words *"weier haws"*, signifying *Weiherhäuser*, small houses in the country, often surrounded by water and used for the billeting of troops.

95. GERARD DAVID
Triptych with the Nativity,
c. 1505-10, exterior
landscape wings. Panel,
each 35⅜ x 12″ (90 x
30.5 cm). Mauritshuis,
The Hague.

meant to be considered in conjunction with what this triptych's interior reveals (FIG. 96).

In David's work, the shepherds are journeying into Bethlehem (which looks suspiciously like a Flemish wood) in order to adore the new-born Saviour. The triptych is closed, and through the light-dappled trees a dilapidated shed can be glimpsed. Before this is a stream at which two oxen drink. A donkey curls up at the left. Opened, the triptych reveals the interior of the shed; the ox and ass reappear, worshipping the Child, as do the patrons on the wings. For David, the landscape had become the leading edge, the element that draws the viewer ineluctably into communion with the divine. As in many fifteenth-century works before it, David's Flemish forest is recognisable as such. What is remarkable here is the way in which the artist, in a consistent, level, and thorough-going fashion, used that local feeling for nature to entice the viewer into the role of traveller through a religious scene.

The word landscape (*landschaft*) was first used in the art context in German literature when Albrecht Dürer described his visit to Joachim Patinir, "the good landscape painter," in Antwerp in 1520. This is significant because it certifies the growing awareness of the fact that artists at this time were specialising; they were becoming recognised professionals in certain branches of secular art (such as landscape, portrait, and still-life). It is, however, difficult to justify calling Patinir's paintings "secular works of art," for in them there is always a religious story or figure(s) present, however small. In a way, that is analogous to Witz's *Miraculous Draught of Fishes*, in which the landscape was adjusted to the religious elements. Patinir's *Landscape with St. Jerome* (FIG. 97) is a good example of this. Jerome has retreated into the wilderness in order to face his inner demons; the "dark night of his soul" is clearly alluded to by the inky clouds that seep into the painting at the upper left. To this Patinir added human, anecdotal interest about Jerome's life, and so he depicted him in a monastery in which he tames a wild lion by removing a thorn from its foot.

Patinir's landscape is a patchwork of images and ideas. Alongside the various parts of the Jerome story are other allu-

sions and incidents: pilgrims, explorers, a blind man and his guide. The artistic composition of the painting reinforces its puzzle-like nature. The horizon is quite high, so that the viewer mounts up the panel in order to go back in space. Colour-coding helps create a sense of recession, from the warmest colours (brown) in the foreground, through a middleground of green to a cool background of blue and grey. Patinir came from the town of Dinant on the River Meuse, in present-day southeastern Belgium, where he would have seen huge rocky outcroppings such as those he inserted, sometimes almost playfully, into this and indeed most of his works. These rocks, as well as the many other prominent vertical elements in the composition, reassert the integrity of the picture plane, that imaginary transparent surface of the panel. In a way reminiscent of Holbein's portrait style, Patinir enjoyed a tension between the two- and three-dimensional elements of his work. His is a landscape through which one might travel for many reasons; the pilgrimage of life was becoming increasingly complicated for the artist and his contemporaries who travelled for religious reasons but also for commercial ones, for their health (to visit spas) and just to enjoy new and exciting vistas. Patinir's art, the way in which he manipulated and stylised the landscape elements, mirrored the richness of that experience.

96. GERARD DAVID *Triptych with the Nativity*, c. 1505-10. Interior landscape wings, tempera and oil on canvas, transferred from wood. Central panel 35¼ x 28″ (89.6 x 71 cm), each wing 35¼ x 12″ (89.6 x 31 cm). The Metropolitan Museum of Art, New York.

97. JOACHIM PATINIR
Landscape with St. Jerome,
c. 1520-24. Panel, 29¹/₈ x
35⁷/₈" (74 x 91 cm). Prado,
Madrid.

The blind man and his
guide at the lower right
may be an indicator of false
pilgrimage, since they
move away from Jerome's
monastery; this group was
familiar in other
Netherlandish paintings
(such as Hieronymus
Bosch's *Triptych with Hay
Wagon* FIG. 107) and was
also used in a positive
sense, to indicate the value
of truly searching for a
miraculous cure.

Patinir's style and conception of the landscape were ex-
tremely influential on sixteenth-century Flemish artists. Imita-
tions and adaptations of his works also became quite popular in
Italy, where the sense that this was a new category of art was
even stronger than in the North. In Flanders, even as original a
talent as Pieter Bruegel, working almost fifty years after Patinir,
continued to draw from the earlier artist's models. In Bruegel's
panel of the *Return of the Herd* (FIG. 98), Patinir's river Meuse
rocks jut up and out of the land alongside a meandering stream.
Like Patinir, Bruegel included a monastic complex snuggled into
a large, cave-like opening in a rocky promontory at the right,
singled out by a rainbow cutting through the dark storm clouds
above it. Bruegel's panoramic image is an idealised combination
of the artist's experience of both art and nature. Some of it
surely reflects his journey across the Alps to Italy in the early
1550s, though it is clear that he also carefully observed and
recorded the rich, rolling hills, fertile farmland, and peasant life
of Flanders, between the cities of Antwerp and Brussels, in

which he lived at different times in his life. Overall, he envisioned a panoramic world landscape.

Bruegel's *Return of the Herd* is part of a series of six paintings representing the seasons of the year (only five of which have survived). In some ways, such concern with representing the changing appearance of nature was quite traditional. The opening pages of books of hours from the fourteenth and early fifteenth centuries included a religious calendar illustrated with scenes of typical activities, or occupations, for each of the months. In addition, fifteenth-century northern artists had often shown a seasonally specific and accurate picture of the natural world behind their religious scenes; thus Hugo van der Goes' *Portinari Triptych* contains a bleak winter landscape appropriate for December in northern Europe. Bruegel's *Return of the Herd* represents the late autumn, centring on October, alluded to by the grape harvest in the middleground, while the bare trees and the corralling of cows into the village nestled in the left middleground suggest November activities. Thus we discover that Bruegel, although referring to past traditions concerning the typical labours of the months, did not compartmentalise nature in the neat and systematic way of his manuscript predecessors. Just as Bruegel's contemporaries were bent on exploring the world in a more challenging and expansive fashion, so his paintings enlarge upon the sense of narrow compartmentalisation found in earlier works.

Bruegel's horizons expanded literally and figuratively. His painted world is rich in the rhythms of nature; even a single scene from the series such as the *Return of the Herd* suggests the passage

98. PIETER BRUEGEL
Return of the Herd, 1565.
Panel, 3' 10" x 5' 2⁵/₈"
(1.2 x 1.6 m).
Kunsthistorisches
Museum, Vienna.

of time and people's response to it. The eye wanders through the image, up one hill and down another, into the distance and back to the foreground. The sense of containment and control – indicated by the monastery in the rocks, as well as by features such as the parenthetical trees at each side of the composition – is constantly played against the grandeur and power of the vast natural panorama. This seems a perfect combination of feelings and views for a wealthy banker who owned and hung such paintings in his new home just outside the city. In all likelihood, that is what happened to Bruegel's series of season paintings, which were probably commissioned by the Antwerp banker Niclaes Jonghelinck. Jonghelinck might have looked down upon the peasants, sensing their mechanical roles in the cycles of nature; from his estate, he might also have felt the vitality and variety of the primitive natural order.

Landscape images from both Germany and the Netherlands illustrate the growing allure of a primitive ideal. In ways this can be related to some of the inspiration for the Protestant Reformers. Reformers criticised the pomp and ceremonies that had grown up around the Church's hierarchy, especially around the papacy, and urged a return to the primitive beginnings of Christianity, with its emphasis on a simple, egalitarian, evangelical community. Similarly, social commentators in the sixteenth century rediscovered the primitive tribal roots of German society in the ancient writings of Tacitus (*Germania*) and others. They worried about reports that the *conquistadors* in the New World were desecrating primitive, peaceable kingdoms. The German ideal was held up by Albrecht Altdorfer's engaging portrayal of a *Satyr's Family* (FIG. 99); the fear of the pillaging of primordial societies is illustrated in Jan Mostaert's *Landscape with Primitive Peoples* (FIG. 100).

Albrecht Altdorfer (c. 1480-1538) was one of several German painters, working in the early years of the sixteenth century, who took inspiration from the particularly lush forests and vistas found along the Danube River. As with Patinir, certain distinctive features of this landscape, like the larch tree, became what amounted to personal emblems for the artist. That Altdorfer was the most vivid

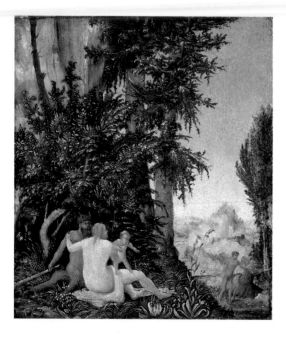

99. ALBRECHT ALTDORFER
Satyr's Family, 1507. Panel,
9 x 8″ (23 x 20.3 cm).
Staatliche Museen zu
Berlin, Preussischer
Kulturbesitz,
Gemäldegalerie.

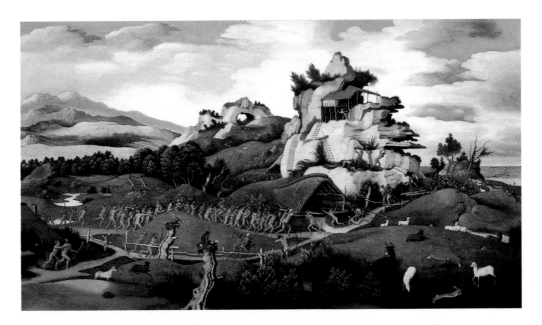

100. Jan Mostaert
Landscape with Primitive Peoples, c. 1545. Panel,
33⅞ x 59⅞" (86 x 152 cm).
Dutch government on loan
to Frans Halsmuseum,
Haarlem.

painter of landscape in Germany is confirmed by the composition of his *Satyr's Family*. The viewer is immersed in the forest; in the distance, beyond the larch tree, man-made buildings, signs of civilisation, rise out of the landscape. The middleground contains an enigmatic confrontation between what looks like a hairy, nude wild man and a figure, variously identified as man or woman, in a long red gown. German humanists at the same time wrote about the power of nature to renew and revive a moribund society, such as they felt the Holy Roman Empire had become; painters envisioned saints and heroes going into a harsh but cleansing natural world in order to restore their sense of purpose and ideals.

Exploration of the natural world revealed a moral order – or, at times, its violation. Jan Mostaert's (c. 1475-1555/6) landscape has often been thought to represent a specific incident in the discovery and conquest of the New World. In fact, this Netherlandish artist declined to paint primitive peoples in a way that would certify them as New World inhabitants, with the features, dress, and accoutrements that, by the second quarter of the sixteenth century, Europeans knew the inhabitants of Central and North America to possess. Mostaert also continued to use the Netherlandish-based conventions of Patinir – colour-coding, rock formation, vignette-like groups – in order to compose his "exotic" world. Mostaert's history painting is a more generic image of primitive society, complete with idyllic European animal life, rather than a specific report from the American

101. Queen Europa, from
SEBASTIAN MÜNSTER's
Cosmographia (Basel,
1588). 10³/₈ x 6¹/₄" (25.5 x
15.8 cm). The British
Library, London.

The fifteenth and sixteenth
centuries were times of
geographical exploration
and discovery, and both
landscape painting and
map-making flourished.
While the painted and
charted natural worlds
were treated at times with a
sense of scientific
observation, there was a
simultaneous tendency to
reconstruct and even
allegorize geographic
observation. In this map the
European continent is fitted
to the form of the Virgin
Queen, whose head is
Spain. This probably
alludes to the power of the
Spanish Hapsburg rulers
during this period.

frontier. These naked peoples are stoutly defending their simple
way of life against an advancing horde of armed marauders who
push two long cannons before them. The Holy Roman Emperor
Charles V removed Francisco Coronado from his leadership of
the Mexican expedition in part because of reports about the
explorer's brutality toward innocent, primitive peoples. The
works of Mostaert and Altdorfer show that the early growth of
landscape painting was linked to an increasing sense of contrast
between city and country, culture and nature.

Still-life and Genre Imagery

The story of the development of still-life and peasant "genre"
painting in the sixteenth century can be told rather simply,
largely because the history of these types of imagery is extremely
confined in the fifteenth century. Still-life detail (the depiction
of a small group of objects) was an integral and repetitive part of
Northern art. Painters and sculptors alike delighted in adding
minute realistic particulars to their works. Perhaps it is their very
ubiquity that keeps such elements from standing out or becom-
ing an entity of their own. Only rarely in the fifteenth century
did enough still-life elements pile up, in one place, to make what
today might be labelled a still-life painting. One notable example
is the floral arrangement in the foreground of Hugo van der
Goes' *Portinari Altarpiece*. In fact, this is a case that illustrates well
another limiting factor in the development of still-life at this
time: Hugo van der Goes did not, in any sense, choose his flow-
ers at random. The number, variety, colour, and even relative
position of each and every blossom had a special role in explain-
ing the significance of Christ's mission on earth. This still-life is
modelbook-like, both in its limited variety and in its prescribed
symbolism. An independent interest in still-life needs the free-
dom to mix and combine a variety of elements and associations
from one's environment.

Under the auspices of increased mercantile activity and agri-
cultural production, this happened in the sixteenth century.
Quinten Massys' *Money-Changer and His Wife* (FIG. 102) is an
image that was produced in the midst of this transformation. A
beautifully detailed Eyckian convex mirror rests on the money-
changer's counter-top in the foreground. Reflected in this mirror
is the customer who waits by a window, as his money is tested
for value in the balance. According to a seventeenth-century ob-
server, an inscription on the original frame (now lost) read: "Let
the balance be just and the weights equal" (derived from Leviti-

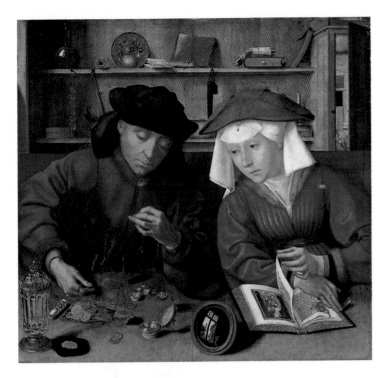

102. Quinten Massys
*Money-Changer and His
Wife*, 1514. Panel, 27³/₄ x
26³/₈" (70.5 x 67 cm).
Louvre, Paris.

The still-life details,
especially the foreground
convex mirror, and the
costumes suggest that it may
be a copy or adaptation of
an early-fifteenth-century
image by Jan van Eyck.
Massys no doubt updated
the social message about
the relation of worldly
goods and religious
devotion.

cus 19:36). Clearly there is a moral here not only for the money-changer but also for his wife. In the midst of her devotions (her book is open to an image of the Virgin and Child) she has looked up and away, perhaps simply approving her husband's truthfulness in business but perhaps distracted from her devotions by her greed. The prayerbook culture of the fifteenth century, so extensively documented in the art, was in fact in the process of being replaced by a growing capitalist economy and mentality bringing with it a variety of new commercial, mercantile ideals. Massys' painting is one of the first to indicate this.

Somewhat casually arranged on shelves behind the couple's heads is an interesting group of objects. Some are recognisable from such Eyckian prototypes as the *Arnolfini Double Portrait* – a crystal vase, crystal beads, and a piece of fruit – but in Massys' work, these objects, are now mingled with the normal scraps of paper and dog-eared accounts books that would lie casually around in any merchant's chambers. The interaction between these different kinds of objects again encourages thoughts of contemporary social and economic change as people became newly wealthy through burgeoning trade and exchange.

By mid-century the prosperity of Flanders, especially in agricultural terms, was overwhelming. The great international

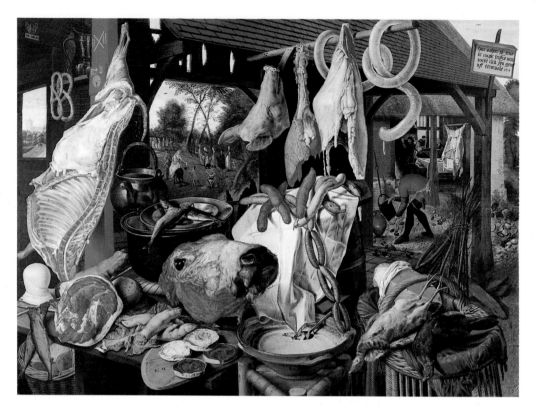

103. PIETER AERTSEN
Meat Still-Life, 1551. Panel,
4' ³/₈" x 6' 5³/₄" (1.23 x 1.67 m).
Uppsala University Art
Collections, Sweden.

The whole composition of
Aertsen's work is enigmatic
and jarring, with background
vignettes constantly forced
into startling juxtapositions
with the foreground still-life.
Thus the sausage hanging
from a pole seems to drip on
a servant by the well at the
right; the crossed fresh fish
and pig's ear seem to point to
the beggars and Holy Family
at the centre.

trading centre of Antwerp was the birthplace of Flemish land-
scape painting, in the hands of Joachim Patinir, and of still-life
painting, in the hands of Pieter Aertsen (c. 1507/8-75). Actually,
Aertsen came from Amsterdam, to which he returned in 1557.
While living in Antwerp, he painted his first still-life, a *Meat
Still-Life*, dated March 10, 1551 (FIG. 103). This large painting is a
remarkable, revolutionary work, and it has consequently been
difficult to evaluate in modern times. Certainly, in the sixteenth
century, Aertsen was almost immediately praised and accorded
patronage for the startling brilliance and virtuosity of his still-life
imagery. At the same time, he had to witness the iconoclastic
destruction of some of his traditional religious images. According
to near-contemporary accounts, the burning and slashing of
some of his great altarpieces made him furious. He did continue
to receive commissions for religious works, but the widespread
questioning of their value in the Netherlands at the time may
have encouraged him to expand his options.

For some modern observers, Aertsen has been viewed as the
inheritor of a complex system of religious symbolism similar to
that found in the *Portinari Altarpiece*. From this point of view, a
work such as his *Meat Still-Life* is essentially a negative image

meant to criticise worldly riches and to point the viewer toward the supreme holy ideal at the painting's core. In a way analogous to Patinir's landscapes, Aertsen's still-lifes almost always have a religious story or group of figures buried, usually centrally, within them. In the case of the *Meat Still-Life*, it is a scene of the Holy Family, Joseph leading Mary and the Child Jesus, seated on a donkey, presumably on the Flight into Egypt. Their flight has taken them through the Flemish countryside, where they are seen offering alms (two gold coins) to a beggar and his son by the side of the road. All the contemporary Flemish men and women pass by these beggars without responding. Aertsen's is an image of poverty and charity, and their relation to prosperity, which was real and which he so vividly brought to life in the foreground still-life. But rather than simply condemning the wealth stockpiled in the foreground of the painting, Aertsen's image might have been meant as a plea for its more equitable distribution, following the model of the Holy Family's almsgiving.

Aertsen's painting is dated in the middle of Lent, a time of abstinence which followed Carnival (or Mardi-Gras). No doubt this has some bearing on the rather heavy-handed presentation of meat here since the Church had traditionally given meat to the poor during Lent. That practice had been abandoned earlier in the century. The celebration of Carnival and Lent was given different if equally memorable expression in Pieter Bruegel's 1559 painting (FIG. 104). In this work a Flemish town square, observed from a bird's-eye point of view, is the scene of the traditional battle between the proponents of feasting (a fat Carnival with a roasted pig on a skewer at the left) and fasting (a thin Lent with dried herring on a wooden server at the right). This opposition is worked out in compelling details throughout the image. On the right, Lent's followers emerge from church giving alms to the poor while Carnival revelers enact skits at the left. Today some observers see this as an image of social cohesion, of the city's ability to contain and even harmonise these varying human impulses; others see the opposite – religious and social conflict. The artist, Bruegel, is surely bent here on ethnographic accuracy: never before had such a profusion of everyday genre activities and popular pastimes been so carefully and pointedly recorded in paint.

In the fifteenth century, peasant imagery was even more limited than still-life. Calendar illustrations in books of hours do provide one predictable but limited venue for the appearance of the hard-working members of the lower class, but in panel paintings, only the adoring shepherds at Christ's birth form interesting, full-fledged embodiments of the peasantry. It is true

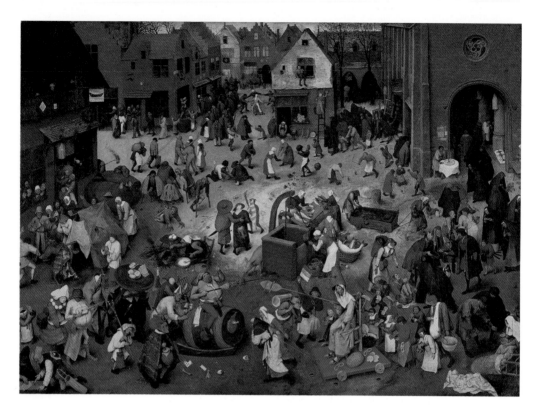

104. Pieter Bruegel
*Battle Between Carnival
and Lent*, 1559. Panel,
3' 10¹/₂" x 5' 3³/₈" (1.18 x
1.61 m). Kunsthistorisches
Museum, Vienna.

that these shepherds could be treated in an unusually provocative and engaging way. Hugo van der Goes' ecstatic shepherds (see FIG. 34, page 56) were remarkably influential on Italian artists once the altarpiece was set up in Florence. Hugo's work also presents a quandary that was worked out with considerable ingenuity in the sixteenth century. Were the lower classes envisioned as good or bad, admirable models or indecorous fools?

In the second half of the fourteenth century, sporadically in the fifteenth and especially in the early sixteenth century, there were revolts of the peasants in Flanders, England, and especially Germany. These culminated in the widespread German Peasants' Revolt of 1525 which was based on peasant objections to excessive taxation and regulation and in general high-handed treatment by the German lords. This revolt was at least partly connected with the Protestant Reformation, since followers of Luther helped frame the peasants' demands, and Luther's own disavowal of spiritual authority must have served as at least a partial model. The peasants were often supported by middle-class burghers and guildsmen who, like them, felt oppressed by imperial regulation and taxation. Luther himself wrote vociferously against what he called "the robbing and murdering peas-

ants;" still, after the Peasants' Revolt was crushed, conditions did improve somewhat and the basic human rights of all individuals were more fully recognised.

Sometime in the late 1520s, the Dutch prodigy Lucas van Leyden painted a small triptych (only about three feet [0.9 m] tall) showing the *Adoration of the Golden Calf* (FIG. 105). This work incorporates a dramatic background landscape along with the romantically detailed Israelite camp in the foreground. The tiny figure of Moses, gone up on Mt. Sinai to receive God's commandments, appears both on a Patinir- like promontory in the midst of a whirlwind and again directly below, as he and Aaron approach the Israelite camp. There they catch sight of the people worshipping the golden idol, disobeying Moses' command not to adore false gods. All this takes place in an area of the painting characterised by reduced, almost ghost-like colour. In the foreground is Lucas van Leyden's depiction of the carousing Israelites, in vivid, full colour, highly detailed. Lucas van Leyden apparently saw the Israelites as carefree gypsies, perhaps thinking that historically appropriate for a desert people; or perhaps his lower-class characterisation was meant to reinforce the negative image of the masses as idolaters, ignorant people who could worship false idols.

A decade or two earlier Hieronymus Bosch had addressed the issue of false idols in a more purely economic sense. His *Triptych with Hay Wagon* (FIGS. 106 and 107) shows the downfall of humanity beginning with the Expulsion from the Garden of Eden (on the left wing) and ending with torment in Hell (right wing). There is little of the ambiguity about the central panel of

105. LUCAS VAN LEYDEN *Adoration of the Golden Calf*, c. 1525-30. Panels, centre 36⅝ x 26⅜" (93 x 67 cm), each wing 35⅞ x 11⅞" (91 x 30 cm). Rijksmuseum, Amsterdam.

The scalloped top of this small triptych is typical of the more inventive shapes used by Northern artists in the early sixteenth century. Just as artists such as Lucas van Leyden sought to give a new, sometimes "inverted," view of the religious narrative, they also framed their works in ways that broke out of the traditional rectangular format.

106. HIERONYMUS BOSCH
Triptych with Hay Wagon,
c. 1490, exterior view.
Panels, each wing 53⅛ x
17¾" (135 x 45 cm). Prado,
Madrid.

this triptych found in his "*Garden of Earthly Delights.*" The central Hay Wagon composition is not self-sufficient but moves inevitably from left to right, as all get into line greedily grabbing for straw (worldly goods). In the foreground of the work various sinful wayfarers are portrayed – gypsies and a blind man and his guide (now on a false pilgrimage). What then are we to make of the exterior of this work? Here, through a landscape full of robbers, wastrels, and signs of death, another tramp warily makes his way. Perhaps this is a voluntary poor person, aware of the ever-presence of death, who has decided to renounce the deceits of the world and the pursuit of earthly gain. Although the interior of the triptych may be unequivocal, this exterior view, typically for this artist, leaves the viewer guessing, pondering the path to take.

A typical peasant painting by the mid-sixteenth-century Flemish master Pieter Bruegel, the *Peasant Dance* (FIG. 108, page 152), depicts dancing, drinking, kissing, and pissing men, women, and children in what is obviously a highly contrived composition, not meant for popular, peasant consumption. That the peasants are to be the objects of scorn, providing a lesson for the upper classes in how *not* to behave seems, to many people today, to be the intention of this picture as well as of much, if not all, of Bruegel's peasant imagery. One man, in the very centre of the composition (but far in the background), is seen as the embodiment of such an attitude. He is dressed in a sombre black robe, with a close-fitting black hat on his head and a disagreeable scowl on his face; he seems not only unhappy but out of place, a city-dweller who has wandered into the country and does not like what he sees.

Bruegel clearly knew well the habits and the proverbial sayings of the peasants. In the foreground of his *Peasant Dance*, he illustrated one of them: "As the old ones sing, so the young ones twitter" – the habits of the parents are, invariably, passed on to the children, as generation after generation joins in the dance. Perhaps the artist, or his patron, saw this process as not only inevitable but even comic, a relief from the plodding humdrum existence of daily urban life. Perhaps they saw the peasant as an

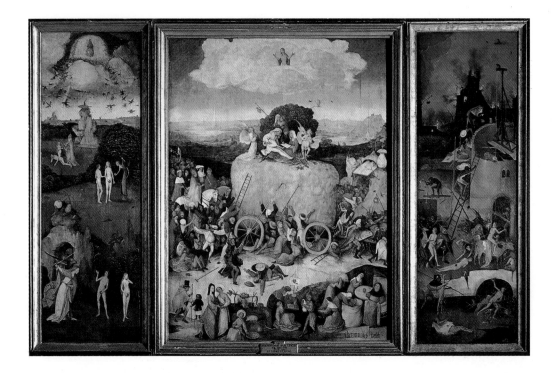

embodiment of native culture, something to preserve in opposition to the increasingly oppresive foreign Spanish rule. Beside the man dressed in black at the back of Bruegel's image stands a figure with upraised hand and open mouth dressed in the red-and-yellow costume of a fool (jester). These two men seem the embodiment of the traditional theatrical masks, comedy and tragedy. Certainly some of Bruegel's contemporaries saw peasants as examples of ignorance and folly; others lauded the good peasant, plowman, or shepherd and the value of lower-class traditions and lack of inhibitions. Sometimes Bruegel's peasants seem grim and distorted, their heads buried in their hats so that they become automata, creatures of their own instincts and base desire. If Bruegel's original purpose was to criticise and belittle, he certainly seems to have been won over – and to win over those who view his works, which as a near-contemporary remarked are hard not to smile at. Perhaps it is not too modern a judgment to believe that Bruegel sensed and portrayed the inherent complexity, even ambiguity, in this situation. As one of the first great painters of peasant life, he might well have been of two minds about it. Peasant painting, like the sixteenth-century Peasant Revolt, might also ultimately have suggested something about shared humanity, the foibles as well as the joys that tied people together across the social spectrum.

107. HIERONYMUS BOSCH *Triptych with Hay Wagon*, c. 1490, interior view. Panels, centre 53$^1/_8$ x 39$^3/_8$" (135 x 100 cm), side wings 53$^1/_8$ x 17$^3/_4$" (135 x 45 cm). Prado, Madrid.

108. PIETER BREUGEL
Peasant Dance, c.1566.
Panel, 3′ 8⁷/₈″ x 5′ 4¹/₂″
(1.14 x 1.64 m).
Kunsthistorisches Museum,
Vienna.

A deserted church stands at
the rear of the image, while
people come and go freely
from the tavern with a
banner at the left. A small
devotional image of the
Virgin and Child, complete
with floral offering, hangs
askew from a tree trunk at
the right.

Dogma into Dialogue

A number of the most interesting paintings and prints studied in
this chapter are united by the common compositional feature
that modern scholars have termed an "inverted composition,"
meaning that artists such as Lucas van Leyden and Pieter Aertsen
apparently buried the traditional religious subject or story in the
background of their paintings, surrounding it with a variety of
interesting landscape, still-life, or figural detail. In a sense the
landscapes of Joachim Patinir, even some of the peasant paint-
ings of Pieter Bruegel with their tiny figures and overwhelming
natural vistas, might also fall into this category. One anachronis-
tic view of this development must be readily dismissed. These
small religious elements are not mere excuses put in as a sop to
tradition, which the artist would just as soon do without; these
artists are not bent on such a thing as a "pure landscape" or
"pure still-life." Rather, their works maintain an intriguing rela-
tion or tension between the old and the new, the traditional reli-
gious subject or meaning and novel concerns about, or interests
in, the visible world.

Compositional inversion could well indicate an artistic
malaise, even boredom. In that sense, it could be seen as a

response to the homogeneity of fifteenth-century religious imagery. The kind of artistic development we witness in the sixteenth century in the North has a dual nature: it represents a search for novelty alongside a continued dependence on, and manipulation of, the past. The results often seem playful, even at times perverse.

However, these compositions are not merely playful. Lucas van Leyden's new questions about the nature of baptism and idolatry, Pieter Aertsen's confrontation of economic inequities and the contemporary lack of charity, Joachim Patinir and Albrecht Altdorfer's examination of motive for admiring nature are serious propositions. Above all, compositional inversion turned images from dogma into dialogue, from the presentation of a single, official point of view to the suggestion of a conversation between spectator and work. These "inverted" images have been seen as a convenient way of avoiding idolatry, creating a new, more casual interaction between the human and the divine. The Reformation was at work here. This was a time of great flux and change: old answers were questioned, new ones proposed. Those who were immediately certain of the path, new or old, that they would follow would no doubt respond favourably to the kind of straightforward didactic art that Lucas Cranach produced under Martin Luther's direction; others were less dogmatic than the great Reformer and his immediate followers.

Artists had to be practical – they had to succeed in an increasingly open, competitive market. Practical considerations merged with ideological ones. Some artists may have been content to limit their appeal, but most needed to broaden it. Inverted compositions, which cleverly lead the viewer through a variety of options and ideas, which seemed both novel and traditional, would have been a powerful new weapon in the painter's arsenal. Perhaps it was their love of detail that made them, finally, so successful. Over and over, sixteenth-century artists, specialising increasingly in one aspect of the earlier tradition, used this sense of detail and careful visualisation both to draw the viewer in and lead the viewer on. Thus new moral perspectives, new ideologies, subtly and slowly emerged from the old.

Italy and the North

E ven though Italian views of northern art are not always acceptable to modern analysts, they are instructive. Writing in the mid-sixteenth century, the Portuguese painter Francisco de Hollanda recorded what he claimed was Michelangelo's (1475-1564) opinion when asked about the achievement of Flemish art:

> Flemish painting, slowly answered the painter, will, generally speaking, please the devout better than any painting of Italy, which will never cause him to shed a tear, whereas that of Flanders will cause him to shed many.... It will appeal to women, especially to the very old and the very young, and also to monks and nuns and to certain noblemen who have no sense of true harmony. In Flanders they paint with a view to deceiving sensual vision....They paint stuffs and masonry, the green grass of the fields, the shadow of trees, and rivers and bridges, which they call landscapes, with many figures on this side and many figures on that. And all this, though it pleases some persons, is done without reason or art, without symmetry or proportion, without skill, selection or boldness and, finally, without substance or vigour.... And I do not speak so ill of Flemish painting because it is all bad but because it attempts to do so many things well (each one of which would suffice for greatness) that it does none well.

109. MICHAEL PACHER
Nativity, from the *St. Wolfgang Altarpiece,*
c. 1471-81. Panel, 5′ 8⁷/₈″ x
4′ 7¹/₈″ (1.75 x 140 m).
Church of St. Wolfgang,
Austria.

Despite the fact that Michelangelo's own aesthetic priorities forced him to rate the northern achievement rather poorly, he was sensitive enough to recognise many of its outstanding features: its love of detail, textures, and subtle, illusionistic light effects, its piety juxtaposed with its obvious love of natural beauty in areas such as landscape. Even in the fifteenth and sixteenth centuries, commentators noticed the distinctive proclivities of the northern tradition that still fascinate us – and call out for study and evaluation – today.

Northern Artists' Travels to Italy

Although travel between Italy and the North was quite possible in the fifteenth and sixteenth centuries, many more important northern artists travelled to Italy than Italians went north. While this

110. ANONYMOUS ITALIAN ARTIST
Studiolo, Ducal Palace, Urbino. Still-life of books, and other objects of a scholar's study, completed 1476. Intarsia.

This is an inlaid wall decoration from the most complete surviving early Renaissance studiolo executed for the Duke of Urbino in 1476. The Duke had a taste for northern art and artists, importing both painters and tapestries. At this time art work from Urbino often showed a fascinating mingling of northern and Italian interests. Here the northern love of illusionistic still-life detail is filtered through a virtuoso use of linear perspective which has the effect of reducing all objects to essential stereometric shapes.

can be explained partly by northern Europeans' need to visit the most venerable and important Christian shrines in the West, there is also justification in seeing the northerners' travels as a reflection of some of the outstanding features of their art – its focus on landscape and a sense of almost naive discovery of both micro- and macrocosm. Because of the frequency of northerners' travels to Italy, it is also often thought that they must have been seeking guidance and inspiration from their Italian contemporaries. What is clear however is that northern artists had their own well-established tradition, their own sense of priorities, and thus they reacted very selectively to the stimulus of an Italian journey. Four examples from the fifteenth through the early sixteenth century will illustrate this, while at the same time reinforcing aspects of the northern tradition that have been described in previous chapters.

At the request of his patron, Philip the Good, Duke of Burgundy, Jan van Eyck travelled repeatedly: to the Iberian peninsula to record the appearance of the Duke's prospective wife, Isabella of Portugal, and on various secret diplomatic missions, possibly even to the Holy Land. Whether on his way there or as part of another mission, van Eyck also probably travelled through parts of Italy. There he could have seen an Italo-Byzantine icon on which he based both his *Virgin in a Church* (see FIG. 63, page 98) and another painting of the *Virgin by a Fountain* (now in Antwerp). (The specific icon now in Cambrai [see FIG. 68, page 102] did not come to the North until after van Eyck had

used its composition in his works.) Thus, while van Eyck might have learned some things from fifteenth-century Italian art to aid him in his search for a more convincing view of the physical world, his presumed journey to Italy above all provided him with a model of timeless religious truth, which he could alter and adjust to fit his own realist vision.

Roger van der Weyden found a more up-to-date religious model when he journeyed to Rome, the goal of the jubilee pilgrimage of 1450. No doubt stopping in Florence on his way to the Eternal City, he was clearly struck by the reductive but still quite tangible, real-appearing frescoes of Fra Angelico (c. 1395/1400-1455) in the monastery of San Marco (FIG. 111). Fra Angelico's works are a perfect complement to the spare cells and passageways of the Italian cloister. With few colours, limited space, and only several monumental figures in each image, the Italian artist managed to suggest both the focus and the living presence of the monks' devotions. On his return to the North, Roger van der Weyden made several donations to the Carthusian monastery of Scheut, near Brussels, probably including his *Crucifixion Diptych* (FIG. 112), in which, as in Fra Angelico's work, the reduced colour-scheme is appropriate to the physical context, especially here since the Carthusian habit is white. Roger van der Weyden appears to have staged Christ's Passion within the monastic confines; over the high stone walls two scarlet cloths of honour set off the mourning figures of the Virgin and John the Evangelist at the left and Christ on the cross at the right. Also, as in Fra Angelico's work, Roger van der Weyden restricted his landscape setting to stylised, isolated rocky outcroppings: this three-dimensionality is so peculiarly limited that it is difficult to think of it as anything other than a product of the painter's (and the viewer's) devotional imagination. Thus Roger van der Weyden searched out in Italian painting the perfect model for a newly enhanced but highly stylised monastic setting. Italian art here reinforced a northern obsession with directing art toward its specific physical location.

111. FRA ANGELICO *Crucifixion with St. Dominic,* c. 1438-45. Fresco. Monastery of San Marco, Florence.

Michael Pacher (c. 1430/2-98), one of the greatest German painters and sculptors of the late fifteenth century, lived and worked most of his life in the town of Bruneck (Brunico) in the south Tyrol, in what is today northern Italy. One of his major works was executed between 1471 and 1481 for the parish church of St. Wolfgang on the Abersee in Austria (FIGS. 109 and 113). From the point of view of Italian influence, this work shows quite clearly that Pacher had travelled through northern Italy, where he would have seen the dramatic perspectival compositions of Andrea Mantegna (1431-1506) in Padua and Mantua. Unlike Mantegna's classically derived buildings and arches, Pacher's elaborate architectural constructions are either humble (vernacular) or Gothic in style. Alongside the architectural fantasies, Pacher included sharply foreshortened animals and humans. His attraction to extreme Italianate perspective effects is just one element in a complex monumental whole. As Michelangelo observed, the artist treated each element in this complex polyphony with equal care. This was a pre-Reformation work of art: Protestant Reformers would agree with Michelangelo that some of the northern decorative sense here was excessive, at least in a religious context.

113. MICHAEL PACHER
St. Wolfgang Altarpiece, c. 1471-81. Limewood and pine, centre 12′ 9½″ x 10′ 4″ (3.9 x 3.15 m). Church of St. Wolfgang at Wolfgang-See, near Salzburg, Austria.

This elaborate altarpiece contains two sets of movable wings. The exterior ones illustrate scenes from St. Wolfgang's life (he was the patron saint of the church in the village that also took his name). The second set illustrates Christ's preaching and healing. The final transformation focuses on a carved relief of the *Coronation of the Virgin* flanked by paintings of the *Nativity, Circumcision, Presentation of Christ in the Temple* and *Death of the Virgin Mary.* Such elaborate series of images and carved framework was typical of German production at this time (see also FIGS. 75 and 76).

114. HIERONYMUS BOSCH
Carrying of the Cross,
c. 1505-15(?). Panel, 30⅛ x
32⅞" (76.7 x 83.5 cm).
Museum voor Schone
Kunsten, Ghent.

St. Veronica is at the lower
left with her sudarium, the
cloth with which she wiped
Christ's brow and on which
a true image (*vera icon*) of
his face miraculously
appeared. At the upper and
lower right are the two
thieves, the good one
above, the bad below.

To modern eyes the surreal work of Hieronymus Bosch might at first seem an example of a northern artist untouched by the ideals of balance, simplicity, and clarity espoused by so many in the Italian Renaissance. But Bosch did almost certainly travel to Italy, probably to Venice and northern Italy around 1505. At that time and place Boschian imagery emerged frequently as exotic detail in many north Italian artists' works (including images from the circle of Giorgione [c. 1476/8-1510] and Titian [c. 1490-1576]).

One of Bosch's most striking portrayals of the *Carrying of the Cross* (FIG. 114) shows several groups of bust-length figures piled up, flattened like masks against the picture surface. In completing this work, as well as several others, Bosch drew upon bust-length compositions of Christ's Passion common in north Italy at this time. He must also have had access to the

physiognomic studies of Leonardo da Vinci (1452-1519), which explore facial distortion and at times show a similar concern for surrounding an image of nobility with grotesque tormentors (FIG. 115). But Bosch seems to have abandoned what for Leonardo was at least in part a scientific study of physiognomic extremes; for Bosch, the image became an insistent morality play about the paucity of good in a world teeming with evil monsters. In general, as Michelangelo sensed, the northerner more often bent his imagery in ways that instilled fear or pity, while the Italian demanded wonder at his artistic prowess alone.

The Revival of Ancient Art and Subject Matter

115. LEONARDO DA VINCI *Studies of Five Heads*, c. 1490. Pen and ink on paper, 10¹/₄ x 8″ (26 x 20.5 cm). The Royal Library, Windsor Castle.

For the Italian, artistic power often came from the ancients. It was, of course, the rebirth in the fifteenth century of interest in ancient Roman and Greek art that has given the period its traditional name – Renaissance – rebirth. The reunion of classical form and classical content, portraying ancient stories and legends in an ancient artistic style, is sometimes claimed as a distinguishing mark of Renaissance culture. At that time, it is thought, the ancient past was being considered as distant and could be admired as such; ancient style and ancient content could be revived simultaneously. Such a goal was rarely sought or accomplished in the North. The ancient artistic tradition was clearly not the literal, omnipresent physical force there that it was in Italy, and ancient myths needed adaptation and alteration in order to make them compelling on northern soil. The point is not so much that this traditional definition of the Renaissance achievement was wrong for the North as that northern Europeans had their own intriguing ways of adapting and learning from ancient Greek and Roman civilisation. Again in observing several northern artists' interest in ancient art and subject matter, we can strengthen our sense of a distinct northern tradition.

When the Flemish painter Jan Gossaert (often called Mabuse, from his birthplace, Maubeuge, in Hainault, c. 1478-1532) was taken to Rome in 1508 by his patron, Philip of Burgundy, this was the first known instance of a northern patron personally shepherding an artist south in order to enlarge his horizons. In Rome, Gossaert made drawings of antique trea-

sures, including an ancient bronze statuette, since 1471 displayed in the Capitol in Rome; it measured slightly over two feet (0.6 m) in height and showed a nude young boy seated on a rock apparently pulling a thorn from the sole of his left foot, which rested on his right knee (FIG. 116). In general, Gossaert's sheet of studies shows an emphasis, quite unclassical, on finely wrought surfaces and decorative detail. In the artist's study of the thorn-puller, it is obvious that he insisted on viewing the work from an extremely low angle so that the figure's limbs are locked together in a puzzle-like fashion that almost flattens the drawing's perspective illusion. At the same time, the spectator's erotic involvement with the work is dramatically heightened. For the northerner, ancient nudity was not a simple artistic ideal but a provocative sexual ploy. The classical vocabulary led to a quite different syntax in northern hands.

116. JAN GOSSAERT
Sheet of Sketches after Antique Sculpture, c. 1508-9. Pen and ink on paper, 10¼ x 8" (26 x 20.5 cm). Rijksuniversiteit Prentenkabinett, Leiden.

In terms of classical mythological subject matter, northern artists often either Christianised or tribalised it, making the ancient myth into a Christian or Nordic one. Jan Gossaert's image of *Danaë* (FIG. 117) typifies this development. In the Greek legend, although Danaë's father confined her to a tower to protect her virginity, the god Jupiter, transformed into a shower of gold, impregnated her, and she gave birth to a son, Perseus. Gossaert cleverly wove together at least three strands of artistic and iconographic tradition here. He had studied ancient monuments, such as the Colosseum in Rome, and they are reflected, if also elaborated on, in Danaë's tower, as well as in the architecture viewed through the colonnade. Gossaert's technique, like that of Massys, his contemporary, found its closest analogies in the hundred-year-old art of Jan van Eyck, in that costly materials glow through the miracle of the oil glaze technique. To this, Gossaert added something already seen in the work of Hans Holbein: real gold leaf floating on the surface of the panel, used here to represent Jupiter's shower of gold. The gold leaf breaks the Eyckian

illusion and emphasises the painter's wilful preciousness which is now moving out of a holy sphere into a more secular one. This is also the case with his interpretation of the scene, for here Danaë is clothed in blue, seated on a red, tasselled pillow, the traditional pose and colour scheme for the Virgin of Humility. (This type of image of the Virgin Mary is also reflected in the Campinesque painting of the *Virgin before a Firescreen*; FIG. 32, page 51). Gossaert's Danaë also brings to mind stories of Christian princesses such as St. Barbara, who confined herself to a tower to protect her virginity from the pagans. However, in Gossaert's work the figure submits, ecstatically welcoming Jupiter, as her robe slips from her shoulder and reveals her breast. A pure nurturing Virgin has been transformed into an object of extreme sensual beauty.

Contemporaries of Gossaert's could take the ancient myths and stories out into the landscape. Albrecht Altdorfer did this; so did Joachim Patinir. Patinir's painting of *Charon's Boat on the*

117. JAN GOSSAERT
Danaë, 1527. Panel, 44⅝ x 37⅜" (113.5 x 95 cm). Alte Pinakothek, Munich.

On this panel, Gossaert proudly signed his name. "IOANNES, MALBODIVS, PINGEBAT, 1527," is painted as though carved into the ledge beneath Danaë's feet.

118. JOACHIM PATINIR
Charon's Boat on the River Styx, c. 1520-4. Panel, 25¹/₈ x 40¹/₂″ (64 x 103 cm). Prado, Madrid.

River Styx (FIG. 118) weaves a discordant variety of sources into an engrossing whole. In the left foreground are Patinir's characteristic northern marshlands, delicate iris, and River Meuse rocks emerging from fertile soil and water. The rocks at the left, like the trees at the right, seem to be stunted, a throwback to compositional conventions over one hundred years old (see FIG. 16, page 24). Patinir clearly had more in mind than the realistic rendering of a Flemish landscape. The horizon is high and sharply defined, again emphasising the two-dimensional composition, as element is piled on top of element. To the left is Paradise, with a central Fountain of Life and angels guiding blessed souls through the greenery. Features such as the fountain imitate similar details found in the works of Hieronymus Bosch, as do the fiery eruptions on the painting's right side, where Patinir's vision of Hell makes thrifty use of Bosch's visionary language (see FIG. 49, page 79).

In classical legend, Charon ferried souls on a one way journey, across the River Styx into Hades. Here he seems to occupy the position of a potential judge, suspended in midstream, able to row to Heaven or Hell. Patinir has cleverly turned an ancient pagan myth into a Christian allegory of the Last Judgment, with Charon taking the place of Christ. For sixteenth-century northerners, classical myth still benefitted from being understood in terms of Christian morality. Both Gossaert's *Danaë* and Patinir's

Charon are also reminders of the tradition of inverted composition that characterises some northern representations of the sixteenth century. Gossaert's and Patinir's classical images similarly invite the viewer into a conversation with the painting, poised as they are between classical novelty and Christian tradition.

The Naked Body

Unlike Italians, who had a classical culture close at hand, northern Europeans found little justification within an exclusively Christian tradition for the portrayal of the nude human figure. Most often in northern art, the naked body was an object of pity or shame (Christ on the cross; Adam and Eve), or isolation and loneliness (the infant Christ). It requires some explanation, therefore, that at the beginning of the second quarter of the sixteenth century a number of northern artists began to portray the nude, both male and female, in a sexually explicit way, sexual organs exposed or touched. Sometimes, as with Bosch and Gossaert, it might be at the desire of particularly worldly patrons, such as Philip of Burgundy, a bishop who was an illegitimate son of Duke Philip the Good. Later, Protestant

119. LUCAS CRANACH THE ELDER
The Judgment of Paris,
c. 1530. Panel, 13¾ x 9½"
(35 x 24 cm). Kunsthalle, Karlsruhe.

circles provided equally startling images and a more novel and far-reaching justification for their production. Luther disavowed the celibate, monastic ideal that had governed the Church for so many centuries and which continues to this day to regulate the lives of its leaders. Luther, a former Augustinian canon, himself married a former nun, and his recorded conversations (or table talks, as they were called) show that he often expressed himself in a forthright manner on sexual matters. He declared that sexual intercourse within marriage was not, as the Church had claimed, an unchaste necessity but was good and could be positively enjoyed. Such a radical change of attitude toward sexuality found an interesting parallel in the art of the chief Lutheran propagandist, Lucas Cranach the Elder.

At the same time as Cranach was perfecting his images of Lutheran theology, he painted a series of provocative female

nudes, variously representing *Venus and Cupid, a Nymph at a Spring,* and *The Judgment of Paris* (FIG. 119), among others. All these scenes have been transported into northern settings. In *The Judgment of Paris,* for instance, the shepherd Paris is outfitted as a contemporary German knight, Mercury looks like the ancient Nordic god Wotan, and the whole scene transpires before a lush German forest. The three goddesses perform a kind of sexual dance for Paris, looking more naked than comfortably, ideally nude – only their necklaces, headgear, and gossamer veils "covering" their genitals remain. Such erotic images by Cranach almost invariably made reference to the notion of the pain or suffering of love. Cupid complains to Venus, the Nymph looks like Diana, who refused to let men look upon her beauty, and the Judgment of Paris leads to the Trojan War. This is a new and indulgent, human point of view. Fascinating but threatening, sexuality has appeared in a way that modern pornography still exploits.

120. ALBRECHT DÜRER
Adam and Eve, 1504.
Engraving, 9³/₄ x 7⁹/₁₆" (24.8 x 19.2 cm). British Museum, London.

Rather inventively, Dürer gave his serpent a peacock's crown (the four pin-like protrusions coming out of its head). Peacocks were birds of paradise but also, because of the way they strutted around, extending their tail feathers, one of the time-honoured emblems of pride. Dürer thus suggested with this small device that it was the snake's appeal to Adam and Eve's pride that led to their downfall.

In the Introduction to this book we learned that Albrecht Dürer's deep philosophical self-consciousness set him apart from his more practical, craft-oriented contemporaries. In an analogous way, Dürer had, for a northerner, an unusually intense, intellectual and theoretical, interest in Italian Renaissance culture and its classical heritage. Thus in his engraving of *Adam and Eve* (FIG. 120), Dürer was trying to come to terms with his fascination for the nude human body with the direct help of Italianate classical ideals. He went to great trouble, moving through numerous preparatory studies and stages, in order to achieve the rare northern image of physical perfection and harmony that his print sets before us. He based Adam on an ancient statue of Apollo, Eve on Venus. These are bodies perfectly poised, articulated, and interrelated: Adam and Eve before the Fall. This is a crucial point. For the northern artist, Dürer, the pursuit of artistic (and physical) perfection in these two bodies was not an end in itself. As with many other works in the northern tradition,

like van Eyck's Arnolfini couple, Dürer's Adam and Eve are heraldically displayed, surrounded by numerous details, charged with meaning. Most important are the four large animals below – cat, rabbit, elk, and ox, which stand for the four tempera-ments, choleric, sanguine, melancholic, and phlegmatic. It was thought then that, after the Fall, each human body was ruled by a fluid that brought with it behaviour and attitudes characteris-tic of one of these temperaments (or personality types): anger, cleverness, depression, and laziness. *Before* the Fall, as the bodies of Dürer's First Parents so ably demonstrate, all was in harmony, both within men and women and without, in the world, the landscape all around. A peaceable kingdom truly reigned. Thus the cat does not (yet) pounce on the mouse. No human body can be as perfectly made as Adam and Eve are here shown to be: in Christian theology, that perfection was found only in paradise – or in the mind of the artist.

In order to accomplish this ideal, Dürer studied not only his own piously detailed northern tradition, but also the southern, idealised classical tradition. Shortly after he completed this engraving, he made a journey to northern Italy, where he hoped among other things "to learn the secrets of the art of perspec-tive." Writing from Venice to a friend about his eventual return north, he bemoaned: "Oh, how I shall long for the sun! Here I am a gentleman, at home only a parasite...," thus underlining his unusual obsession with Italy and the idealising achievements of its art. More common in the North was the mingling of elements found in Dürer's Adam and Eve engraving: some classically derived vocabulary, treated in a minutely detailed, finely textured fashion and carefully backed up by a rich forest of symbolic ref-erence. Between the figures is an apple tree (with fig leaves!) the Tree of Knowledge from which they are forbidden to eat. Adam's own right hand still grasps the Tree of Life, a mountain ash. On this tree sits a parrot, a talking bird, symbol of the Word, of Christ and eternal life. Beside this bird hangs a tablet on which Dürer inscribes "ALBERT DÜRER NORICVS FACIEBAT 1504" (Albrecht Dürer of Nuremberg was making [this] 1504). What-ever he may later have felt, Dürer was proud to be a northerner. Here, as in the case of Michelangelo, we have entered the realm of Renaissance polemics. We do not need to espouse the value of Dürer's "northern-ness" so much as we need simply to acknowledge it. From careful study of the distinctive and diverse northern Renaissance tradition we might also gain some insight into what we have achieved and what we have lost in the inter-vening years.

	Historical Events	Architecture, Sculpture and Applied Arts
1450	1378 End of Avignon papacy 1414-17 Council of Constance ends Great Schism (1417) 1438-39 Council of Ferrara-Florence and union with the Greek Church	1395-1406 Claus Sluter *Well of Moses* c. 1410 Boucicaut Master *Book of Hours* c. 1415 Limbourg Brothers *Très Riches Heures du Duc de Berry* 1443-53 House of Jacques Coeur, Bourges
1475	1450 Jubilee year in Rome c. 1450 Invention of movable type by Johannes Gutenberg 1452 Election of Frederick of Habsburg as Holy Roman Emperor 1453 Fall of Constantinople to Ottoman Turks	c. 1452-60 Jean Fouquet *Book of Hours* c. 1458-60 Jean le Tavernier miniatures in *Les Chroniques de Charlemagne* c. 1459 Workshop of Pasquier Grenier, tapestry 1467 Gerard Loyet *Reliquary of Charles the Bold*
1500	1482 Peace of Arras: division of Burgundy 1488 Revolt of Ghent; foreign merchants ordered to move to Antwerp 1490 Capitulation of Bruges 1492 Landfall of Christopher Columbus in America 1493 Election of Maximilian as Holy Roman Emperor 1494 French invasion of Italy 1499 Peace of Basle and Swiss independence	c. 1471-81 Michael Pacher *St. Wolfgang Altarpiece* c. 1480 Master of Mary of Burgundy *Book of Hours* 1481-82 Agnes van den Bossche *Flag of the City of Ghent* Late 15th Century – anonymous *Altarpiece of the Passion and Infancy of Christ* c. 1493-96 Adam Kraft Holy Sacrament House in Nuremberg
1525	1506 Maximilian regent of Netherlands 1516 Publication of Erasmus's Greek New Testament 1517 Luther protests against indulgences in his Ninety-five Theses 1519 Election of Charles V as Holy Roman Emperor	Early 16th Century – completion of Basilica of Our Lady, Tongeren c. 1499-1505 Tilman Riemenschneider *Holy Blood Altarpiece* 1519 Quinten Massys *Portrait Medal of Erasmus*
1550	1525 German Peasants' Revolt 1534 Anabaptist community at Münster 1536 Publication of Calvin's *Institutes of a Christian Religion* 1550-51 Formal debates in Spain on morality of intervention in America	
post-1550	1559 Regency of Margaret of Austria in the Netherlands 1545-63 Council of Trent 1566 Iconoclasm and revolt in the Netherlands 1572 Massacre of St. Bartholomew 1576 "Spanish Fury" in Antwerp	Early 1560s – Antwerp town hall

Painting	Prints
c. 1425 Robert Campin attrib. *Virgin and Child before a Firescreen*	
Completed 1432 – Jan van Eyck *Ghent Altarpiece*	
1434 Jan van Eyck *Arnolfini Double Portrait*	
c. 1435-40 Roger van der Weyden *St. Luke Portraying the Virgin*	
c. 1440 Jan van Eyck *Virgin in a Church*	
c. 1440 Stefan Lochner *Virgin and Child in a Rose Arbour*	
1444 Konrad Witz *Miraculous Draught of Fishes*	
c. 1450 Jean Fouquet *Self-portrait*	**1466** Master E.S *Large Madonna of Einsiedeln*
c. 1460 Roger van der Weyden *Portrait of Francesco d'Este*	
c. 1470 Petrus Christus *Portrait of a Lady*	
c. 1470-75 Dirc Bouts *Justice of the Emperor Otto III*	
c. 1475-76 Hugo van der Goes *Portinari Altarpiece*	**c. 1490** Martin Schongauer *Virgin and Child in a Courtyard*
1480 Hans Memling *Scenes from the Life of the Virgin and Christ*	
c. 1480 Master of the St. Lucy Legend *Virgin Among Virgins in a Rose Garden*	
c. 1490 Studio of Gerard David *Virgin and Child with Prayer Wings*	
c. 1490 Hieronymus Bosch *Triptych with Hay Wagon*	
c. 1505-10 Gerard David *Triptych with the Nativity*	**1504** Albrecht Dürer *Adam and Eve*
c. 1505-10 Hieronymus Bosch *Garden of Earthly Delights*	**1510** Hans Baldung Grien *Witches' Sabbath*
	c. 1510 Lucas van Leyden *Baptism of Christ*
1515 Matthias Grünewald *Isenheim Altarpiece*	**1514** Dürer *Melencholia I*
c. 1520-24 Joachim Patinir *Landscape with St. Jerome*	**1523** Dürer *Last Supper*
	c. 1523-26 Hans Holbein the Younger *Dance of Death* series
c. 1525-30 Lucas van Leyden *Adoration of the Golden Calf*	**1526** Dürer *Philipp Melanchthon*
c. 1530 Lucas Cranach the Elder *The Judgment of Paris*	**c. 1530** Lucas Cranach the Elder *Allegory of Law and Grace*
1548 Caterina van Hemessen *Self-portrait*	**c. 1544** Hans Baldung Grien *Bewitched Groom*
1551 Pieter Aertsen *Meat Still-life*	**c. 1583** Anonymous *Iconoclasm in the Netherlands*
1553 Marten van Heemskerck *Self-portrait before the Colosseum*	
1554 Frans Floris *Fall of the Rebel Angels*	
1559 Pieter Bruegel *Battle Between Carnival and Lent*, 1565 *Return of the Herd*, c. 1566 *Peasant Dance*	

Bibliography

Due to space limitations only the most recent and important general works in English, as well as those specialised studies directly drawn upon for the views presented in this book, have been included here.

SELECTED GENERAL SOURCES

Michael Baxandall, *Patterns of Intention: On the Historical Explanation of Pictures* (New Haven: Yale University Press, 1985); Otto Benesch, *The Art of the Renaissance in Northern Europe, Its Relation to the Contemporary Spiritual and Intellectual Movements,* (London: Phaidon Press, 1965); Shirley Neilsen Blum, *Early Netherlandish Triptychs, A Study in Patronage* (Berkeley: University of California Press, 1969); Carl C. Christensen, *Art and the Reformation in Germany* (Athens, OH: Ohio State University Press, 1979); Charles D. Cuttler, *Northern Painting from Pucelle to Bruegel: Fourteenth, Fifteenth and Sixteenth centuries* (New York: Holt, Rinehart, Winston, 1968); Detroit Institue of Arts, *Flanders in the Fifteenth Century − Art and Civilization* (Detroit: Detroit Institute of Arts, 1960); David Freedberg, *The Power of Images: Studies in the History and Theory of Response* (Chicago: University of Chicago Press, 1989); Max J. Friedländer, *Early Netherlandish Painting*, trans. H. Norden, 14 vols. (New York: Praeger, 1967-76); Johan Huizinga, *The Waning of the Middle Ages, a Study of Life, Thought and Art in France and the Netherlands in the Fourteenth and Fifteenth Centuries*, trans. F. Hopman (London: E. Arnold, 1924); Barbara G. Lane, *Flemish Painting Outside Bruges, 1400-1500, An Annotated Bibliography* (Boston: G.K. Hall, 1986); Theodor Muller, *Sculpture in the Netherlands, Germany, France and Spain, 1400 to 1500* (Harmondsworth: Penguin, 1966); E. James Mundy, *Painting in Bruges, 1470-1550, An Annotated Bibliography* (Boston: G.K. Hall, 1985); Gert von der Osten, and Horst Vey, *Painting and Sculpture in Germany and the Netherlands, 1500 to 1600* (Harmondsworth: Penguin, 1969); Erwin Panofsky, *Early Netherlandish Painting, Its Origins and Character*, 2 vols. (Cambridge, MA: Harvard University Press, 1953); Linda B. Parshall and Peter Parshall, *Art and the Reformation, An Annotated Bibliography* (Boston: G.K. Hall, 1986); Walter Prevenier and Wim Blockmans, *The Burgundian Netherlands*, trans. P. Kin and Y. Mead (Cambridge: Cambridge University Press, 1986); Sixten Ringbom, *Icon to Narrative: The Rise of the Dramatic Close-Up in Fifteenth Century Devotional Painting*, 2nd ed. (Doornspijk: Davaco, 1984); Larry Silver, "The State of Research in Northern European Art of the Renaissance Era," *Art Bulletin* 68 (1986), pp. 518-535; James Snyder, *Northern Renaissance Art: Painting, Sculpture and the Graphic Arts from 1350 to 1575* (New York: Abrams, 1985).

INTRODUCTION

For the *Arnolfini Double Portrait* (FIG. 3), see the references cited below in chapter 4.

For the Master of St. Lucy painting in Detroit (FIG. 5), see Craig Harbison, "Fact, Symbol, Ideal: Roles for Realism in Early Netherlandish Painting," *Proceedings of the Petrus Christus Symposium* (New York: Metropolitan Museum of Art, 1995 [forthcoming]).

For Adam Kraft's *Sacrament House* and self-portrait (FIG. 6), see *Gothic and Renaissance Art in Nuremberg, 1300-1550* (New York: Metropolitan Museum of Art, 1986), esp. pp. 53-56.

For Bruegel's drawing of an *Artist and Patron* (FIG. 8), see E. H. Gombrich, "The Pride of Apelles," in *The Heritage of Apelles* (Oxford: Phaidon Press, 1976), pp. 132-134 and 153.

For Marten van Heemskerck's *Self-portrait* (FIG. 12), see Robert F. Chirico, "Maerten van Heemskerck and Creative Genius," *Marsyas* 21 (1981-2), pp. 7-11.

For Caterina van Hemessen's *Self-Portrait* (FIG. 13), see Ann Sutherland Harris and Linda Nochlin, *Woman Artists: 1550-1950* (New York: Alfred A. Knopf, 1977), esp. pp. 25-26 and 105. For the status of women in the Renaissance, see for instance David Herlihy, "Did Women Have a Renaissance?: A Reconsideration," *Medievalia et Humanistica* n.s. 13 (1985), pp. 1-22.

For Dürer's self-portrait drawing (FIG. 14), see Joseph Leo Koerner, *The Moment of Self-portraiture in German Renaissance Art* (Chicago: University of Chicago Press, 1993), esp. pp. 3ff.

For Dürer's *Melencholia* (FIG. 15), see Erwin Panofsky, *The Life and Art of Albrecht Dürer* (Princeton: Princeton University Press, 1955), esp. pp. 156-171.

CHAPTER 1

For the fifteenth century contract requiring bourgeois furniture, see Lorne Campbell, "The Art Market in the Southern Netherlands in the Fifteenth Century," *Burlington Magazine* 118 (1976), pp. 192-3.

For Jean Pucelle and the *Book of Hours of Jeanne d'Evreux* (FIG. 17), see Richard H. Randall, "Frog in the Middle," *Metropolitan Museum of Art Bulletin* 16 (1958), pp. 269-275.

For a comparison of northern and southern styles and painting techniques, see E. H. Gombrich, "Light, Form, and Texture in Fifteenth-Century Painting North and South of the Alps," in *The Heritage of Apelles* (Oxford: Phaidon Press, 1976), pp. 19-35.

For Claus Sluter (FIG. 27), see Kathleen Morand, *Claus Sluter: Artist at the Court of Burgundy* (Austin, TX: University of Texas Press, 1991), esp. pp. 91-120 and 330-349.

For the relation of Philosophic Realism and Nominalism to early Netherlandish art, see Craig Harbison, "Realism and Symbolism in Early Flemish Painting," *Art Bulletin* 66 (1984), pp. 588-602.

For Roger van der Weyden's *Deposition* (FIG. 28), see Otto G. von Simson, "*Compassio* and *Co-redemptio* in Roger van der Weyden's *Descent from the Cross*," *Art Bulletin* 35 (1953), pp. 9-16; for the shape of Roger's painting, see Lynn F. Jacobs, "The Inverted 'T'-Shape in Early Netherlandish Altarpieces: Studies in the Relation between Painting and Sculpture," *Zeitschrift für Kunstgeschichte* 57 (1991), pp. 33-65.

For the Flemish tapestry from Tournai (FIG. 31), see Roger-A. d'Hulst, *Flemish Tapestries from the Fifteenth to the Eighteenth Century*, trans. F. J. Stillman (New York: Universe Books, 1967), pp. 49-58.

For the patronage of early Netherlandish art, see Craig Harbison, *Jan van Eyck: The Play of Realism* (London: Reaktion Books, 1991), esp. pp. 93-99 and 119-123.

For the theory of "disguised symbolism" in early Netherlandish art, see Erwin Panofsky, *Early Netherlandish Painting* (Cambridge, MA: Harvard University Press, 1953), esp. pp. 131-148; and Otto Pächt, "Panofsky's 'Early Netherlandish Painting'-II," *Burlington Magazine* 98 (1956), esp. pp. 277-79.

For doubts on the attribution of the *Firescreen Virgin* (FIG. 32) to Robert Campin, see Lorne Campbell, "Robert Campin, the Master of Flémalle and the Master of Mérode,"

Burlington Magazine 96 (1974), pp. 634-646.

For grisaille painting as Lenten observance, see Molly Teasdale Smith, "The Use of Grisaille as a Lenten Observance," Marsyas 8 (1957-59), pp. 43-54. For grisaille and "degrees of reality," see Paul Philippot, "Les grisailles et les 'degrés de réalité' de l'image dans la peinture flamande des XVe et XVIe siècles," Musées Royaux des Beaux-Arts de Belgique, Bulletin 15 (1966), pp. 225-42.

For Hugo van der Goes' biography and floral symbolism (FIGS. 33-36), see Robert A. Koch, "Flower Symbolism in the Portinari Altarpiece," Art Bulletin 46 (1964), pp. 70-77; for the presence of the devil see R. M. Walker, "The Demon in the Portinari Altarpiece," Art Bulletin 42 (1960), pp. 218-219.

CHAPTER 2

For the craft and profession of painting in general, see Lorne Campbell, "The Art Market in the Southern Netherlands in the Fifteenth Century," Burlington Magazine 98 (1976), pp. 188-198; idem., "The Early Netherlandish Painters and Their Workshops," in Le Dessin sous-jacent dans la peinture, Le Problème Maître de Flémalle-van der Weyden, ed. D. Hollanders-Favart and R. van Schoute (Louvain-la-Neuve: Université Catholique de Louvain, 1981), pp. 43-61; and Jill Dunkerton, Susan Foister, Dillian Gordon and Nicholas Penny, Giotto to Dürer, Early Renaissance Painting in The National Gallery (London: Yale University Press, 1991), esp. pp. 122-204.

For canvas painting, see Diane Wolfthal, The Beginnings of Netherlandish Canvas Painting: 1400-1530 (Cambridge: Cambridge University Press, 1989), esp. pp. 38-42 (for Bouts [FIG. 37]) and p. 50 (for van den Bossche [FIG. 38]).

For the contract for Enguerrand Charonton's Coronation of the Virgin (FIG. 39), see Wolfgang Stechow, Northern Renaissance Art, 1400-1600, Sources and Documents, (Englewood Cliffs, NJ: Prentice-Hall, 1966), pp. 141-145; also Don Denny, "The Trinity in Enguerrand Quarton's Coronation of the Virgin," Art Bulletin 45 (1963), pp. 48-51.

For the marketing of art in the later fifteenth and sixteenth centuries, see Jean C. Wilson, "The participation of painters in the Bruges 'pandt' market, 1512-1550," Burlington Magazine 125 (1983), pp. 476-479; and Dan Ewing, "Marketing Art in Antwerp, 1460-1560: Our Lady's Pand," Art Bulletin 72 (1990), pp. 558-584.

For carved altarpieces (such as FIG. 41), see Lynn Jacobs, "The Marketing and Standardization of South Netherlandish Carved Altarpieces: Limits on the Role of the Patron," Art Bulletin 71 (1989), pp. 208-229; and idem., "The Commissioning of Early Netherlandish Carved Altarpieces: Some Documentary Evidence," in A Tribute to Robert A. Koch: Studies in the Northern Renaissance (Princeton: Princeton University, Department of Art and Archeology, 1994), pp. 83-114.

For drawings in general, see Maryan W. Ainsworth, "Northern Renaissance Drawings and Underdrawings: A Proposed Method of Study," Master Drawings 27 (1989), pp. 5-38.

For Bosch's "Garden of Earthly Delights" Triptych (FIGS. 48-50), see R. H. Marijnissen and P. Ruyffelaere, Hieronymus Bosch, The Complete Works (Antwerp: Mercatorfons, 1987), esp. pp. 84-102; and Paul Vandenbroeck, "Jheronimus Bosch's zogenaamde Tuin der Lusten, I en II," Jaarboek der Koninklijk Museum voor Schone Kunsten Antwerpen 1989, pp. 9-210 and 1990, pp. 9-192.

For the Ghent Altarpiece (FIGS. 51 and 52), see Elizabeth Dhanens, Van Eyck: The Ghent Altarpiece (New York: The Viking Press, 1973); and Lotte Brand Philip, The Ghent Altarpiece and the Art of Jan van Eyck (Princeton: Princeton University Press, 1971).

For Dirc Bouts' Justice of the Emperor Otto III (FIGS. 53 and 54), see Frans van Molle, Jacqueline Folie, Nicole Verhaegen, Albert and Paul Philippot, et. al, "La Justice d'Othon de Thierry Bouts," Bulletin de l'Institut royal du patrimoine artistique, Brussels 1 (1958), pp. 7-69; and for the history of judicial ordeal, see Robert Bartlett, Trial by Fire and Water, The Medieval Judicial Ordeal (Oxford: Clarendon Press, 1986).

For Grünewald's Isenheim Altarpiece (FIGS. 56 and 57), see most recently Ruth Mellinkoff, The Devil at Isenheim, Reflections on Popular Belief in Grünewald's Altarpiece (Berkeley: University of California Press, 1988); and Andrée Hayum, The Isenheim Altarpiece: God's Medicine and the Painter's Vision (Princeton: Princeton University Press, 1990).

CHAPTER 3

For the religious history of the fourteenth, fifteenth, and sixteenth centuries in general, see Steven Ozment, The Age of Reform, 1250-1550, An Intellectual and Religious History of Late Medieval and Reformation Europe (New Haven: Yale University Press, 1980).

For the religious situation in Flanders, see Jacques Toussaert, Le Sentiment religieux en Flandre à la fin du Moyen Age (Paris: Plon, 1963); Craig Harbison, "Visions and meditations in early Flemish painting," Simiolus 15 (1985), pp. 87-118; James Marrow, "Symbol and Meaning in Northern European Art of the Late Middle Ages and Early Renaissance," Simiolus 16 (1986), pp. 150-169; Barbara Lane, "Sacred and Profane in Early Netherlandish Painting," Simiolus 18 (1988), pp. 107-115; and Craig Harbison, "Religious Imagination and Art Historical Method: A Reply to Barbara Lane's 'Sacred Versus Profane,'" Simiolus 19 (1989), pp. 198-205.

For liturgical symbolism, see Barbara G. Lane, The Altar and the Altarpiece, Sacramental Themes in Early Netherlandish Painting (New York: Harper and Row, 1984).

For the role of images in private devotion, see Sixten Ringbom, "Devotional Images and Imaginative Devotions: Notes on the Place of Art in Late Medieval Private Piety," Gazette des Beaux-Arts ser. 6, 73 (1969), pp. 159-170; also idem., "Vision and conversation in early Netherlandish painting: the Delft Master's Holy Family," Simiolus 19 (1989), pp. 181-190.

For pilgrimage and fifteenth century religious imagery, see Matthew Botvinick, "The Painting as Pilgrimage: Traces of a Subtext in the Work of Campin and his Contemporaries," Art History 15 (1992), pp. 1-18; and Craig Harbison, "Miracles Happen: Image and Experience in Jan van Eyck's Madonna in a Church," in Iconography at the Crossroads, ed. B. Cassidy (Princeton: Index of Christian Art, 1993), pp. 157-170.

For the copying or repetition of fifteenth century religious images, see Larry Silver, "Fountain and Source: a Rediscovered Eyckian Icon," Pantheon 41 (1983), pp. 95-104.

For Hans Holbein's Dance of Death woodcuts (FIG. 71), see Natalie Zemon Davis, "Holbein's Pictures of Death and the Reformation at Lyons," Studies in the Renaissance 3 (1956), pp. 97-130.

For Michael Ostendorfer's Regensburg woodcut (FIG. 73), see Charles Talbot, From a Mighty Fortress, Prints, Drawings, and Books in the Age of Luther, 1483-1546 (Detroit: Detroit Institute of Arts, 1983), esp. pp. 323-325 (cat. no. 184); and for the use of prints as factual records of miraculous events, see Peter Parshall, "Imago contrafacta: Images and Facts in the Northern Renaissance," Art History 16 (1993), pp. 554-579.

For Tilman Riemenschneider's Holy Blood Altarpiece (FIGS. 75

and 76), see Michael Baxandall, *The Limewood Sculptors of Renaissance Germany* (New Haven: Yale University Press, 1980), esp. pp. 172-190.

For Lucas van Leyden's *Baptism* engraving (FIG. 77), see Craig Harbison, "Some Artistic Anticipations of Theological Thought," *Art Quarterly* n.s. 2 (1979), pp. 67-89.

For Albrecht Dürer's *Last Supper* (FIG. 78) and Dürer's relation to the Reformation, see Craig Harbison, "Dürer and the Reformation: the Problem of the Re-Dating of the *St. Philip* Engraving," *Art Bulletin* 58 (1976), pp. 368-373.

For Lucas Cranach's *Allegory* (FIG. 79), see Donald L. Ehresmann, "The Brazen Serpent, a Reformation Motif in the Works of Lucas Cranach the Elder and his Workshop," *Marsyas* 13 (1966), pp. 32-47.

CHAPTER 4

For portraiture in general see John Pope Hennessy, *The Portrait in the Renaissance* (New York: Pantheon Books, 1966); Lorne Campbell, *Renaissance Portraits* (New Haven: Yale University Press, 1990); and Angelica Dülberg, *Privatporträts* (Berlin: Gebr. Mann Verlag, 1990).

For Roger van der Weyden's d'Este portrait (FIGS. 83 and 84), see Guy Bauman, "Early Flemish Portraits, 1425-1525," *Metropolitan Museum of Art Bulletin* n.s. 43 (Spring 1986), esp. pp. 38-41.

For the *Arnolfini Double Portrait* (FIGS. 3 and 4), see Erwin Panofsky, "Jan van Eyck's *Arnolfini Portrait*," *Burlington Magazine* 64 (1934), pp. 117-127; Craig Harbison, "Sexuality and Social Standing in Jan van Eyck's Arnolfini Double Portrait," *Renaissance Quarterly* 43 (1990), pp. 249-291.

For Dürer's Melanchthon portrait (FIG. 86), see Charles H. Talbot, *Dürer in America, His Graphic Work* (Washington, D.C.: National Gallery of Art, 1971), esp. pp. 156-158.

For Holbein's *Portrait of Erasmus Writing* (FIG. 87) and *Portrait of a Lady* (FIG. 82), see John Rowlands, *Holbein, The Paintings of Hans Holbein The Younger, Complete Edition* (London: Phaidon Press, 1985), esp. pp. 58-9 and 129-30 (cat. no. 15) and p. 146 (cat. no. 69).

For Massys' Erasmus medal (FIGS. 90 and 91), see Erwin Panofsky, "Erasmus and the Visual Arts," *Journal of the Warburg and Courtauld Institutes* 32 (1969), pp. 200-227, esp. 214-219.

For an Italian-based view of the development of sixteenth century landscape painting, see E. H. Gombrich, "The Renaissance Theory of Art and the Rise of Landscape," in *Norm and Form*, 2nd ed. (London: Phaidon Press, 1971), pp. 107-121 and 150-153.

For Memling's *Scenes from the Life of the Virgin and Christ* (FIG. 92) and mental pilgrimage, see Craig Harbison, *Jan van Eyck, The Play of Realism* (London: Reaktion Books, 1991), pp. 186-7.

For Conrad Witz's *Miraculous Draught of Fishes* (FIG. 93), see Molly Teasdale Smith, "Conrad Witz's *Miraculous Draught of Fishes* and the Council of Basel," *Art Bulletin* 52 (1970), pp. 150-156.

For Patinir's work (FIGS. 97 and 118), see Robert A. Koch, *Joachim Patinir* (Princeton: Princeton University Press, 1968). See also Kahren Jones Hellerstedt, "The blind man and his guide in Netherlandish painting," *Simiolus* 13 (1983), pp. 163-181.

For Bruegel's *Return of the Herd* (FIG. 98), see Walter S. Gibson, "Mirror of the Earth," *The World Landscape in Sixteenth Century Flemish Painting* (Princeton: Princeton University Press, 1989), esp. pp. 69-75.

For Albrecht Altdorfer's *Satyr's Family* (FIG. 99), see Larry Silver, "Forrest Primeval: Albrecht Altdorfer and the German wilderness landscape," *Simiolus* 13 (1983), pp. 4-43;

and Christopher S. Wood, *Albrecht Altdorfer and the Origins of Landscape* (Chicago: University of Chicago Press, 1993).

For Jan Mostaert's *Landscape with Primitive Peoples* (FIG. 100), see Charles D. Cuttler, "Errata in Netherlandish Art: Jan Mostaert's 'New World' Landscape," *Simiolus* 19 (1989), pp. 191-197.

For still-life painting in general, see Norman Bryson, *Looking at the Overlooked, Four Essays on Still-Life Painting* (London: Reaktion Books, 1990); and Norbert Schneider, *The Art of Still-Life, Still-Life Painting in the Early Modern Period* (Cologne: Benedikt Taschen, 1990).

For Massys' *Money-Changer* (FIG. 102), see Keith P. F. Moxey, "The criticism of avarice in sixteenth-century Netherlandish painting," in *Netherlandish Mannerism*, ed. G. Cavalli-Björkman (Stockholm: Nationalmuseum, 1985), pp. 21-34.

For Aertsen's *Meat Still-life* (FIG. 103), see Kenneth M. Craig, "Pieter Aertsen and *The Meat Stall*," *Oud-Holland* 96 (1982), pp. 1-15; and Ethan Matt Kavaler, "Pieter Aertsen's Meat Stall, Diverse aspects of the market piece," *Nederlands Kunsthistorisch Jaarboek* 40 (1989), pp. 67-92.

For several views of Bruegel's images of peasants and civic life (FIGS. 104 and 108), see Svetlana Alpers, "Bruegel's festive peasants," *Simiolus* 6 (1972/73), pp. 163-176; Robert Baldwin, "Peasant Imagery and Bruegel's 'Fall of Icarus,'" *Konsthistorisk Tidskrift* 55 (1986), pp. 101-114; Margaret D. Carroll, "Peasant Festivity and Political Identity in the Sixteenth Century," *Art History* 10 (1987), pp. 289-314; and Margaret Sullivan, *Bruegel's Peasants: Art and Audience in the Northern Renaissance* (Cambridge: Cambridge University Press, 1994).

For Bosch's *Triptych with Hay Wagon* (FIGS. 106 and 107), see Virginia G. Tuttle, "Bosch's Image of Poverty," *Art Bulletin* 63 (1981), pp. 88-95; and R. H.Marijnissen and P. Ruyffelaere, *Hieronymus Bosch, The Complete Works* (Antwerp: Mercatorfons, 1987), esp. pp. 52-9.

For "inverted compositions," see, for instance, Craig Harbison, "Lucas van Leyden, the Magdalen and the Problem of Secularization in Early Sixteenth Century Northern Art," *Oud-Holland* 98 (1984), pp. 117-129.

CONCLUSION

For Francisco de Hollanda's account of Michelangelo's opinion of northern art, see Robert Klein and Henri Zerner, *Italian Art, 1500-1600, Sources and Documents* (Englewood Cliffs, NJ: Prentice-Hall, 1966), pp. 33-35.

For the possibility of Jan van Eyck's travels to Italy, see Craig Harbison, *Jan van Eyck, The Play of Realism* (London: Reaktion Books, 1991) esp. pp. 158-167 (with further references).

For Roger van der Weyden's Crucifixion diptych (FIG. 112), see Penny Howell Jolly, "Roger van der Weyden's Escorial and Philadelphia *Crucifixions* and their Relation to Fra Angelico at San Marco," *Oud-Holland* 95 (1981), pp. 113-126.

For Hieronymus Bosch and Italy, see Leonard J. Slatkes, "Hieronymus Bosch and Italy," *Art Bulletin* 57 (1975), pp. 335-345.

For the notion that the Renaissance was characterised by the reunion of classical form and classical content, see Erwin Panofsky, *Renaissance and Renascences in Western Art*, 2nd ed. (Stockholm: Almqvist and Wiksell, 1965).

For Gossaert's *Danaë* (FIG. 117), see Madlyn Millner Kahr, "Danaë: Virtuous, Voluptuous, Venal Woman," *Art Bulletin* 60 (1978), pp. 43-55.

For sexuality in Lutheranism, see Manfred P. Fleischer, "The garden of Laurentius Scholz: a cultural landmark of late-sixteenth-century Lutheranism," *Journal of Medieval and Renaissance Studies* 9 (1979), pp. 29-48.

Picture Credits

Unless stated differently museums have supplied their own photographic material. Supplementary and copyright information is given below. Numbers are figure numbers unless otherwise indicated.

title page: Staatliche Museen zu Berlin, Preussischer Kulturbesitz Gemäldegalerie, photo Jörg P. Anders
1: Courtesy Museum of Fine Arts Boston, Gift of Mr. and Mrs. Henry Lee Higginson
page 7, detail of figure 12: Fitzwilliam Museum, Cambridge
2: RMN, Paris
5: The Detroit Institute of Arts, Founders Society Purchase, General Membership Fund
6: Michael Jeiter, Morschenich, Germany
10: The Metropolitan Museum of Art, New York. Gift of J. Pierpont Morgan, 1917
11: © British Museum
13: Colorphoto Hinz SWB
15: © British Museum
page 25, detail of figure 30: © Treasury of the Cathedral of Liège/Paul M. R. Maeyaert
17: The Metropolitan Museum of Art, New York, The Cloisters Collection, 1954
18: Giraudon/Bridgeman Art Library, London
19, 20: Scala, Florence
22, 23, 24, 25: Paul M. R. Maeyaert, Mont de 1 'Enclus (Orroir), Belgium
26: photo Jörg P. Anders
27: Paul M. R. Maeyaert
30: © Treasury of the Cathedral of Liège/Paul M. R. Maeyaert
33, 34, 36: Scala
page 63, detail of figure 51: Paul M. R. Maeyaert
38: Paul M. R. Maeyaert
39, 40: Photo Daspet, Villeneuve les Avignon
41: Paul M. R. Maeyaert
43: Smith College Museum of Art, Northampton, Massachusetts. Purchased, Drayton Hillyer Fund, 1939
44: photo Elke Walford
47: © British Museum
51, 52, 55: Paul M. R. Maeyaert
56, 57: Giraudon, Paris
page 91, detail of figure 75: Florian Monheim, Dusseldorf
61, 63: photo Jörg P. Anders

64: Paul M. R. Maeyaert
65: Henk Brandsen, Amsterdam
66: © British Museum
67: Rheinisches Bildarchiv, Cologne
68: Photo Caudron, Cambrai
69: Lauros-Giraudon/Bridgeman Art Library, London
71, 74: © British Museum
75, 76: Florian Monheim, Dusseldorf
77, 78, 79, 81: © British Museum
82: The Toledo Museum of Art, Toledo, Ohio. Purchased with funds from the Libbey Endowment, Gift of Edward Drummond Libbey
page 123, detail of 102: RMN
83, 84: The Metropolitan Museum of Art, New York, Bequest of Michael Friedsam, 1931. The Friedsam Collection
85: photo Jörg P. Anders
86: © British Museum
87: RMN
88: RMN (Cabinet des dessins inv. no 18697)
90, 91: © British Museum
92: Artothek, Munich
93: © Musee d'Art et d'Histoire, Geneva, photo Bettina Jacot-Descombes
94: © British Museum
96: The Metropolitan Museum of Art, New York, The Jules Bache Collection, 1949
98: Bridgeman Art Library, London
99: photo Jörg P. Anders
100: © Rijksdienst Beeldende Kunst, The Hague
101: © The British Library, London (Maps C.39.d.1 p.54)
102: RMN
109: Tourist Information St. Wolfgang, Austria
page 155, detail of figure 114: Museum voor Schone Kunsten, Gent
110: Foto Moderna, Urbino
111: Scala
112: Philadelphia Museum of Art, The John G. Johnson Collection, photo by Graydon Wood
113: AKG London, photo Eric Lessing
115: The Royal Collection © Her Majesty Queen Elizabeth II. The Royal Library no 12495 recto
117: Artothek, Munich
120: © British Museum

Index